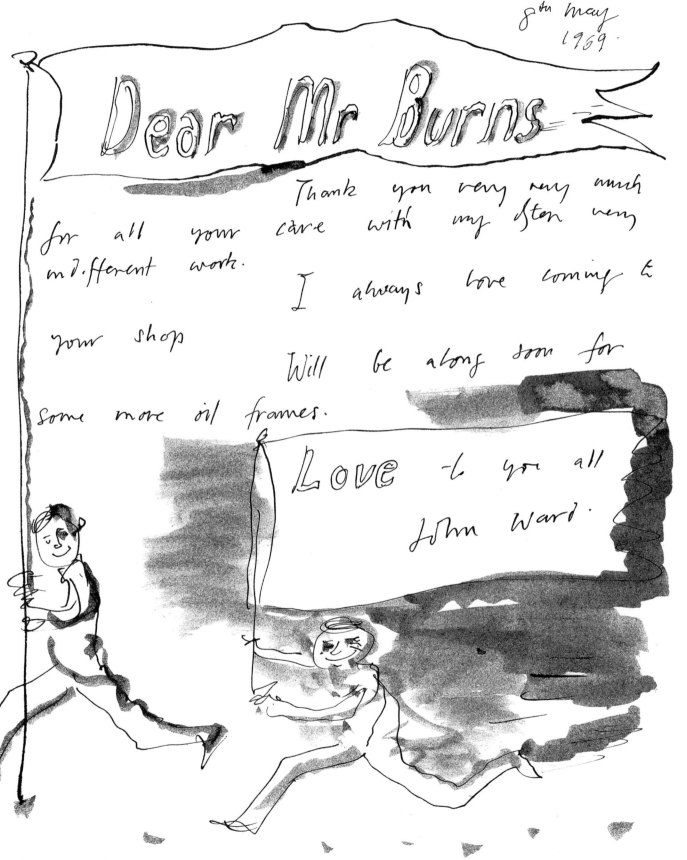

# THE PAINTINGS OF
# JOHN WARD

THE PAINTINGS
of
John Ward
CBE RA

DAVID & CHARLES
Newton Abbot   London

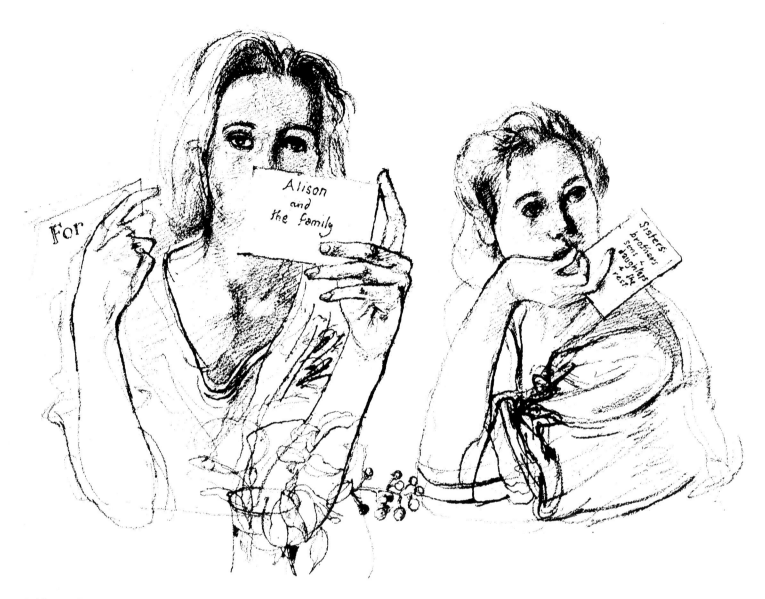

**British Library Cataloguing in Publication Data**
Ward, John *1917 Oct. 10*
    The paintings of John Ward.
    1. English paintings. Ward, John, 1917 Oct. 10
    I. Title
    759.2

    ISBN 0–7153–9822–9

Typeset by ABM Typographics Limited, Hull
and printed in Singapore
for David & Charles plc
Brunel House  Newton Abbot  Devon

# ACKNOWLEDGEMENTS

I must first acknowledge my great good fortune in having Sir Brinsley Ford write the introduction. Invaluable help in making the book came from Susie Williams, who helped me with the choice of pictures to be reproduced, and Gillian Andrae-Reid, who watched over the photographing of them with an expert eye. The photography was in the capable hands of Michael Todd-White and Vision Studios, Canterbury.

Faith Glasgow, my editor, has been the chief driving force. She has chivvied and guided and wonderfully encouraged me. It was my son George who sorted out the first outpourings of an in-experienced author – and did all the typing.

Henry Ford did useful work tidying up at proof stage, adding an index and details of the pictures. In doing this, he had to put up with my having forgotten most of them, so that he was obliged to tax the patience of their present owners. I am most grateful to these owners for their help, both in providing information (rush-ing about with tape-measures!) and in letting me take away the pictures to be photographed. More importantly, I am grateful to them for buying the pictures in the first place.

Looking back over my life, which writing this book has in-volved, I have had enormous pleasure in remembering the many people for whose help or whose company I have reason to be grateful. Teachers, dealers (Jeremy Maas in particular), fellow-artists and Academicians, models, framers, photographers, writers, critics, collectors, patrons, my family and friends in all walks of life – the list is endless. My chief acknowledgement is to them. And, of course, my heartfelt thanks to Alison.

I hope I have the picture details correct. Height is given before width. Some measurements are more precise than others; those preceded by a small c (Latin, *circa*) I know to be approximate. The same is true of the date of painting.

# CONTENTS

it was miles but near St. P. we came upon a travel agency & a kind young girl telephoned round Rome hotels but without luck so we opted for Venice. I went on to do some work & darling A. got us fixed up at Hotel Tivoli in Venice. After lunch a bit more work & then a taxi to Borghesi Gardens & villa

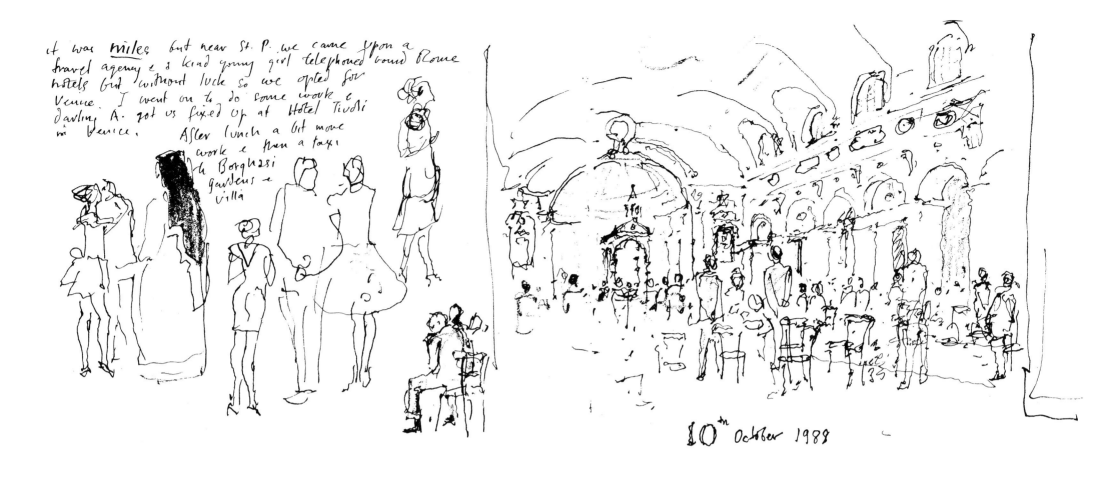

10th October 1988

Harry's Bar
Venice

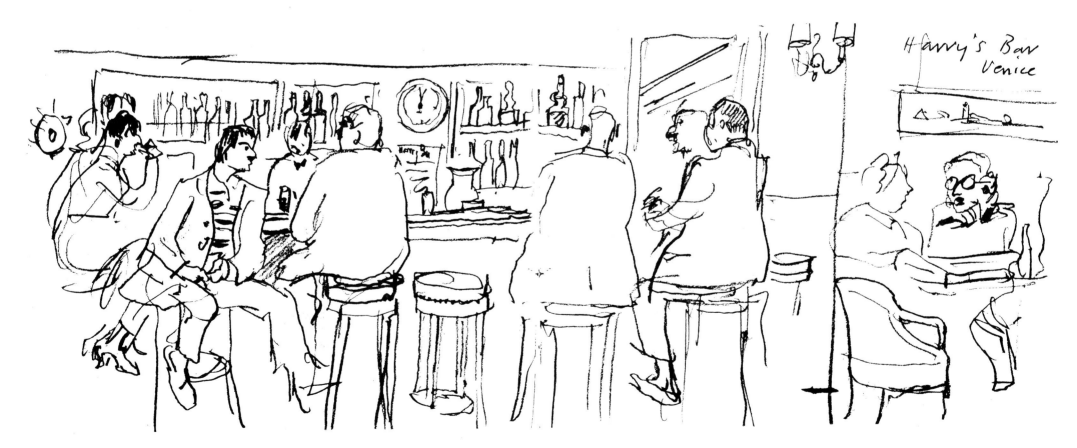

# INTRODUCTION

## *Sir Brinsley Ford*, CBE

In January 1972 Lord Plunket and I succeeded the 8th Earl Spencer as joint Secretaries of the Society of Dilettanti. We agreed that it would be highly desirable if we could find an artist to paint a conversation piece of members of the Society, and the only man we thought capable of doing it was John Ward.

Since Reynolds had painted his two famous groups in 1777-9, the only conversation piece that had been commissioned was that by Sir James Gunn, which was completed in 1959. The portraits were excellent likenesses, but the composition, as someone observed, resembled that of *The Last Supper*. The task of painting the conversation piece we desired should have been undertaken by Sir William Coldstream, who held the title (which John Ward now holds) of 'Painter to the Society'. But, as thirty members had agreed to be painted, and as Sir William sometimes took eighty sittings over one portrait, he conceded that he was not the man for the job. However he was strongly in favour of our inviting John Ward to undertake this commission, and he showed his support by seconding John for election to the Society, of which he duly became a member in January 1973.

In the journal that I kept in those days, I have recorded that on 1 August 1973 John lunched with me to discuss the conversation piece, which he had agreed to paint. His aim, he said, would be to show the members at the end of a dinner when most of them had risen from the table and were forming into groups. He had recently returned from Venice, and talked of trying to get the effect in the Dilettanti picture of one of Guardi's ridotto scenes in which all was 'fluttering movement'. He was keen on the idea of a group of men shown wearing dinner jackets, as he felt that this kind of uniform made it easier to bring out the character of the individuals. He laid great emphasis on the importance of catching the sense of actuality, of the fleeting pose of the sitters; the passing moment must not be lost, nothing must be static or rigid. As an instance of what he meant, he cited Sargent's picture of Robert Louis Stevenson (1884), which is in the Taft Museum in Cincinnati.

I was the first to sit to John Ward on the morning of Tuesday, 29 January 1974. Lord Spencer sat to him on that afternoon. John always asked for two sittings, sometimes three. At the first he made a drawing of the head which took about two hours. Using the drawing, he later sketched the head onto the canvas, so that at the second sitting he was ready to paint the head direct from life. It fell to me to arrange the sittings (seventy-five), which proved quite a formidable task.

The picture was nearing completion in March 1976, and was shown at the Royal Academy summer exhibition of that year (page 57). It is a brilliant composition and a splendid achievement, for every part of the canvas is animated with figures, and although the staid members of the Society can hardly be said to have the 'fluttering movement' of the masked courtesans in Guardi's *Ridotto*, in all other respects the picture fulfils the intentions that John had expressed in his conversation with me. I should perhaps add that Kenneth Clark thought it the best portrait ever painted of him. If I have dwelt at some length on the Dilettanti picture, the reason must be that it is the most ambitious work that John has ever undertaken and, though I was cast for the role of midwife, it was the beginning of our friendship.

Two other notable conversation pieces are reproduced in this book: *The Cabinet Secretaries* (1984, page 93), which was commissioned by the National Portrait Gallery, and *The East Kent School* (1985, page 91), in which the principal figure, holding a mahlstick, is John's great friend Jehan Daly, a painter of rare distinction. John has painted many family groups, including those of the Duke of Westminster at Eaton, Lord Montagu at Beaulieu and Lord Faringdon at Barnsley.

In the eighteenth century the qualification for belonging to the Dilettanti Society, founded in 1732, was to have been in Italy, though not, as Horace Walpole sneeringly observes, to have been drunk during the whole visit. In 1981 I sent John the first of several articles that I have written on the Grand Tour. In return John sent me an account of the Grand Tour that he had made with his wife, Alison, and a friend in 1951. After 'rumbling' across France 'in a jeep, a reliable vehicle with a top speed of 40 mph', they entered Rome, where they had the good fortune to have as their cicerone the English Minister to the Vatican, Sir D'Arcy Osborne, who had bought drawings from John when he was a student. Their tour started with the Piazza Navona where they 'nearly went mad with excitement', and they returned at 5.30am the next morning to sketch Bernini's fountain. They lodged in a little pensione behind the Pantheon in the Via S. Chiara, a pensione to which they returned year after year. In his letter John dwelt on the light and beauty of those early Roman mornings, and on their nightly walks from the Pantheon, up the Spanish Steps to the Trinita de' Monti, and along the Via Sistina, past Piranesi's house, to a favourite restaurant 'where we would be greeted with all the bowing and scraping which is so dear to my heart'. On the envelope was a pen drawing of a Roman baroque church, and another of the artist sketching an antique column. The letter itself was written under a heading adorned with a drawing of the dome of St Peter's and a view of the Forum.

A fine example of John's Roman drawings is that, executed in pen, ink and wash, of the *Arch of Septimus Severus* (page 36). It combines architectural accuracy with a lightness of touch and, as a fantastic embellishment, he has sketched across the top of the arch the winged figure of Victory that occurs in the left spandrel. The mastery which John displays in this Roman view availed him when he faced a far more difficult challenge – that of depicting the great campo at Siena, mentioned by Dante, where the Palio horserace is run. His two watercolours of this subject (page 61) are nothing short of a *tour de force*, for not only has he captured the spatial dimensions of the campo and indicated the character of the different palaces, but he has animated the whole scene by the liveliness of his figures.

Attached as he was to Rome, there can be little doubt that the city which captured his heart was Venice. His skill as an architectural draughtsman is illustrated in his watercolour, *Basilica from the Doge's Palace* (page 47). As a subject, however, Florian's proved a rival to St. Mark's. There are no less than six paintings reproduced in this book which are connected with Florian's, one of the world's most famous cafés, which lies in the arcade under the Procuratie Nuove. Of these paintings, *Jane at Florian's* (page 82) is the most enticing. It combines 'a pretty girl, a café, still life, etc, all the things I love painting', as John once wrote to me. The composition is very subtly and skilfully contrived, for the lucky young man whom Jane is welcoming is reflected in the mirrors which line the walls of the café. And, reminiscent of Ingres' portrait, *La Comtesse d'Haussonville*, Jane's back view is also seen in the mirror.

John and Alison were constantly on the wing, and during the last decade I have received letters and postcards from India, Macau, Hong Kong, Turkey, Spain and Egypt, not to mention France and Italy. The drawings done on his travels have been shown at the exhibi-

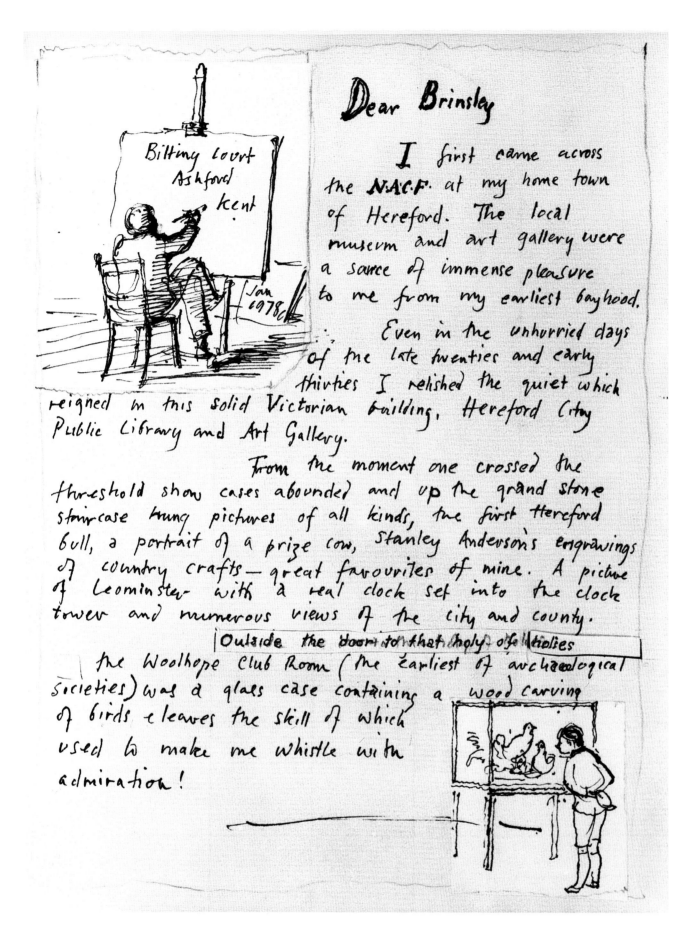

Dear Brinsley

I first came across the N.A.C.F. at my home town of Hereford. The local museum and art gallery were a source of immense pleasure to me from my earliest boyhood.

Even in the unhurried days of the late twenties and early thirties I relished the quiet which reigned in this solid Victorian building, Hereford City Public Library and Art Gallery.

From the moment one crossed the threshold show cases abounded and up the grand stone staircase hung pictures of all kinds, the first Hereford bull, a portrait of a prize cow, Stanley Anderson's engravings of country crafts — great favourites of mine. A picture of Leominster with a real clock set into the clock tower and numerous views of the city and county.

Outside the door to that holy of holies the Woolhope Club Room (the earliest of archaeological societies) was a glass case containing a wood carving of birds & leaves the skill of which used to make me whistle with admiration!

tions which have been held at the Maas Gallery almost every other year for nearly a quarter of a century. Jeremy Maas, one of John's greatest supporters, wrote the tribute to him for the booklet that was published for the exhibition 'Fifty Years of Painting', which was shown at the Royal Museum during the Canterbury Festival in 1987. I have tried not to duplicate what Jeremy Maas has written, but his tribute contains a great deal of invaluable information about John's early career, the artists under whom he studied, and the old masters whom he admired. The invitation cards to the Maas Gallery exhibitions were always designed by John himself, and more often than not were adorned with the portrait of a pretty girl.

John is a born illustrator, and it is difficult to think of any subject that could defeat him. For instance I have a letter, dated 2 May 1983, in which unexpectedly he wrote, 'I am horse painting in Glos. In and out of showers and gales'. It is illustrated by a lively ink sketch of a groom holding two horses, a sketch nearly worthy of Stubbs. In *Who's Who* he gives his recreation as 'book illustration'. Happily he has had many opportunities of enjoying this pursuit. The books he has illustrated include Jane Austen's *Pride & Prejudice*, Laurie Lee's *Cider With Rosie*, Joyce Grenfell's *George – Don't Do That* and *Two into One*, poems by Patric Dickinson, whose portrait he exhibited at the Royal Academy in 1984. John's gifts overflow in many different directions; his instinctive flair for design must have developed during the time he spent at the Royal College of Art. It has led to his being asked to design almost everything from charity concert programmes to the slippers presented to me when I retired from the Secretaryship of the Dilettanti Society. Such is his generosity when called upon to support a good cause (though I certainly cannot be counted as one) that he has rarely refused such requests. I have been fortunate enough to enlist his help on two occasions. In 1978, as Chairman of the National Art-Collections Fund, I arranged a special issue of our report to mark our 75th anniversary. John, who had joined our Committee in 1976, contributed two delightful pages (one of which is shown, left). He came to my help again when, as Chairman of the National Trust Foundation for Art, I asked him in 1986 to make a sketch of one of the Trust's houses as a heading for our writing paper.

One of the prettiest cards that John has designed is that for a Midsummer Eve celebration held at the

Royal Academy in June 1982 in aid of its Trust Appeal. Joyfully, he let his fancy run riot. Naked nymphs (one provocatively wearing a hat), drawn in brownish-gold ink, climb a ladder to garland the statue of Sir Joshua Reynolds; it must have trembled with delight.

The most memorable of John's booklets is that which he designed for the tercentenary celebrations of the Royal Welch Fusiliers, which took place at Powis Castle in April 1989. It was no doubt that fact that John's son, Toby, was a subaltern in the Regiment that prompted him to produce this enchanting little publication.

It might be thought that with so many commissions, so many other demands on his time, John would have no energy left for a pursuit that has brought such incalculable pleasure to all his friends. Happily for them John has always, as he wrote to me, 'loved mixing writing and drawing'. He has an itch to draw. It comes to him as naturally as breathing, and is, I suspect, his form of recreation after the strain of portrait painting. The pursuit to which I refer is of course his correspondence, his ilustrated letters and envelopes of which I have been one of the many happy recipients. To find amongst the morning's post, amongst the tax demands and gas bills, an envelope on which one's name and address is being held in the beak of a robin redbreast, or being painted, as it it were on canvas, by one of Domenico Tiepolo's *punchinelli*, is to start the day with delight.

John's letters fall into two categories. First there are those, written on studies that he has made for paintings, in which the illustrations have nothing to do with the contents of the letter. These studies are usually drawn in black chalk on thick white or brown paper. I have one letter written on an early study of Kenneth Clark's pose in the Dilettanti Society conversation piece, and another letter on a drawing of my hands for my portrait in the same picture. Many letters are written in the margins of preliminary studies of pretty girls. One letter is written beside a pencil drawing of architectural detail on the Doge's Palace in Venice, detail which is observed with a perception worthy of Ruskin. For my birthday John sent me a letter on which was a small pen and ink self-portrait, and a delicate watercolour, rather Japanese in its restraint, of his pocket watercolours box. A final example of a letter in this category is one written to my wife on a beautiful watercolour of bamboo grasses in Tuscany, as intricate in its design as anything created by William Morris.

To the second category belong all those letters in which the subjects he mentions are illustrated. In a few lines he can capture the likeliness of a workman or of the Lord Great Chamberlain in his magnificent uniform. In a characteristic letter to me dated 18 November 1980, John wrote: 'This week I devote my time between painting a Vice Chancellor and a large ex-actress – both splendid subjects tho' I suspect the V.C. of having ants in his pants since he figits [sic] terribly. All good wishes John. P.S. have been drawing K.C. in v. good humour. Such a pleasure. J.' These observations are accompanied by lightning sketches of his three sitters. Although the head of Kenneth Clark is only the size of a ten pence coin it is an easily recognisable likeness.

John is rarely malicious but one letter from him contains a brilliant caricature of a fellow artist, which illustrates his description of him as looking like a 'living corpse'.

Much of John's life has been devoted to painting and drawing portraits, a branch of art at which he excels. Looking through the catalogues of the Royal Academy summer exhibitions, one is struck by the way that John has balanced the task of painting official portraits of the presidents of obscure republics, cabinet ministers, heads of colleges, archdeacons, city tycoons, etc, with the pleasure of painting his ravishing models (his work for *Vogue* seems to have given him a sharp eye for female beauty).

There have, however, been happy occasions when the subjects of official portraits have also been beautiful. In April 1984 John painted an enchanting portrait of the Princess of Wales in her wedding dress (page 78). On 17 August 1987, he wrote to me, 'My next Royal venture is the Princess Royal for the N.P.G. I was moved by her beauty and presence when she came to an R.A. dinner two years ago.' This grand, yet sympathetic, portrait (page 79) was shown at the Royal Academy in the following year. He has also painted the Duchess of Gloucester.

He has had a number of other what he calls 'royal ventures'. Her Majesty the Queen commissioned him to make drawings of Balmoral. On 30 April 1985 he sent a postcard saying he was 'just going off to Sicily to join the Prince of Wales and help row the boat (*Brittania*) [sic] to Venice'. John was invited to join the cruise in order to give Prince Charles guidance with his sketching. No one could have been better qualified to do so. His Royal Highness is proving a great patron of artists, both young and old. He gave John the commission, which no other contemporary artist could have accomplished with such success, to record in watercolour two great royal occasions – the christening of his sons: Prince William in 1982 in the Bow Room at Buckingham Palace and Prince Henry in 1985 in St George's Chapel, Windsor.

Since his appointment as an ARA in 1956, John has exhibited more than a hundred portraits in the summer exhibitions at the Royal Academy. The list of his distinguished sitters includes Sir Roger Bannister, Lord De L'Isle, Lord Denning, Miss Joyce Grenfell and Mr Norman Parkinson.

If any fun was to be had from doing portraits, one can be sure that John never missed it. 'I have just returned from Cambridge', he wrote on 2 April 1985, 'where I've been drawing a lovely, long old don sitting like an ancient hen in a coop filled with books and papers'. A summary sketch of the old don reading accompanied this description.

John's speed at execution has served him very well when it comes to drawing children. In a letter dated 23 November 1977, he wrote that he was drawing some children in Hampshire: 'I had forgotten how enchanting babies were in high chairs'. This observation was accompanied with a lively sketch of the subject. Another sketch of a baby was made in response to my telling John that when I was opening an exhibition I had found a live bomb on the platform, in the shape of a baby whose bawling drowned the first part of my speech. In a few lines he wittily recaptured my painful experience.

In spite of all the success that John has had, and the fact that he is generally regarded as one of our most distinguished painters, he remains the most modest of men. In August 1980, he wrote to me that a very distinguished Oxbridge college (which had better remain nameless) 'wanted a portrait of the Master and wrote to me but I felt that for such a place they should have someone better than me – Sutherland or Moynihan or dear Peter G. (Greenham) and I withdrew and now to my horror I find that they went to the dullest of painters who titivates from photographs'.

At a later date I suppose I must have commiserated with him on having so many portrait commissions. To this he replied on 22 December 1986, 'I don't find portraits tedious, I'm just not very good at the job. There is nothing, nothing more wonderful than the human head but it is *too* difficult. When anyone says the expression is wrong, the eyes don't match, I can see that they are absolutely right and I retire defeated.'

John has chosen all the illustrations for this book. Many of the works that he has included were shown at his retrospective exhibition, which was held at Agnew's in April last year. It was subsequently shown at Cheltenham, and at his native city, Hereford, where it attracted no less than 14,000 visitors. The catalogue that John designed for the exhibition is a sheer delight for, instead of using dull photographic reproductions of his works, he produced small and enchanting watercolour and pencil copies of them, copies in which he yet managed to retain the spirit of the originals. One is reminded by this rarest of gifts of the brilliant thumbnail sketches with which Gabriel de St Aubin illustrated the margins of French eighteenth-century sale catalogues.

On some occasion John wrote to me that he wished 'art schools could be a little more joyous, – only great artists can cope with drabness'. John's work is always joyous, life-enhancing, and it reflects the happiness and fullness of his life; his love for Alison, his affection for and pride in his children. Celia is herself a very gifted young artist.

John is pleased with the honours that have been bestowed on him. When I congratulated him on the CBE that he received in 1984, he replied, 'I *love* medals and orders and dingle-dangles and I shall certainly wear mine *all* the time or at least the first week; the last thing I wore round my neck were my identity discs!'

On 10 May 1990, while the retrospective exhibition was at Agnew's, John wrote to me: 'Agnew's have been very good and generous to me, and I am immensely honoured by their promoting the exhibition, and at long last the Tate are considering two of my works, an early one and a recent one. But I cling to my pleasure in being an *unimportant* painter so that I may indulge to the full the exercise of my old fashioned skills.'

The illustrations in this book will show that John's 'skills' are of the highest order, and it is difficult to think of any other living English artist who can wield them with such brilliant diversity.

## Early Days

I was born on 10 October 1917 in Hereford, and until I was fifteen lived in Church Street, a narrow, pleasant street which leads up to the cathedral. It has now been pedestrianised, which is a good thing, but the merging of pavement and road into one surface has robbed the street of some character. It now looks less narrow, like an old friend who has become plumper and more commonplace.

In the street there were four antique shops, a second-hand bookshop and a picture framer-cum-engraver who was our next-door neighbour. On special occasions I was allowed to watch him engrave names on coffin plates – his main work. I was fascinated by the skill and beauty of his lettering and the great flourishes which swirled around the name, and awed by the thought that his work's destiny was the grave.

My father kept one of the antique shops, specialising in pictures, which he cleaned and restored. My two brothers were also in the business. We were a family of seven, but my two elder sisters had fled the nest and I was an afterthought, arriving eight years after my sister Patsy, the sixth child. My family were not local, having moved from London where both sets of grandparents had antique shops. During the 1914–18 war, when that kind of business no longer prospered, my parents decided to move away. I think Hereford was chosen because an uncle of mine had a job in the city as an electrical engineer and had spoken of its charms and possibilities – and there was a job going in the antique department of Greenland's, the large Hereford shop. The move was a success: my parents fell in love with both the city and the countryside, and above all with the River Wye.

We lived above the shop, which was in an old building with a backyard shared by the neighbours on either side. The framers, a dear family, also had a confectionery shop in another part of the city, but they made their icecream in the yard in a wooden tub machine, churning the ice and custard until the delicious yellow concoction formed. The other neighbour had a knife shop and the wife was distinctly strange, occasionally appearing clad in her nightie, brandishing carving knives and dancing around the yard.

Our house, half workshop, half junk shop, saw a constant flow of all the flotsam and jetsam of the sale rooms: spears, swords, model ships and engines, collections of butterflies in beautifully made airtight boxes, chests of polished stones, and fishing rods and tackle. (My brother George had become a passionate fisherman and haunted the banks of the Wye throughout the year.) Then there were bulging portfolios of prints and drawings and huge books of lithographs, views of the great rivers, and boring historical scenes, and an endless supply of engravings after Landseer – then so common but now recognised for the wonders of craftsmanship they are.

We ate our meals in the room my father used as a studio. An easel always stood in the window, catching what light came into the narrow street. Around the easel was a clutter of varnish pots and brushes, paints, nails, screw rings and stretcher pegs. The smell of turpentine and linseed oil was all-pervading and pleasing. When people come to my studio they often comment on these same smells, but to me they have by now become as the air and no longer register.

I can't remember the shop ever thriving, but it sufficed. While I never for a moment thought of us as being poor, I realised at an early age that there were times when the house was quite bereft of money. But there was always paper for me to draw on, and whenever pocketmoney came my way I would go to Boots the Chemist, which in those days also sold artists' materials.

Christmas time would bring a great upheaval and by some miracle the shop would be cleaned by my brothers, the windows whitewashed, decorations put up, and friends and relations would join us for the great Christmas dinner. Christmas cards would be posted on Christmas Eve, and delivered on Christmas Day. Sending Christmas cards has now become an early December slog; otherwise much the same now happens at my own studio and home.

Sunday suits and church attendance were not of the first importance, although my father was interested in sermons and would at times do a round of the churches, bringing back his opinion of the speakers. Neither did we have the great Sunday teas in winter which my friends had: tinned salmon, jellies, sponge cakes, shop cakes and fish-paste sandwiches. We had home-made cake and I thought how hypocritical my family were when they praised this dull, homely produce instead of the iced and coloured jobs which came from a proper shop. Of course, when I had my own family, they never saw a shop cake outside my mother-in-law's house, and Sunday supper usually consisted of boiled eggs and bread and cheese!

Years later, when I came to read that masterpiece *The Diary of a Nobody*, I recognised much of my family, the same snobbishness, the same deep affections, hopes and foolishness. We were very much a Pooter family, but there was no doubt that we enjoyed life. Something was always going to 'turn up', and my mother would talk confidently of our ship coming home.

The names of the great painters flew around the house – Reynolds, Gainsborough, Lawrence – for these were the great days of the boom in buying and selling eighteenth-century English portraiture, inspired by the dealer Joseph Duveen. Pictures bought at auctions would be anxiously rubbed with turps. How lovely it was to see the dull, drab surface of a dark picture gleam into life and to see figures and animals where only blackness had existed before. Signatures would be sought, and a brother sent round to the public library to consult reference books. A landscape with a little impasto would evoke the name of Constable, and just once my brother did, for £1, buy a sketch by Constable, a beautiful study made near Salisbury, which we sold at Christie's and which is now in the Fitzwilliam Museum.

It was this promise of excitement which kept my brothers in the business. I would sigh for the security and calm of the wage-earning household and vowed I would, if possible, have a regular job with regular holidays and a Sunday suit.

My father died when I was ten years old, but I can only remember my parents going away for a holiday twice in his lifetime, and then only to relations in London. Once I went with them and the train journey was something of an adventure, since it was the time of the General Strike. My father took me to the Tower of London, the National Gallery and the Tate, with meals in between at a Lyons tea shop. I thought it all wonderful.

The family had fallen in love with the River Wye and all through the summer we would anxiously hope for a fine Sunday to go 'up the river'. It was a serious ritual. Everyone dressed up, except my father who, as far as I can remember, always wore the same suit. My brothers were in white flannels, my sisters in summer dresses, and I had a white sailor-suit. Picnic preparations were considerable. A grand picnic basket (we enjoyed all kinds of rather grand kit via the sale rooms) was filled and, along with baskets of bathing things,

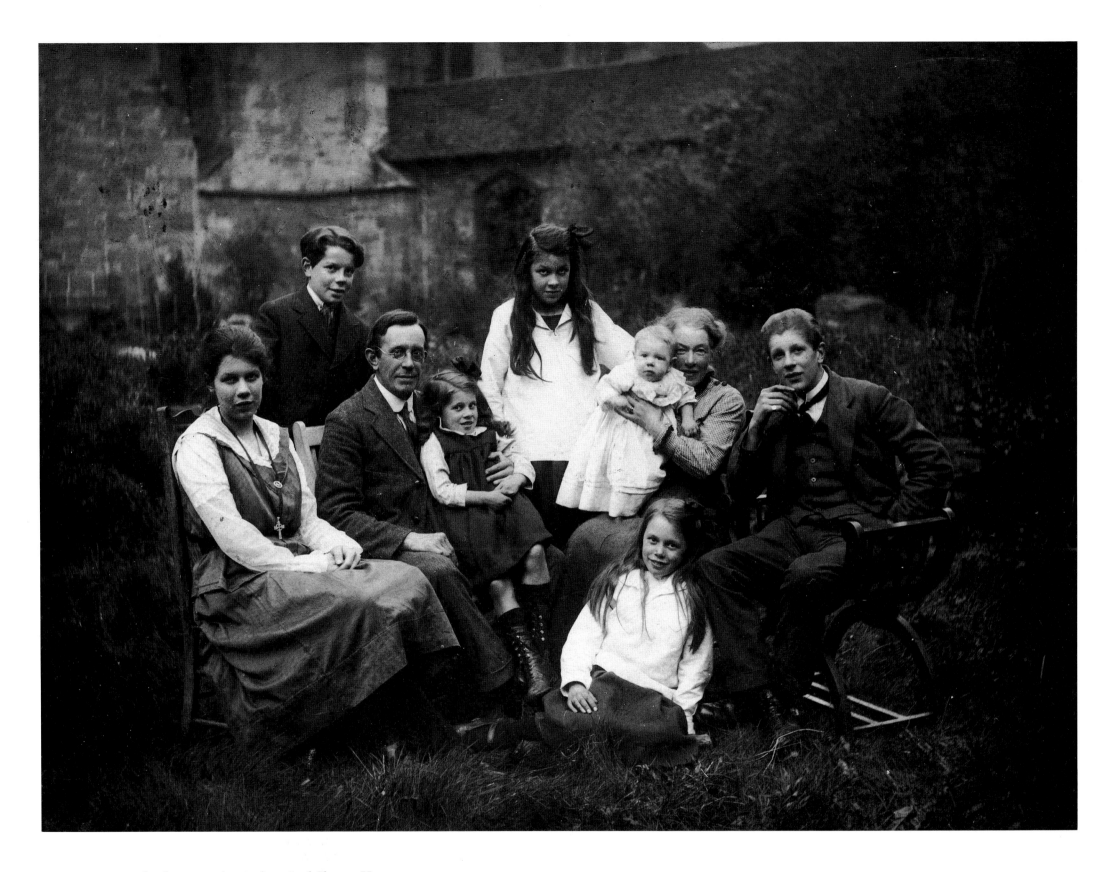

1918 – a family group taken in the ruined Chapter House of Hereford Cathedral, the occasion being a family gathering before my brother Russell, on the right, joined the Army. I am the babe.

paddling shoes and fishing gear, was lugged down to Mr Jordan's boathouse.

It is impossible to write of the awe and fascination this place and its owner had for me. Mr Jordan was the archbishop of the river, tall and spare and mustachioed, tremulous with age and short-spoken. He would confer quietly with my father and brothers as to which craft we should have. Often it was the largest boat, a randan with seats for three sculling, wrought iron seats back and sideways, and plenty of room fore and aft for the picnic gear and the smaller members of the party. From the shed would come the beautiful sculptured sculls, the rudder and lines, then the crimson buttoned cushions, and finally the pole, for both my brothers were skilled watermen and could manage these frail mahogany clinker-built craft through the shallows and against the swift current. Punts, with their blunt ends, were considered a very low form of river life.

The River Wye is a swift, shallow river needing both skill and knowledge beyond the first half mile out of the city, and from my earliest days I thought there could be no more beautiful place than this river, no lovelier motion than the steady movement through the water with the regular knock of scull against rowlock. The river bank seemed to change endlessly from shingle to muddy, humped and cavernous bank, to sheer walls of dripping moss-covered rock, larded with ferns and trees. On hot days the cattle would stand in mid-stream with the water curling around their thick legs while moorhens and dabchicks paddled by, with now and then the racing flash of blue and red of a kingfisher.

Ever-changing too was the bed of the river, and now in some Pre-Raphaelite paintings I catch an echo of the brilliance of the waterweed and the colour of the rock bed, the darting fish, and, when the water was low, the profusion of white flowers which starred the river.

There was a point some three or four miles upstream which we had to negotiate before even considering a picnic place, a spot called the Vee stream where the rock bed stretched across the river, channelling the stream into furious rapids. It was *the* moment of the journey, and for a few seconds the boat would scarcely hold steady; but then skill and strength prevailed and we would be through the rough onto a placid deep perfection, where the high bank on our left was mirrored exactly. A little way on there was an island, a wilderness of willow and water-plants and above, on a hill, a favourite pub with great views up and down the river.

Often we picnicked here and always there was the picnic fire. Everyone except my mother, who would be getting out the food, would go off for wood. Wood found alongside a river is lovely, bleached bone-coloured, and burns beautifully. The day would go by with me making harbours and forts in the shingle and catching minnows while my brother and father fished, George with a fly rod, and my father bottom-fishing with a tin of lugworms by his side. There were hills and woods fringing the river and precarious paths to scramble along, with nests to be found, and I must confess that in those days small boys collected the wild birds' eggs. Moorhens were so common that two or three might be taken from the eight or nine eggs in a nest, but from other birds only one could safely be taken.

Rain would create the need for shelters to be built out of groundsheets and branches, the fire would be made to blaze; and there would be gossip about the river, of pools where salmon lay, and where unfortunates had been drowned, and of how during floods the river had reached right across the fields leaving a tidemark of pallid grass, twigs, and the odd sheep – or piece of sheep.

The journey back downstream was, for me, intensely romantic. The sculling would be gentle, little more than guiding dips and a tug on the lines. There would be the evening rise with drifts of flies across the river, and my brother would cast deftly and accurately at the puddles the rising trout would leave. There is a magic in the handling of a fly rod in experienced hands; the looping out of the line, the flash of the slender rod and the quiet click of the reel. On a summer evening I thought that these moments were near perfection.

## Schooling

The strangeness and terror of school are hard to recollect. The infant school I attended was beautifully pictured in Alick Rowe's book *A Boy at the Commercial,* and I can still see the kindly, authoritative figure of the headmistress and the comforting pair of sisters, the Misses Caldecott, who taught there.

From there I moved to the local elementary school, St Owen's, and in a life that has been full of lucky breaks this was one of the most important. The headmaster, P. H. Alder-Barratt, was a man of rare gifts, rare even by the standards of the eminent figures in public life one gets to know as a portrait painter.

He had an inborn authority, he ran the school with ease and efficiency, and he was a scholar. Brought up in Oxford by a grandfather who was head printer for the Oxford University Press, he told me how his grandfather had printed five copies of a children's book. The author, Dodgson – Lewis Carroll – had objected to the illustrations, and had consigned the books to the dustbin. One, however, was salvaged for the grandchild, and the rare copy became a family treasure, only finally parted with when his daughter needed money to go to Oxford.

While reading, writing and arithmetic were recognised as fundamental subjects, history, poetry, music and the visual arts were thought to be necessities for any decent education, and the assumption was that, no matter from what background a boy came, it would be a grave mistake for him not to be shown the possibilities of these subjects. It was a rule that all boys should be members of the public library and learn its uses. Here Alder-Barratt had the support of an equally gifted man who was both head librarian and curator of the museum and art gallery, Mr F. C. Morgan.

The benefits of a good, confident headmaster were immense. Rules were strict but set aside without fuss. Lessons could wander if a subject came up that warmed the interest, for the staff had been chosen with care and most of them had a subject or hobby which enriched the straightforward teaching. One was mad about the theatre, another about France, and the science master was a devotee of Mark Twain. There were lessons given on the wireless, and essays written and sent to the BBC, and to hear your name broadcast was fame indeed. I can still recall how good, how well printed, were the pamphlets published by the BBC which went with those courses of lessons.

At the age of eleven we all took scholarship exams which gave entrance to the local grammar school or the pleasant-looking cathedral school which adjoined the cathedral. Both my sisters had won scholarships, but – apart from my total inability to spell – I think there was something uncoordinated about my thinking and work. I greatly enjoyed writing essays and can still remember the line which looms forever over a portrait painter's head, the quotation from Shakespeare, 'There is no art to find the mind's construction in the face'; but I think there was a way-

wardness about all I did that did not suit the examiners.

Sensing my disappointment, the headmaster arranged for me to attend the junior classes at the local art school, and this was ample compensation. I always felt that this good man believed that every boy should, if possible, be shown that there was some subject or activity at which he could shine and where he could find a lifeline – for times were not easy for the poor and I well remember the soup kitchens set up for the unemployed.

If this account of my childhood sounds too good to be true, it may be because from my earliest days I realised how precarious life is, and this realisation, added to an awkward, distinctly cowardly and weak nature, made me vividly alive to what is good and enjoyable. I never thought of the future. I knew that if I could survive day-to-day as did my family, then when the sun shone life should be enjoyed. Evidence of sadness was always to hand in a street such as the one we lived in, and the pawn shop was an active form of banking – indeed I remember my headmaster lecturing us on the use of this life-saving establishment, its ancient history, and how the sign of the three balls came from the arms of a great Italian banking family.

When, through the kindness of that fine painter Allan Gwynne-Jones and the gifted secretary of the Royal Academy, Humphrey Brooke, I was elected to the Athenæum, I relished not only the great honour but also belonging to a club where the rooms had the same silence and book-stuffed atmosphere as the public library in Hereford. The furniture of the library had solidity and ponderousness, the staircase was wide and handsome, and there were never many people around at any one time. Above all there was a rich sense of security, that the fine things of life were being regarded and looked after.

It was over the library, museum and art gallery that Mr F. C. Morgan presided. We first met over an accident I had with one of the vast volumes of the *Oxford English Dictionary*. In some way only a child could contrive I managed to let this precious book slip behind the library shelves and immediately, behind me, flaring like a wounded eagle, was the librarian. I can't remember how he reproved me, but from that day on the library became an even richer institution in my life. He showed me how to make use of the reference library, discussed the various books on painting and drawing, and showed me where I would find copies, current and past, of that exciting periodical, the *Studio* magazine.

The library was a subscriber to the Vasari Society, which published a beautifully coloured and bound folio of fine reproductions of Old Master drawings. Here it was I came across the drawings of Stubbs, Rossetti and Botticelli, in the great series these three masters produced: Botticelli's illustrations to Dante, Stubbs' *Anatomy of the Horse,* and Rossetti's drawings of Elizabeth Siddal. To all this, this dear man Morgan added the gift of believing in me, and permitting me to take home books from the reference library. This I felt to be the greatest privilege and token of trust.

It was Morgan who first took me to Birmingham Art Gallery, which was the nearest major gallery, and together we looked at the Pre-Raphaelites and the David Cox collection. Cox had lived in Hereford and the gallery had some fine examples of his work. There were trips to local churches, for Herefordshire abounds in fine parish churches with magnificent seventeenth-century tombs, masterpieces of sculpture which are even now too little regarded. He was a fine photographer and recorded those treasures with love and care. As with my headmaster, we remained close friends until he died, greatly honoured by the City of Hereford and the University of Birmingham, at the age of a hundred.

In 1932, aged fifteen, after feeble efforts to find a job as an office boy, I became a full-time student at Hereford School of Arts and Crafts – full-time being Tuesday, Wednesday, and Thursday, 9am to 9pm, and Saturday mornings. The school stood alongside my beloved River Wye on the Castle Green, a Regency building with a Classical portico with its name displayed on a large notice printed across the front:

### Hereford School of Arts and Crafts

The staff consisted of the principal, Mr Vaughan Milligan, and his assistant, Miss Paton, a Scot from the Glasgow School of Art. There were visiting teachers in the evening for woodcarving, building construction, and sign-writing. The principal had served his five years at the Royal College of Art and had been well trained. The staff at the RCA had been a notable lot at that time: Lanteri, the pupil of Rodin, taught sculpture, Beresford Pyte architecture, and Professor Lethaby design. But Mr Milligan was a shy, unambitious man who had also fallen in love with Herefordshire, the Wye and its fishing.

Here at Hereford Mr Milligan taught architecture, machine drawing, perspective, drawing from the antique, life drawing, clay modelling and jewellery – with asides about fishing, local antiquities and motor-bike engines. His assistant taught still life, design, embroidery, pottery and leatherwork. She was handsome and I fell in love with her straightaway – but then I can't remember a time when I wasn't in love with someone.

I began by drawing casts – of bits of fruit, and then heads of Roman emperors – good casts made by a famous Italian family who supplied the Victoria and Albert Museum. After the first year I graduated from the casts to complete figures: the clapping fawn, upright discobalus, and *Venus de Milo.* Drawings were made on half imperial sheets of cartridge paper with a hard pencil and the aid of a plumb-line.

I painted still life in watercolour, studied solid geometry, and learned to do scale drawing, using rule pens and the beautiful impedimenta of the architect. My brother found me a fine shagreen case of ivory and brass drawing instruments, but I was hopelessly clumsy at first, flooding the ruling pens, finding the springbow compass difficult to manage, and blotting my drawings with ineradicable Indian ink.

Sometimes, on fine afternoons, Mr Milligan would scoop us up and we would fill a couple of ancient cars and go into the country to sketch the landscape. This I loved, although I could never manage the lush Herefordshire countryside, with the dark deep greens of the elms, and the red earth. Now and then, when I see a watercolour, those moments of bliss flash back – with all the talk about the gear for watercolour, papers, brushes, and stretching paper on fine mahogany stretchers. The equipment, supplied by Windsor and Newton or Roberson, was of superb workmanship, mahogany and brass and fine japanned boxes and leather cases, sable brushes in quills bound with gold thread and a touch of scarlet wax.

The regular students numbered about a dozen, but there were old ladies who came too, well-trained and often well-travelled, from whom one could learn a lot. How I wallowed in the joy of being an art student! Looking at all the art magazines, and pestering the life out of the poor principal about Brangwyn, Turner and Wilson Steer, who had spent some of his youthful years in Herefordshire.

All this, however, was tempered by my attendance at the sign-writing evening class run by a splendid craftsman called Fred Lofts. He showed me what an

art lettering was, would brook no carelessness or arti-ness, and was scornful of my talk about the great masters. 'All talk you are, let me see you draw!'

He had been to an art school in Canterbury and would show me quite good life drawings he had made there. He had that excellent foremanlike authority which enabled him to serve up severe criticism on a platter of rough goodwill. Together we discussed post-ers and I came to know the work of all the best poster artists of that time. He would supply me with poster paint, which I never managed with the flourish he commanded. How I longed to produce a poster!

In Hereford he earned his living doing lettering on vans and shop fronts. He showed me how good quite ordinary commercial art could be. Years later I heard a friend declare that she would supplement her income doing 'hack work', and I thought that while her efforts at painting had a feeling and a charm and a character, she had not the remotest idea of the skill which even the least-regarded of commercial work demanded. And, as Fred Lofts would point out, his clients didn't soften opinions by murmuring, 'Of course, it has a nice feeling.'

After the first year I was allowed to draw from life. Heavens, the excitement over this next step! Alas, Hereford did not go as far as naked girls, but they would pose in bathing costumes. Lord only knows how Mr Milligan, the shyest of men, coped with the recruitment of models. I imagine girls occasionally came from the Labour Exchange since these were the years of the Depression and great unemployment.

The hours of drawing from the antique were time well spent, since when I came to draw a live figure I did have some idea of what to look for, how to 'set it up', as old teachers in life rooms used to say. Plumb-lines and anatomy books were much in evidence, and Mr Milligan could illustrate with vigour and clarity a point of structure which we had missed.

Sometimes one of the girl students would pose for me between classes when the school was deserted. How ravishingly beautiful was the body of that young girl! Always the best models are those who, out of greatness of heart, take their clothes off for one artist rather than for a classful of students.

The only fly in the amber of this beautiful world was, what happened at the end of this blissful school-ing? There were, it seemed, two sources of employ-ment in Hereford: an architect's office where one could be a draughtsman, or the local tile works, which produced fireplaces and had a few trained people who drew and coloured the illustrations for catalogues. Anything beyond Hereford was a blank, although people did mention the Slade School, and there were those with a School Certificate of higher education who could teach art.

Mostly, however, I put these uncertainties behind me and told myself that I was different. I clung to the two subjects that I thought looked impressive, architecture and perspective, and on Mondays and Fridays when the art school was closed I set myself up at home with the T-square and set-square and copied the orders of architecture and did perspective problems. My instincts were sound. While a pencil drawing of a cast isn't of much interest and can be examined critically, since you don't have to know much to spot weak drawing, the mysteries of vanishing points and plans and eleva-tions left people silent and vaguely impressed.

At that time there was an examination called the Drawing Exam. This had never been attempted by the school before, but a model appeared who was willing to pose in just her pants, and about five of us were ambitious enough to spur the principal into action.

The exam comprised life drawing, drawing from the antique, composition, perspective, and architecture. For architecture the classic orders – Doric, Corinthian and Ionic – had to be learned by heart, so that a mea-sured drawing could be made. This was done from a book of fine engravings and the beauty of the engraved line greatly influenced me. About that time I came across etchings by Picasso which had the same unvarying line – I wondered whether this great man had also looked at such architectural engravings.

I remember one fine problem in the perspective exam: an umbrella, open, resting on a puddle of water with the sun shining from such-and-such an angle, all reflected in the puddle. The arc of the spokes, the reflection and the shadows made for splendid complications.

I did well in the exam and pressed Mr Milligan about London art schools, but he knew only the RCA, which he explained took only students who had School Certificate. In desperation I wrote to Sir William Rothenstein, then principal of the RCA, and in agony awaited a reply. To my intense excitement he wrote that the School Certificate was necessary only if I wanted to be an art teacher. If I wanted to be a painter it was not necessary, and if I cared to send him some of my work he would see whether he could help.

This I did, and another handwritten letter came back. Yes, he could see promise. There were no scholarships at the RCA, but he himself would approach the Hereford education people to see what could be stirred into action. Eventually, because of the support of Sir William, I was offered a £40 loan and, through the kind attention of one of the City Fathers, Sydney Marchant, a grant of £40 from the Society for the Art of the Industrious, a charitable fund to help young people. Thus I had the £80 then considered the minimum sum necessary for a student at the RCA in London.

It was a big step to move from my beloved Hereford, to leave this little pool where I was such a big fish – I had never been away from home before ex-cept for odd holidays in London and to my sister in Canterbury and, ever cowardly, I was frightened. Most youngsters of nineteen long to be away from the constrictions of home life, but not I. I loved home, my room and books, familiar walks and friends.

## The Royal College of Art

I had been to London two or three times and had relatives there, but I did not really know it at all well, and besides, my relatives lived in Cricklewood and Hendon, miles from South Kensington. Arrange-ments were therefore made for me to stay at a YMCA hostel in Walham Green. (I believe that Walham Green has now disappeared from the map, even the underground station which bore that name is now Fulham Broadway.)

I thought I had never seen anywhere so dismal as that hostel, although I only dimly remember it now. Was the dining-room in the basement? But perhaps its wretchedness has merged with similar places I used during the war. Though in fairness the YMCAs during the war were always warm and welcoming, and it was under their sign that I met my wife Alison.

After a few days at the YMCA I set out to look for other lodgings, and bumped into a student from the design school who invited me to share his room in a house in a dreary street called Pond Place, near where David Garnett, that great literary figure, lived, just off the top of Fulham Road.

We had the ground-floor room, with other students taking up the rest of the house. We washed in the kitchen where we breakfasted, but there was a bath-

room beyond the landlady's bedroom which was used on special occasions. The landlady, Mrs Rimmel, was a kind soul with dark, lank hair, and she had a dog which slept on the kitchen table on a grand damask tablecloth with the cathedrals of England woven into it.

That day in 1936, my first day at the RCA, was frightening. There were a lot of new students and we were lined up on the staircase to be interviewed. The college looked dismal, sited off a back entrance at the side of the V&A which for me, at that moment, held all the attraction of an alien railway station.

Sir William Rothenstein had retired as principal the previous year and his place had been taken by Percy Jowett, a good man, but thought to have a bias towards the design and industrial possibilities of the place.

The head of painting was Gilbert Spencer, Stanley's brother, and a man of considerable reputation. Most of the staff were Rothenstein's men: Percy Horton watched over drawing; Charles Mahoney, composition; Barnett Freedman, still life; and Alan Sorrell and Francis Helps the life rooms. Names which the war years and those after obliterated, but which now are floating back, Charles Mahoney looking particularly fine in the great exhibition 'The Last Romantics' at the Barbican Gallery. Alan Sorrell will be remembered for his austere landscapes, his scholarly reconstructions of Saxon and Roman towns and the splendid series of watercolours recording the moving of the Egyptian monuments when the Aswan Dam was built.

Barnett Freedman's illustrated books have always been collected, but the large pictures painted during the last war have yet to be discovered and appreciated for the considerable achievements they are.

Percy Horton's portaits, both oils and drawings, grace the colleges of Oxford and Cambridge, but there is a body of landscape paintings lying unknown somewhere.

There were also schools of architecture, design, sculpture, pottery and engraving, but these were spread around and we only met in the evenings when all the students were supposed to attend life classes, or in the common-room which was an old army shed across Exhibition Road.

After the pastoral days at Hereford the RCA was a gloomy institution, but I struck up a friendship with Jimmy Neal, who had come from St Martin's School of Art. He took me to his home in Islington, to great Sunday lunches and the family affection I so missed. In that year of the abdication, we wandered London together. He was a keen musician and singer, and would launch into airs from Handel as we wandered. Jimmy had a very different training, and knew about oil paint and all the little galleries where living painters showed their work.

The first-year programme for painting students was two days of architecture, one day of still life, and one of life drawing. There was life drawing every evening, and Wednesday afternoons were free.

I resented the architecture class and, with Jimmy Neal, sloped off to the National Gallery, or the endless rooms of the V&A. I was amazed by the industry of fellow students over this subject. We were given the task of designing a town, with individual students taking the various public buildings, and they came up with the most ambitious plans for town halls, schools and theatres. I settled for a memorial to the local saint, thus absolving myself from the problems of staircases, chimneys, etc.

We also measured up architectural features in the V&A, and I was paired with Robert Buhler, who later became the youngest of Royal Academicians, and who had even less enthusiasm for this subject than I. I had never come across his like before. Already quite a painter, he was the most sophisticated of students, living in Soho and knowing many other painters. He left after a year and we were soon reading about his work in *The Listener,* from whose art critic we all longed to have a nod. He was to return to the RCA after the war as a member of staff.

The still life class provided me with the greatest shocks. Barnett Freedman ran this with zest and pungency, but I found him distinctly alarming. My first attendance was with a box of watercolours which he pounced on right away, calling them 'ladies' things' and demanding to know where my oil paints were. I admitted that I did not own any, and he ordered me out to buy some immediately.

For some peculiar reason the only artists' materials shop I knew was Roberson's, under the Ritz in Piccadilly. Catching a bus, I rushed there, bought an assortment of the tiniest tubes available, and hurried back. When I described to Barnett Freedman where I had been, he shouted, 'You fool, are you a rich man or a moron?' I admitted the former was not the case.

Then he explained where students bought their oils, and when I told him I had never used oils he set up a still life of a tin mug and two parsnips and spent the rest of the day painting them for me. It was no sketch: by 4pm a fine, rich, little still life had been executed, thickly painted, glowing – and it was mine.

I didn't know what to say, but from then on I loved the man. He was the only member of the painting school who lived by his work, and had by then made a considerable reputation as an illustrator, but he still undertook all kinds of designs. The George V Jubilee stamp had been his, and his book jackets were outstanding. He designed lettering and painted pictures.

'Paint an important picture every year for the Royal Academy, but don't send it in', he would say. Looking at another student's work, he observed, 'If you go on painting as badly as that you'll end up as President of the RA.' In those days the Royal Academy had few friends at the Royal College of Art.

Percy Horton, who was in charge of drawing, loved his job. He was deeply read in art history and when he came across someone who shared his enthusiasm he blossomed. He was a meticulous teacher, giving attention to every student, doing careful demonstration drawings, and ever ready to reach for a book or reproduction to illustrate a point. This has always seemed to me to be the best way of teaching art history, since learning to draw and paint needs all the time available during the brief years of studentship. Lectures and essays consume time and energy which would be better spent in the practice of the business. The nudge which Percy Horton gave us into reading, via our drawings and paintings, was much more stimulating than the lectures given by non-practitioners.

Students at the RCA were not then cursed with that idiotic title of post-graduate. We were just the products of provincial art schools, often ill-taught and ignorant; and good drawing, thought Percy, was something that *could* be taught. Slovenly observation was corrected, and showy facility was criticised. The V&A library print room was to hand and the British Museum not far away and there we could study the finest drawings, awed by the wonder of handling the originals.

Charles Mahoney was a somewhat fearsome figure, hardly ever to be pleased, and yet everyone recognised what a gifted man and teacher he was. Socialism and Communism were much in the air· at that time and

Jehan Daly. Jehan came to help me with a large painting of the Montagu family in 1979 and, as always, I was avid to paint his spendid head.

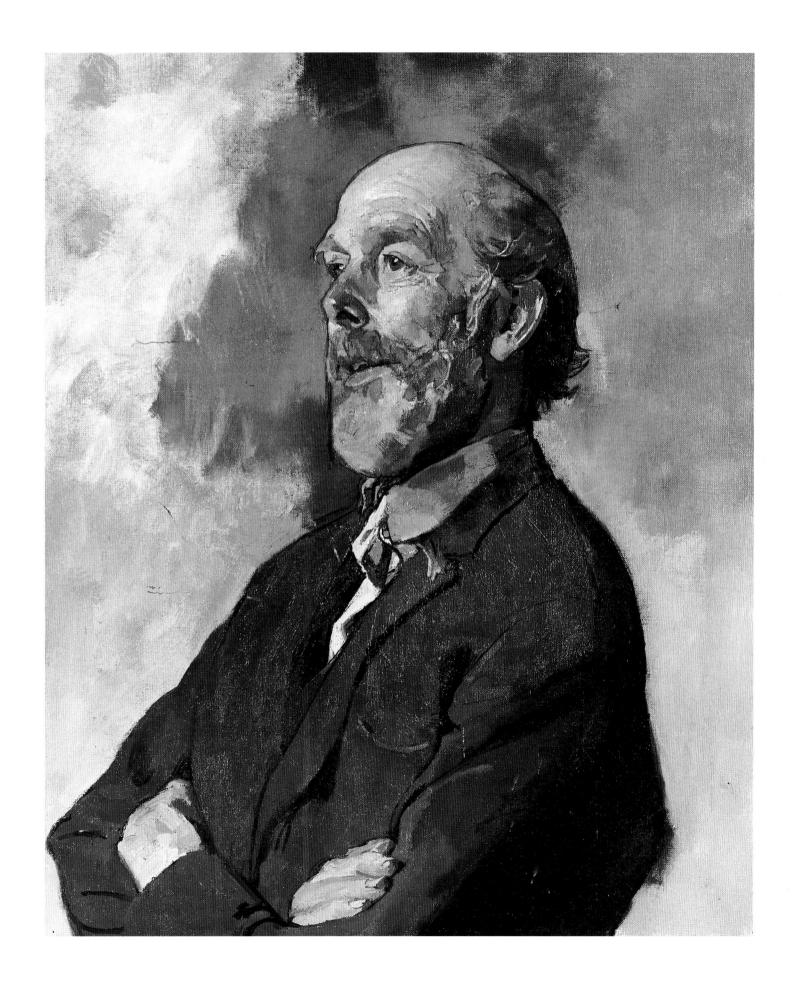

compositions tended to be of a serious nature. This did not suit me, and I tended to avoid Mahoney's class.

It wasn't my cup of tea. I wanted to paint things which delighted me. Once Percy Jowett, looking at a painting of mine, commented that I had great facility, but what was I trying to say? I was at a complete loss. The sadness and problems of the working class were no subjects for me. Anyway, from *my* school-days I remembered snug, polished working-class homes, but then I was totally ignorant of the industrial parts of England. I was all for painting Venus and lush still lives and the pretty mists in Hyde Park.

Later though, when I had left the college, Charles Mahoney and I became firm friends, and it is good to see his work now emerging and being given the recognition it deserves.

Alan Sorrell's company I enjoyed because we shared a love of the Pre-Raphaelite drawings and early fifteenth-century French paintings. He had won a travelling scholarship, but instead of taking the usual paths to France and Italy he opted for Iceland.

His scholarly reconstructions of ancient cities and ways of life, that for years appeared in *The Illustrated London News,* were without rival. He was obstinately his own man, a very fine artist who disdained to fit fashionable modes. After the war he had a blazing row with the new principal, the all-powerful Robin Darwin, gave up teaching and lived entirely by his own work.

It was in that second year that I met Jehan Daly, a student from Kidderminster. His father was head of Kidderminster School of Art, and his mother was French (he had always spent some part of the year in France). I imagine we met over one of those interminable discussions on drawing which were the fashion then, but our real note of friendship was struck when I discovered on visiting him in his lodgings in Earls Court that he had stolen a little painting of mine. When I taxed him he answered, 'Well, I admired it and it seemed a pity to leave it kicking around the college studios.' I was flattered by this response; soon afterwards I joined him in his lodgings and thus began a lifelong friendship. Working with him during those early days I count as one of my greatest good fortunes.

That same year I met Sir William Rothenstein's son Michael, who very much sat at the heart of things. He invited Jehan Daly and myself to his Thursday evening gatherings when his studio was open for talk and tea. It is interesting to remember that the only drink ever served was tea. There was no wine or spirits, and I cannot remember any question that more was either needed or expected.

The gatherings were splendid, though I cannot remember doing any talking myself. Stanley Spencer, Percy Wyndham Lewis and Edward Wadsworth were among the painters, and others included the poet Ruth Pitter and some distinguished refugees. They were wonderful evenings and Michael was unfailingly kind, since we couldn't have added much to these gatherings. Now it is a great pleasure when we meet as fellow Royal Academicians.

In 1938 my third and last year loomed ahead, but there was also Munich. Jehan was at home with us in Hereford during those fine days that September. He too had come to love Herefordshire and the river. He managed a boat beautifully and we spent a lot of time on the water. In October we moved back to London and the new term. I remember little of my time in London during 1939; there was the taking of exams, painting a composition in a cubicle and seeing the great William Nicholson (the man whose command of tone was so assured that he could make ochre sing like gold) come round to judge our efforts. I recall it was a hot summer and we sweltered beneath a glass roof in some part of the Imperial Institute when we took our final examination. At the end of term we sat in the lecture theatre of the V&A and the Duchess of Kent handed out our diplomas. I was given the drawing prize which was £5, an amount I already owed the registry. We did not linger in London once term ended, sensing that what lay ahead of us was even more uncertain than the usual life of a former art student.

Jehan joined me in Hereford and we spent the time picnicking and going for long cycle rides. Towards the end of September we went hop-picking, earning little money since we were slow compared with the locals and gypsies who had been doing the job since they could stand upright. Jehan's father would send him the odd £1 note, I did the occasional job for my brother Russell, May Marchant would buy a drawing, and somehow my mother managed to feed us without there ever being a sense of skimping – indeed we often feasted. My sister Patsy mainly kept us on her wages as a secretary. My other sister Sybil, who lived and worked in Canterbury, paid the rent of the house.

## Art and the Army

On 19 October 1939, Jehan Daly and I joined up: the Royal Engineers – because of our architectural training! Six strange years followed, not particularly adventurous, except to a timorous nature like mine. For a year or more we served together in a field company and worked on the defences along the Kentish coast, building pill-boxes, which have now become listed buildings, and laying mines across Denge Marsh in the chill January of 1941. The men in our company were a wondrous mixed bag, being nearly all tradesmen – builders, lightermen, plumbers, carpenters, saw doctors – as well as insurance agents and architects.

Our training began in Chatham, the home of the Royal Engineers. Here we learnt drill, and how to fire and care for a rifle. We learnt knots and lashings, and how to row a cutter, lift huge sections of girder bridges, and manage a pontoon, and even did a brief bit of digging in a mine beneath a hill in Upnor.

The NCOs were, at that time in 1939, still regular soldiers, and impressive men. There was no doubt that they knew their jobs from A to Z, and they coped with the odd mixture of recruits which we represented with easy authority. But as the weeks went past they left one by one to join field companies, regular units and Territorial companies. Of the officers I cannot remember a single thing.

In late December, still with Jehan Daly, I moved to Newark for further field training. The weather was bleak but we were billeted out, and it was my good fortune to be housed with a dear family called the Grimstons. Mr Grimston worked in the ball-bearing factory, his wife was an ardent member of the Salvation Army, and they had a daughter called Bertha. I drew them all, and we were looked after with the greatest kindness and good humour. Jehan Daly was in a rather grander house where the son played the organ in Newark's splendid parish church.

Our days were spent on a wasteland named Beacon Hill, digging trenches and learning about barbed wire, latrines, road-making and pontoon bridging. The latter we practised on the River Trent, where the abilities of the Cockney lightermen came into play, dealing with the awkward blunt-nosed pontoons with nimble skill against the strong current.

Night exercises were often a shambles, but nearly always there was someone who could make sense of the equipment and what went where. I used to feel

that I was part of a painting by Brueghel, a mixture of horror and hilarity; but hot food and a bed somewhere, and life became possible again. I was to realise subsequently that this training was pretty casual compared with that demanded later in the war.

The training went on through the winter until the ill-fated expedition to Norway, when a group of us was posted north to join a division which was to take part in the operation. We got as far as Ripon and, in this pleasant place, permission was given to us to spend what was left of the day in the city. Jehan and I opted for a look at the cathedral and then supper in a café in the narrow street leading up to it. Here we relaxed and wrote letters and then walked the few miles back to Lucan House – to find the place deserted, a mess of blankets, palliasses and half-empty tins of jam.

Through the night other men turned up and by morning there were about six or seven of us. Apparently the Military Police had scoured the pubs rounding up all the men they could find for a frantically brought-forward move to Scotland.

For quite a while we were forgotten men. The May and June of 1940 were beautiful months and Yorkshire looked its loveliest as the disaster of Dunkirk unfolded. One evening we clambered over a wall and walked the stately paths which took us to Fountains Abbey. There was not another soul about and, in summer silence, we had our first sight of that great ruin. Later, much later, news filtered through of the Norway campaign, leaving me glad that our taste for tea and letter-writing had saved us from that experience.

Eventually we were rounded up.

Always in the army there was good talk, and the odd regular soldier who was a first-rate story-teller. Jehan and I both kept paper and inks and watercolours and the men were avid to be drawn. I loved drawing them asleep, when even the toughest face relaxed between snores, revealing the face of the man as a child. Sleep was such a vastly important thing in the army, to be snatched at any odd moment and on whatever was to hand.

Sometime in 1942 Jehan was posted away, and I was sent to an HQ in the 3rd Division. This had been a regular division with a Brigade of Guards attached,

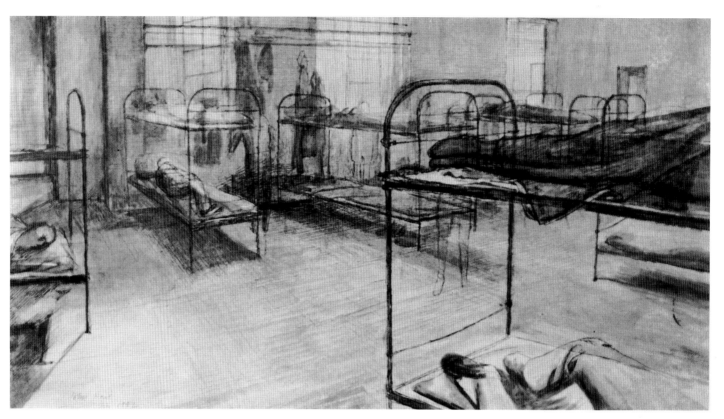

One of the many barrack rooms I slept in, probably Shorncliffe Barracks.

Training session on Beacon Hill, November 1939.

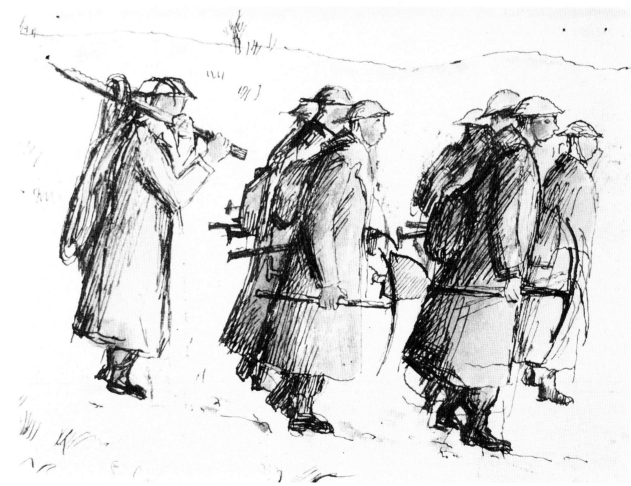

and as the threat of invasion receded it was given the job of one day returning to France.

The officer I served, as a draughtsman, was Colonel R. W. Urquhart DSO, who even to my unmilitary eye was an outstanding man for whom the vast problems of invasion were meat and drink. The work was intense and fascinating, and culminated in a fortnight in London, in Ashley Mansions, Victoria. There, in a third-floor flat, I was one of two sappers attached to the RE planning party to be shown – awestruck – the map which detailed where everything would happen on the great day when we would set out for France. For days I pondered on the wisdom of knowing so much. It horrified me. Alas, I cannot remember whether so grand a scheme touched my imagination, which is disgraceful, but in the army imagination was something not to be encouraged too greatly. It was unprofessional.

On the paintable side of training, the clambering on and off ships, and the soakings in the sea off the coast of Nairn, I made only the briefest of notes. We were busy, but I did draw a page of portraits of the little party of us which was to land on D-Day. Sometime later my sister had it photographed and I dished out copies.

On the night before the landing we were all vilely sick as we wallowed up and down the Channel until midday, when we landed. Even then there was always time for some drawing. The abandoned gliders of the Airborne Division, strewn across the fields, were a fine subject.

I coloured photos of soldiers' wives and made birthday cards. Perhaps, I sometimes thought, this is how a painter is most happily at one with the community. That I drew and painted was also a source of entertainment. The skill needed to make a likeness – and in those days I drew directly with pen and Indian ink – fascinated my fellow soldiers.

There were children to draw too; the first, a child killed by gunfire, but the face unscarred. Since there was no camera to hand I was asked to make a drawing. It was the only possible record. To draw the children was a happy gesture when we were billeted in farmers' barns. In Holland I drew an entire family in exchange for half a dozen eggs. How greatly we admired those Dutch families who had suffered such privations.

The winter of 1944 was severe and I found the pine forests grim, but the orchards, stark against the snow, were good subjects.

As the war drew towards an end I did portraits of NCOs and men who had won decorations. The division was moved to Ghent, en route for the Far East, but the atom bomb ended that war and so the move was switched to Palestine. Having a high demob number I had a glimpse of release, and was left stationed in Ghent, that most beautiful of cities (and blessed forever for me since it was there, at a YMCA, that I met my wife Alison).

As we all had time on our hands, I organised a little studio in the handsome building where the YMCA had settled, held classes, found models and students, and set soldiers to draw their girlfriends, life-size, from memory. I met local painters and with a new friend, Roy Spencer, explored the architecture of Ghent. Roy had trained as an architect and we marched around the city in snow and frost examining every building of note.

It was one of those periods of blank time which army life throws up, and I loved my days in that beautiful city.

## After the war

Demobilisation came early in 1946. In Hereford my mother, my sister Patsy and, after years in north Africa and Italy, Jehan Daly, welcomed me back – Jehan with a beautiful eighteenth-century tail coat, chocolate-coloured and richly embroidered, as a welcome-home present.

After some sprees on our gratuity Jehan went off to London and found us a room in Fulham Road, number 528. It was a first-floor room in a tall terraced house, with a tap and basin on the landing. The landlord was a Mr Spiller whose brother, he told us, had cornered the antique picture frame business and had a fine shop in Soho near where Canaletto had lived.

Mr Spiller had pictures – a Romney, a Reynolds, a Rossetti, and a Lawrence – and I believe he cleaned them once a week. He also had a lavatory seat of which he was proud, made of beautiful Spanish mahogany, with a rectangular cover which was fondly polished. This he would show us regularly.

From the window of this lavatory could be seen a family of children we thought it would be good to draw. After a polite enquiry at the front door, an old man, who certainly did not live in the basement we overlooked, produced a waif of a child called Janet. She was his granddaughter and would be pleased to sit

for us. Thus began a long association. She would come every afternoon after school, sometimes in her school slip, sometimes in a knitted silk dress which hung heavily against her bony frame, showing up her voluminous knickers. She had wit and stamina and was wonderful to draw.

Our return to college was a dismal affair. Democracy reigned; no longer did we get to the life rooms at the crack of dawn to ensure the best easel and the best place. It was 'fairer' to draw lots for places. I remember spitting with rage. But mostly we worked in our Fulham room, keeping it uncluttered by beds and sleeping on the floor as we had done for most of the past six years. Antique shops abounded in treasures – it was cheaper to drink out of Rockingham porcelain than to buy a cup from Woolworths – and slowly our room attained a shabby grandeur.

In the summer of 1946 my time at the RCA ended, but student life was prolonged by the gift of a travelling scholarship. In July I started on my scholarship with the main idea of using the money to eke out time, rather than spending it on travel.

First to Cheltenham, that elegant town where my brother George had an antique shop, and then on to my sister Sybil who lived with her husband in a beautiful Cotswold house in the village of Upper Swell, sharing it with a farmer and his family. The house boasted a ballroom which I could use as a studio. Here I painted a small self-portrait wearing my remaining pair of army boots.

My brother-in-law would take me round the fields to shoot rabbits and ducks, and in the little stream we caught freshwater prawns and he occasionally tickled a trout – an art which deeply impressed me.

From Upper Swell I went to friends of my brother-in-law in Charlbury. The Baldwins had a draper's shop embedded in an ancient stone house, with a garden cosseted for generations where fruit, vegetables and flowers grew in hugger-mugger profusion.

The object of the move was to be near enough to Oxford to travel daily to look around the Ashmolean and draw the architecture. But Mervyn Baldwin made a round of the villages in a van laden with frocks, coats, corsets, stockings, suspenders, hats and trimmings, and I found these trips irresistible. At lunchtime we would fish the nearest stream, dropping a line with a live mayfly or dragonfly over somnolent trout. These trips were to serve me well when I came to illustrate Laurie Lee's *Cider with Rosie*.

At Oxford I discovered the ornate college barges which lined the river. I was drawing these gilded confections one day when a man asked me for whom I was doing the drawing.

I told him they were for myself and when he asked if I wanted to sell them I said, of course! He turned out to be John Betjeman, and he gave me the name of a good lodging in Holywell. So for a few weeks I lingered in that pleasant little street, making a drawing of the Sheldonian and the view of the river from the bridge, which afterwards I gave to my old headmaster to remind him of his Oxford boyhood.

When I returned to London in the autumn Percy Bliss, head of teaching at Glasgow School of Art, offered me a job; but Glasgow seemed a long way away and I turned it down. Early in 1947 Michael Rothenstein suggested that I should illustrate one of a series of travel guides on the counties of England for the publisher Paul Elek, and I was elated to be given my home county of Herefordshire.

This I thought a splendid job. The winter of 1947 was of memorable severity – and beauty. Snow and ice covered the land and every tree and bush was a jewelled miracle. I bussed and cadged lifts about the country and I realised to my shame, when I talked to the American lady who was writing the text, how ignorant I was of much of this lovely area – this my home county!

It was exhilarating to explore with a small portfolio of paper, pen and ink, and a pocketful of bread and cheese; drawing until the pen could hardly be held, and feet became numb. 'Always find a bit of wood, a bundle of sticks to stand on,' Percy Jowett used to say. 'That'll give you another half hour's drawing.'

When I had finished the drawings I delivered them to the publisher, the all-important Paul Elek. Seeing my enthusiasm he paid me right away and suggested that, with the £25 in my pocket, I should do another book in the series, about the North Riding of Yorkshire. Remembering from my service days how magnificent the countryside was, the splendours of Rivaulx and Fountains Abbey, Bylands, and the little towns of Richmond and Leyburn Coxwold, I accepted.

The winter of that year gave way to one of the loveliest summers I have ever known, and I wandered, drawing the showpieces of Yorkshire. 'Let's meet in Ripon', Jehan Daly had said, and one day there he was, sitting on the bridge waiting for me.

Later in the year came the offer of a day a week

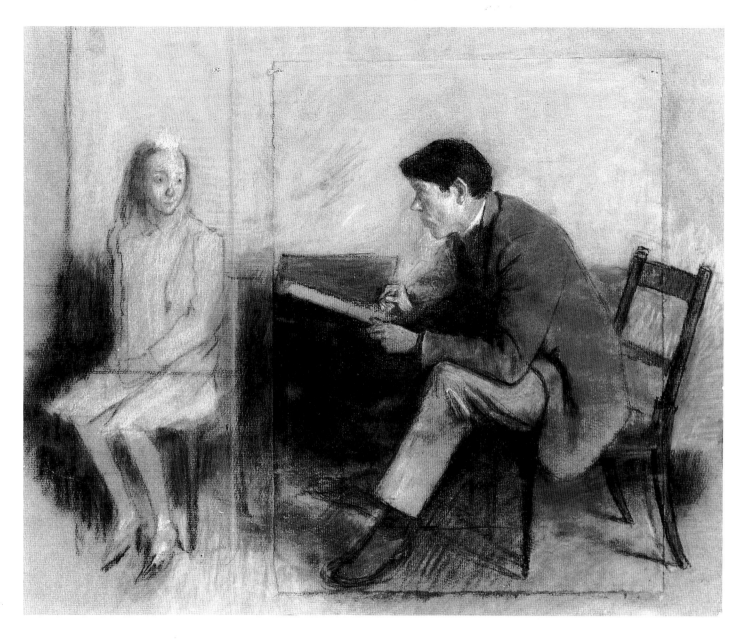

A self-portrait using red chalk, done in the flat in Kempson Road in 1947.

teaching life drawing at Wimbledon, an idea I found very exciting. I can still remember the thrill of my first day. The students, quite a few of them ex-servicemen, were avid for work, and for about three years I enjoyed my days at the school.

Jehan Daly, ever a man for making friends, cultivated our window-cleaner, who told us of a flat off Harwood Road; two floors, three rooms. This time our landlord was a Yorkshireman and our landlady, large and friendly, had been a housemaid at The Pines on Putney Hill and could remember Swinburne. Now and then she would show us a shoebrush which, she said, had belonged to the great poet. The move enabled us to expand our furnishings, and we could set quite a pretty table. Jehan was an excellent cook and, despite rationing and fuel shortages, we found life good.

## Vogue

Deep in my mind was the knowledge that, lurking somewhere in the West End, was John Parsons, who had been a fellow student at Hereford and had since risen to the dizzy heights of art editor at *Vogue*. In Hereford I had often drawn dresses and hats from the museum collection Mr Morgan had made of Georgian, Victorian and Edwardian costumes, sometimes persuading the girls who worked in the library to wear them. I had come to know the fine pen and ink drawings of the great Italian painter Pisanello, drawings of elaborate costumes, hats bedecked with

plumes and other extravagances, and I thought something along these lines could be adapted to modern fashion drawing.

I took my studies along to *Vogue* in Golden Square, where John Parsons was both helpful and kind, and immediately gave me a job to draw the Serenade Concerts at Hampton Court. A commission to draw for *Vogue*, the glossiest of magazines!

For three weeks I worked, with huge effort. I thought I had produced a masterpiece – in fact, quite a large masterpiece. But there seemed no urgency, no one anxiously awaiting this masterpiece, so I telephoned the office.

'Ah, we'd forgotten you were doing it, but do bring it in.' John Parsons' face filled with dismay when he saw it. 'But I only wanted a tiny sketch for the Diary!' I retired in foolish confusion. I can't remember now whether it was ever used; probably not. But I was paid a fiver.

My ridiculous efforts for *Vogue* did, after all, leave some kind of mark, and one day a telegram arrived asking me to come to John Parsons' office. The job was not for *Vogue* but for its sister magazine, *House and Garden*. They wanted drawings of some out-of-season flowers like carnations. Sensing another opportunity, I laboured hard in pen and ink, doing the kind of drawings seldom seen in a fashion magazine. This time the work was acceptable.

It was 1948 and Princess Elizabeth was to be married, and there was excitement about the design of the dress. Could I, John Parsons asked, do a detailed drawing from a sample of the material and embroidery, and the usual abysmal sketch made by the designer, Norman Hartnell? And it was needed in a hurry.

The joy of having something wanted in a hurry! People waiting to see what could be done! Take a taxi! Send a telegram! I sat up all the night with fine pen and watered ink, drawing each pearl, each spray of embroidered wheat, the rich folds of heavy satin.

That great effort looks a wooden job to me now, but it struck some kind of new note in the fashion world, and I was home. For four years I worked under contract for the magazine, and loved it. Each month there would be a conference with John Parsons and the

A dress from Hereford museum's fine collection of costumes. It was drawn in 1946, direct in Indian ink, and is in the possession of Jehan Daly. (14 x 10½ins)

fashion editors, where features would be allotted to photographers and artists. Sometimes I would get four pages, sometimes just a sketch for the Diary.

The staff were kind and jolly, and John Parsons was a dear friend and wonderful art editor, providing all kinds of opportunities for my skills and being lavish in his praise and strong in support when I fell down on a job – and oh, the gratitude one feels forever towards those dear people who nursed one over failures.

The great photographer Norman Parkinson was also working for *Vogue* at that time. We immediately became friends and what a lot I learned from him. This was to go on throughout our long friendship, and his death in 1990 has not ended the tuition for I often now ask myself, how would Parks have approached this job? He had flair, that outrageously unfair gift for thinking and acting on original lines, and was blessed with immense energy and a strong will to succeed.

It was salutary to work alongside this man, whose trade had not quite acquired the stuffy respectability of 'Art'. He stood in awe of no one. To be a top photographer was not to be in a rat race, but a tiger race. Circulation numbers and advertising rates stormed around their heads, and there were few cosy teaching jobs for those who had no stomach for the game.

I loved our jaunts together, and learnt much. John Parsons would join us and I relished the rapid observations of these two quick-witted, shrewd and imaginative men.

Parkinson was appalled at the manner in which painters treated models, as creatures rented by the hour to sit or stand glumly for a set time. 'God, man, you can't treat a model like that and expect to get anything out of her! When she, or he, sits for you, you must make it a day they will never forget.

'Talk, dance, anything, but generate the importance of what you are doing. None of that Cézanne's apple lark. The atmosphere must be electric and then, when half of you is entertainer, the other half must be noting every movement.'

But what of the cool, mathematical arrangement? Well, maybe, but without a dynamic approach, too often the work is sterile and still-born.

I remember my days on *Vogue* with pleasure and affection. I enjoyed the fleshpots and jaunts with editors and fashion editors. I liked the excitement of the deadline and the unexpected subjects, debutantes, corsets, jewellery, actors and actresses.

I rather think that on this occasion I went along to *Vogue*'s studios to have a passport photo taken, but my old friend Pat Mathews took some other shots using casts of hands to add interest.

Sir Compton Mackenzie, drawn in about 1959 while he talked about whisky in his house in Edinburgh and used as an advertisement for Grant's Whisky. (c.6 x 5ins)

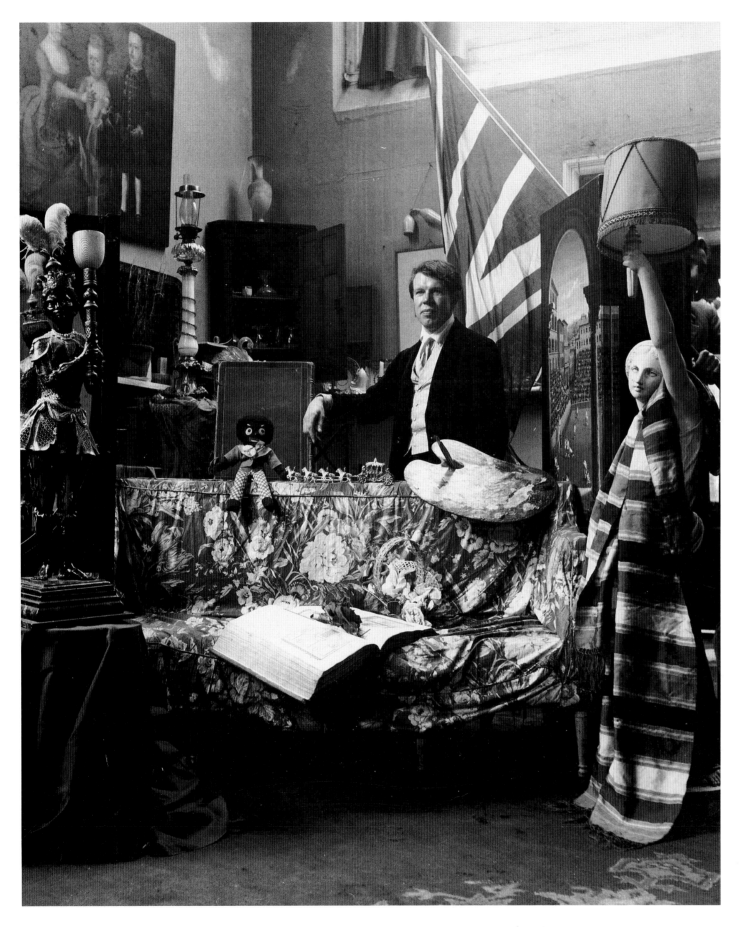

One of the first portraits I was asked to do for the magazine was of Edith Evans. At the theatre I picked up the fact that earlier that evening she had had a flaming row with the producer. I was shoved into her dressing-room during an interval and my alarm was great when this great bedizened, stage-painted woman stormed in. I remember my futile scrawlings and eager escape!

There was the fun of fashion models arriving by taxi in dingy Kempson Road with armfuls of dresses and shoes and hats. My painter friends, with the exception of Jehan Daly who enjoyed the razzmatazz as much as I, wondered dubiously whether this way of life was a 'good thing'. Fashion drawing had been despised, or hardly that – it was an activity which just did not enter into the nucleus of proper painting and drawing. But I found it all new and a great adventure.

Most of the drawings were made in pen and ink. The incisiveness of this medium pleased me and, when I was on form, the act of drawing was a joy. Perhaps this was evidence of a shallowness of outlook, but I have always sensed a falseness when writers and painters go on too much about the agony that their work causes them. I doubt if you embark on anything as daft as painting, music or writing unless somewhere it gives real joy.

And it was wonderful to have my work wanted. I would think of all the care and expense of the printing, the glory of the chairman and the editor, and the grand name of *Vogue*, and I was vastly flattered and tickled.

There was money to spend, and junk shops, with which Fulham and Chelsea were lousy, to be explored with new wealth; and Alison, the love of my life, to pursue, she having left the army and now training as a typist.

My old friend Roy Spencer organised a trip to Paris, my first. Quite a gang of us went, staying at the Hotel du Seine, where Taffy in du Maurier's *Trilby* had lived, in the Rue du Seine. Everything in Paris looked unbelievably beautiful. Out of our high bedroom window the houses looked like rich cheesy crumblings from Chardin paintings, muted colours against the lovely fresh greens of a fine spring.

The shops were full of silks and artificial flowers,

A lovely photograph taken by a fine Dutch photographer in about 1953. The velvet jacket, a present from Jehan Daly, came from a very good second-hand clothes dealer in Victoria; I wore it until it fell from my shoulders five years ago. Note the coronation coach, a present from my mother-in-law to our son William.

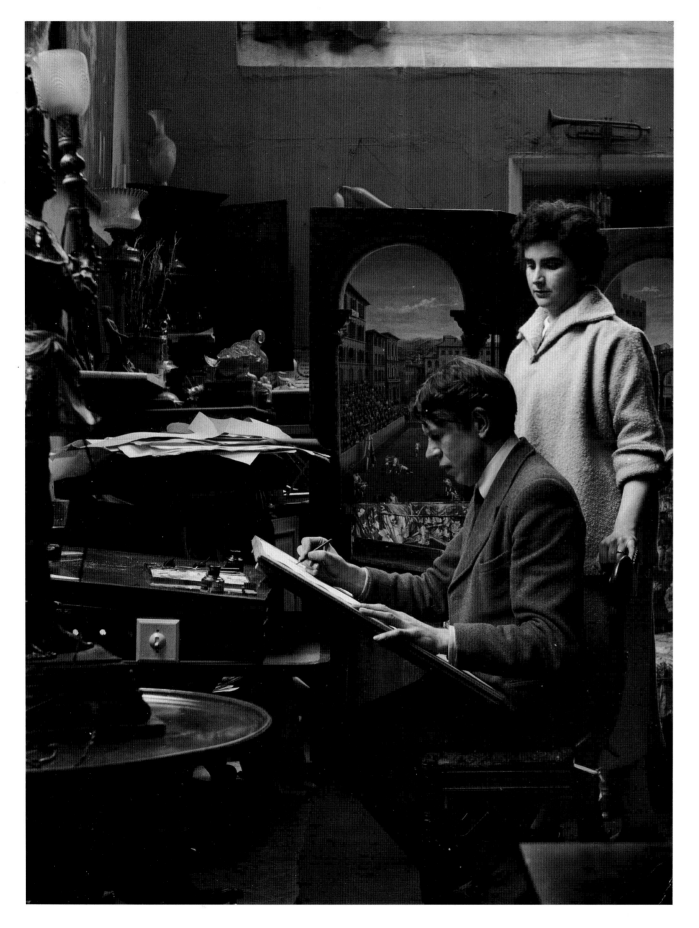

My favourite photograph of Alison, taken sometime in the 1960s in Roger Nicholson's house before going off to a party. Roger was Professor of Textile Design at the RCA. The large painting in the background is Firth's *Derby Day*.

stuffs we hadn't seen for years. We bought straw from the Galleries Lafayette, and my old friend Gordon Davies, sitting in the Luxembourg Gardens, wove an Easter hat for Alison. And at lunchtime we moved to a café where other customers helped us decorate the creation. All that England had lost in the war years and the lean years following seemed to be on hand – and in sunshine with the chestnuts in full flower.

During my four years with *Vogue* there were other visits to Paris and I went the rounds of the fashion houses, loving the style and the nonsense of it all, and realising the importance of this nonsense, that there should be great raging rows over the height or depth of hemlines, or the cutting of photographs.

In 1950, by dint of unwearying courtship, I married Alison Williams and we rented a studio in Glebe Place.

By 1952 I felt my time at *Vogue* should end. Some people were surprised and even concerned. The chief art editor of J. Walter Thompson, George Butler, who helped so many young painters, went so far as to send for me and lecture me on passing up a rare opportunity; but I still had a foot in teaching, doing the odd day at St Martin's, and there was other work.

More work by the good Dutch photographer (I was doing some drawings for a Dutch advertising firm at that time). The place, our studio in Glebe Place; the date, 1953.

25

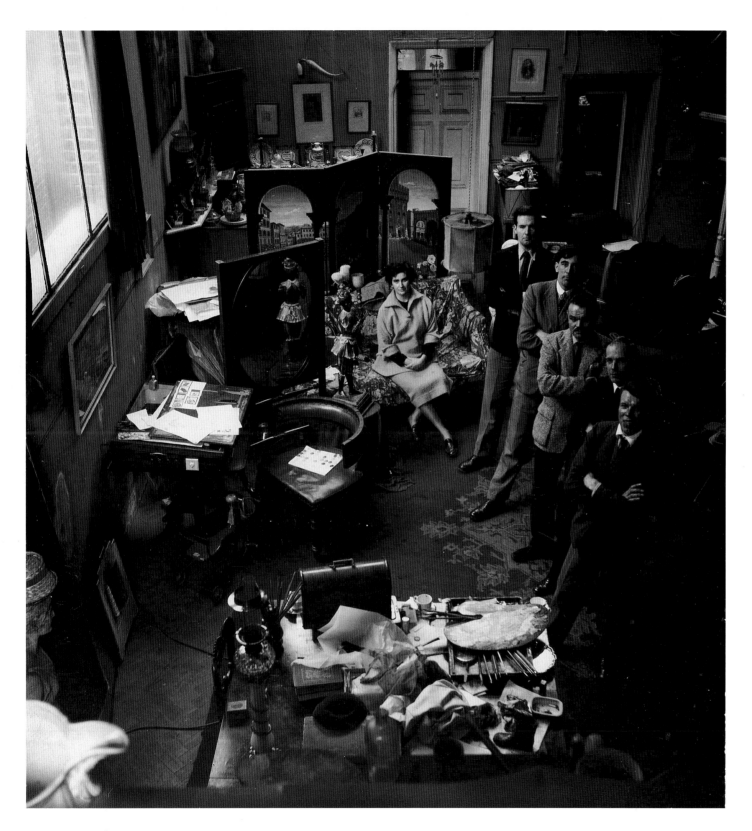

The four years we spent in Chelsea had transformed my outlook and the possibilities open to me, probably mostly through the friendship of Anthony and Nicolette Devas, who seemed to know everyone. Dylan Thomas was a brother-in-law, Nicolette had grown up alongside Augustus John's family, and literary figures moved in and out of their house; Laurie Lee had been a lodger. Anthony was doing splendid portraits of the great and the beautiful – the latter very much against the grain of contemporary art criticism. Their parties, their cooking and their habit of fleeing London for much of the summer were to have a lasting influence on us.

But I am essentially provincial and, after four years, I had had enough of Chelsea – but they had been four important years for me.

## A Full Life

The journey from the days of *Vogue* to my retrospective exhibition at Agnews in 1990 would be tedious to follow in detail and I realise now how unreliable memories become, but there are two stops after my Chelsea days which are easy to record. In 1954 we moved to a flat in Folkestone. In those days east Kent was a depressed area and there were houses and flats to rent – never did we for a moment then contemplate buying a house.

Our flat, a ground floor and basement, was in a pleasant early Victorian house facing the sea and I was interested to read that George du Maurier had stayed in it one holiday. Folkestone then was largely an Edwardian town, the ancient part around the port had been badly damaged by bombing during the war, but the great grass stretch of the Lees and the handsome squares and shops still smacked of the fashionable holiday resort it had been. Sadly, six years of war had left these pleasant houses in a bad way structurally, and by the time we departed in 1957 many of Folkestone's charms had gone and brash concrete and yellow brick were transforming the town – Sainsbury's in particular creating the first major horror.

How did we manage, for our second son George was born shortly after our move? Teaching was a mere token one-evening-a-week at the London School of Printing. But by then I had found a good agent – via Ronald Searle – Alan Bechervaise, who handled com-

Taken from the staircase of the studio at Glebe Place.

mercial work: drawings for advertising and magazines. He was not a particularly friendly or easy man but he was a first-rate agent. He never gave me a job which he thought would not suit me. Most agents snatched at any work and expected their artists to cope, but Alan went into everything thoroughly, driving a hard bargain, paying promptly and dealing with both client and artist in a clear-cut if rather brusque manner.

Bill Gaskell at J. Walter Thompson was helpful, and there was a wide variety of work – and it was always work which demanded good drawing and some imagination. Indeed George Butler, the chairman of JWT and a fine watercolourist himself, was ever-anxious to use the best painters available.

There were book illustrations, poorly paid but fun to do. Once I got a drawing for Keats' 'La Belle Dame Sans Merci' mixed up with an ad for margarine, and to my delight both clients were highly delighted with their drawings, both writing to comment on the originality of my viewpoint.

Portrait commissions, too, began to trickle in, for I had been made a member of the Royal Society of Portrait Painters in 1954 and its exhibitions were a good source of work. The job which perhaps was the most fruitful was making a watercolour conversation piece of Sir Michael Adeane, his wife and son Edward. Sir Michael was the Queen's private secretary and lived in a handsome apartment in St James's Palace, and it was there that I made the drawing. This job led to many splendid times and I owe much to the family's enthusiasm for painting and drawing and their belief in my abilities.

I discovered that there was a demand for small conversation pieces. I relished drawing people in fine rooms and, with the appetite of one eager to show off, I packed the drawings with dogs, cats, children and the bric-à-brac of the drawing room.

About this time I undertook my first mural, again through my good friend Bill Gaskell. He had neighbours, Jack and Dolly Botley, who were much concerned over the restoration of their local church at Challock, and thought the chancel would be enhanced by a mural. It was wintertime when we first visited the church – my father-in-law was staying with us and had generously replaced our ancient Jeep with a small Ford van – and we set off to find the place after a fall of snow.

The church lay remote from the village down a steeply banked and heavily treed lane (Kent is again

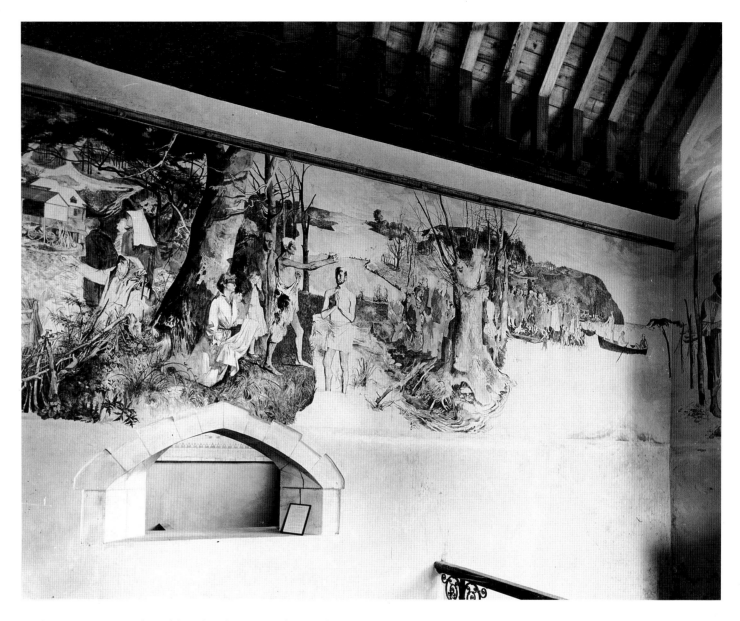

and again surprisingly wild and unknown). The road petered out into a muddy track with the church standing to the left between great old trees. It was locked but, by hanging on to the window-ledge, we were able to see something of the interior, enough to make me wonder whether murals were really necessary. Later I met my patron, the vicar and some members of the parish council, with Bill Gaskell playing the part of the good go-between. Restoration had undoubtedly left the church a little raw and my scruples about the suitability of murals were overcome.

Passages from the Bible were selected and that winter I worked on the designs. From the first I reached for the aid of my old friend Gordon Davies, realising that apart from his undoubted painterly skills he had a practical sense which would be all-important.

In early spring I had the designs settled and we rented a cottage on the Downs not far from the

Challock mural, painted in 1956, the year I was elected to the Royal Academy. The subject on the main wall (about 10 x 25ft) begins with the Annunciation, then the Nativity (shown taking place in the barn which stands across the road from the church). Then follows the Baptism of Christ by St John, and finally Christ preaching from the boat.

church. The weather was fine if cool, and I made studies of plants and trees and buildings – cottages and bungalows and barns – for as far as possible I wanted everything to be identified with the village and countryside around the church.

Our cottage belonged to a dear lady who had moved about the world and spent some time in Paris, and the walls were covered with posters from exhibitions by Picasso, Matisse, and the great names of the twenties. The shelves were stuffed with books. It was here that I had the news of my election to the Royal Academy.

For Laurie Lee's *Cider with Rosie* – here I used my old friend
Gordon Davies as the chap who comes to court Laurie's
sister Phyllis. The artist Pamela Kay posed for Phyllis.
It was drawn directly in pen and ink. (12¼ x 8½ins. 1958)

Most of this summer of 1956 was spent painting the
mural with Gordon Davies, I painting the figures, he
the flowers and birds and rocks. He was a perfect
painting companion, quick and skilful and inventive,
and, swinging about the scaffolding like a monkey,
could make all the adjustments needed for painting at
different heights. We camped in the sexton's hut,
Gordon sleeping on the bier and I on a camp bed.
Gordon was a little given to sleep-walking in those
days, and there were times when I would guide him
back through the tombstones to his bier.

Meals we cooked over an open fire. There was
plenty of firewood and friends would come and spend
evenings picnicking. There were only two cottages
near, one was haunted and empty, and in the other a
delightful family called Jones lived. We would spend
evenings with them. There was no electricity and so no
television, and entertainment came by way of story-
telling from Mr Jones, who had grown up in, and once
owned a small farm on, Romney Marsh.

Few people found their way down to us; sometimes
the vicar, nicknamed Slogger Horsley because of his
preaching style. Looking at our work he would sigh
heavily, and made no bones of his opinion that the
£350, which was our fee, could have been spent on
more practical necessities.

From this rural setting I went to London to my first
Royal Academy banquet, for which Allan Gwynne-
Jones had given me an old but beautifully tailored tail-
coat which I have worn ever since to these dinners.
Each year he used to come and inspect me, to see that I
was looking after this noble garment.

It was while working on the mural that we came
across the house that we still live in. I had known the
valley of the Stour from early holidays with my sister
Sybil, and had been stationed above the river in the
stables at Olantigh during the war. A friend of Sybil's,
Ethel Armitage, a keen botanist and writer on the
countryside, told us of the house, and for our growing
family it seemed ideal, having a large hall-like room
which would make a studio and also being on the bus
route between Canterbury and Ashford. The thought
of buying a house appalled me – £4,250 to be found!
But my dear father-in-law egged us on and forked out
half the sum, and a mortgage secured the rest.

We moved in the autumn of 1957, soon after the
birth of our twin daughters, Celia and Charlotte.
Apart from the 30ft studio the house had a series of
little rooms and was largely of timber construction.
Our vicar, a historian, claimed that it was a medieval
house, and certainly the building was primitive
enough. Then there were about six and a half acres of
garden and field, and behind were woods that
stretched in all directions, with deer, badgers, rabbits,
adders and a few pheasants.

Moneywise this was a keen moment, but my agent
managed a great coup. Whitbreads the brewery was
famous not only for its beer, but also for its calendars –
illustrating these was a job much sought after in those
days, and the one for 1959 was mine to do. The subject
was Drury Lane Theatre, with illustrations of its
history from the days when the National Anthem was
first performed there, and Dr Johnson's *Rasselas*,
down to the latest production of *My Fair Lady* with
Rex Harrison in the lead. The pay was £1,200, a huge
fee in those days. This job was a great relief, and good
to do. I enjoyed the company of the theatre historian
who watched over the work, and the advertising
agency was receptive and enthusiastic.

There were jobs for Shell and BP, and working for
these two companies was very high-class stuff. And I
was now doing portraits in oils. This was an important
move for, as my old friend Vivian Pitchforth used to
say, you were paid 3/6 for a watercolour, but you got
£5 for an oil painting.

For some time I had been illustrating a series of
poetry books for schools. Its editor was Ian Parsons,
chairman of Chatto and Windus and the Hogarth
Press. It was his idea that I should illustrate Laurie
Lee's new book *Cider with Rosie*. I had already met
Laurie with the Devases, and played cricket with him
on a field behind Putney cemetary.

The life he wrote of in his book, that of a boy grow-
ing up in the country, had affinities with my own child-
hood memories. The Cotswolds I knew from holidays
spent with my sister Sybil, who since the war had lived
in a farmhouse in Upper Swell outside Stow-on-the-
Wold.

Somewhere about this time, 1958, Canterbury Col-
lege of Art had produced a model for me, a painting
student called Pamela Kay. She was an inspiring
model whom I used for all the *Cider with Rosie* draw-
ings. How one thanks one's lucky stars for a good
model: so much depends on their responding to the
needs of the drawing or painting. Pamela was also a
gifted painter with determination to do well, and by
shrewdly assessing her abilities she now enjoys no
small reputation and popularity.

The book succeeded beyond all expectations, some
of its success rubbing off on me, with the result that
during this period I was more often referred to as an
illustrator than as a painter.

Over the years I have always managed to keep enough
time free from commissioned work to paint pictures
for shows. My first exhibition, in 1948, was shared
with Dennis Lucas in the Alexander Gallery in Church
Street, Kensington, and John Minton, then very much
a name, generously showed a few things in order to
help. The critics of *The Listener* and the *Daily
Telegraph* wrote us up, and we sold two or three draw-
ings. At another shared show, at Wildenstein's grand
gallery in 1953, nothing of mine sold, but I did get
to know Fred Beddington who worked there at the

time and became a great friend and supporter.

Charles Harding, who then ran the Trafford Gallery in Mount Street, gave me several shows in the mid-fifties, and was the first to sell my work on any scale. From there I moved to the Arthur Jeffries Gallery, where in 1960 I showed my large picture of my sons William and George dressed in newspaper. I have always relished painting crumpled paper and over the previous Christmas, being unwell, I amused myself by making elaborate paper hats for the children. It was from that that the idea sprang for the picture.

The children were all good models; they seemed to sense how important the task was. Once when I was drawing Charlotte playing a recorder, she hung onto the pose long after most children would have been screaming with boredom and fatigue, and I remember how amazed and grateful I was. I think it was the influence of their mother, who was not only a lovely and untiring model, but made the task important so that I should have every help to do a worthwhile job.

I later showed *The Newspaper Boys* in the RA, but it never sold and eventually I gave it to George who, surely purely coincidentally, had by then become a journalist.

After the demise of the Arthur Jeffries Gallery I was without a dealer's gallery, and passing along Clifford Street one day I noticed a watercolour of mine handsomely shown in the window of the Maas Gallery. At that time, 1964, the gallery had already won for itself a reputation for its now historic exhibitions of Pre-Raphaelite and other Victorian pictures.

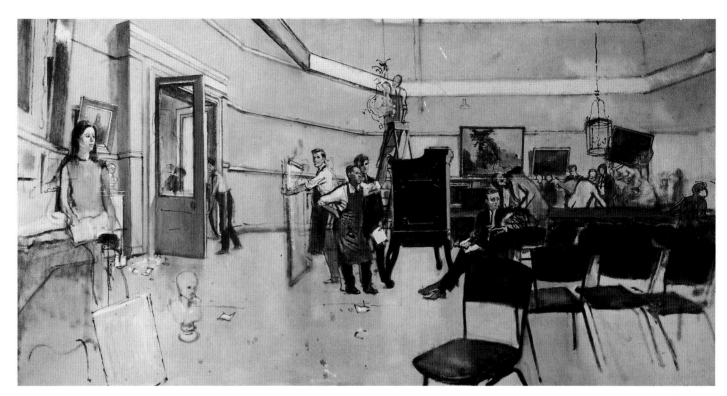

These two pictures for Christie's were great events in my life. I grew up hearing the name 'Christie's' bandied about the house – a name spoken in awe and reverence – and so when I was asked by John Herbert if I would take on the job of painting a picture to commemorate the bicentenary of this famous auction house I was indeed flattered. John Russell, now art critic of the *New York Times* and then of the *Sunday Times*, had recommended me for the commission. I spent months over the work, making endless sketches not only of the sale rooms but also down in the cellars, which were glowing Aladdin's caves.

The mixture of people attending sales, and the combination of tension and boredom during a sale, provided fine subject matter – as did the curious blend of furniture and junk on which people lolled and leaned.

After completing the painting showing the chairman, Peter Chance CBE, taking the sale with all the firm's directors scattered around, I couldn't resist the second picture showing the head porter in charge. I enjoyed my days at Christie's. (both 20 x 40ins. 1967–8)

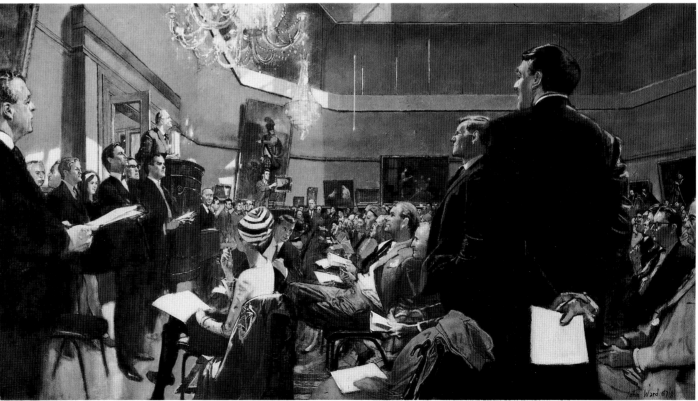

Jeremy Maas, with a fresh and unprejudiced eye, was one of the first dealers to force upon the art world the necessity of revaluing the work of this period. A historian by training, with a passion for both literature and painting, he was a man to be reckoned with. I was thrilled and flattered to see my work in the gallery, and went in and enquired how it had come into Maas' hands. He had, he told me, bought it at a sale room, and I purred my pleasure. Jeremy asked for more, and thus began a partnership that has lasted ever since.

Unflinchingly he goes through my work, accompanied by his son Rupert who now manages the gallery, yes-ing and no-ing without mercy. I have learnt so much through this friendship: where painting is concerned, the sheer ability of the Victorians whose work I see in his gallery is chastening; and Jeremy's opinions have an independence and bluntness which both shock and stimulate.

But behind all my efforts there have been the benefits of being a member of the Royal Academy. Ever since my election in 1956 I have enjoyed the privilege of showing up to six works in the Summer Exhibition. Despite all that is said against the institution it remains a real prop for a painter, enabling his work to be seen regularly by a far greater number of people than is ever possible in a private gallery. It is also an immensely pleasurable institution to belong to. For some reason or other it attracts a permanent staff, from the Secretary downwards, who become devoted to the place and become dear friends.

I have never aspired to any office in the RA, being hopeless at any kind of administration, but having served on many councils and talked through many dramas I have never ceased to admire the dedication which is brought to the offices of President, Keeper, and Treasurer. Painters, sculptors, architects, printmakers and draughtsmen add up to a pretty mixed bunch, with many of us housing some vigorous bees in our bonnets. But meetings are conducted with a shrewd, humorous efficiency; and there are many lovely and splendid occasions carried out with style and aplomb.

The annual dinner is always exciting, the dressing up and the fun of seeing who is there. Such functions are constantly under attack – ridiculous, a lot of people capering around in dress clothes wearing medals and ribbons – but I have ever defended the ridiculous. Art itself is ridiculous. And medals and orders and ribbons and clothes are designed by artists. Whenever I meet a mayor or functionary wearing a chain or badge of office, I ask who designed it and who made it.

My local town of Ashford only recently acquired a mayoral chain, designed and made by the local silversmith, himself an Ashford man trained at the RCA. This I believe to be a good thing. I have always believed that artists are better for being used. Few of us are of the stuff that can just work in the isolation of our studios. We need to be needed, to work to specifications. Most imaginations come to life over problems, problems set by other people.

Wisely the rules of the RA are so devised that, come a member's seventieth year, it is no longer necessary to have a finger in the pie. You can do a little ranting and raving – though long dissertations are strictly taboo – and such is the nature of the membership that the bits of sense are listened to, and the nonsense is treated with wit and humour. It is perhaps not made up entirely of great men (there are never many of those around at any one time) but the RA has always contained more good, really good, painters than it has been given credit for.

With age comes a greater necessity to husband one's energies. I used to love sketching in the evening, and I still do, but I know it means I will not work so well the next morning. Now I look back to old ideas that I never quite managed to bring off between portrait painting and other commissioned works. So much to be done, and with keen eyes I study the fitness of octogenarians. Time is the most valuable of all things, and passing time is always nudging your elbow; the model tires, the still life wilts, and the light comes and goes across the landscape. I try to remember the stubborn patience of Ford Madox Brown, but I also try to remember to enjoy it all and never forget what a wonderful life drawing and painting have given me.

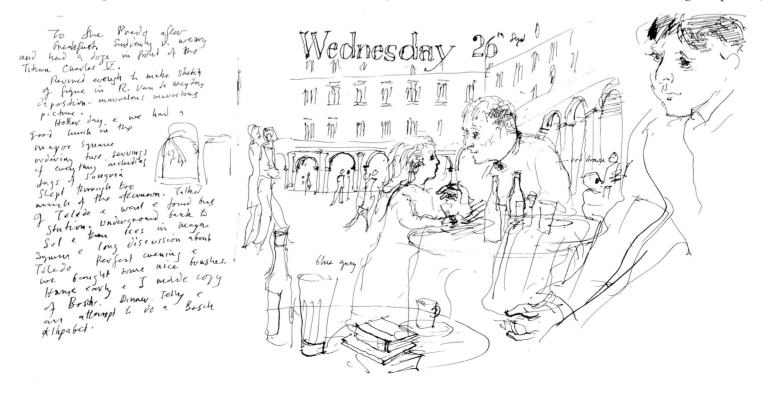

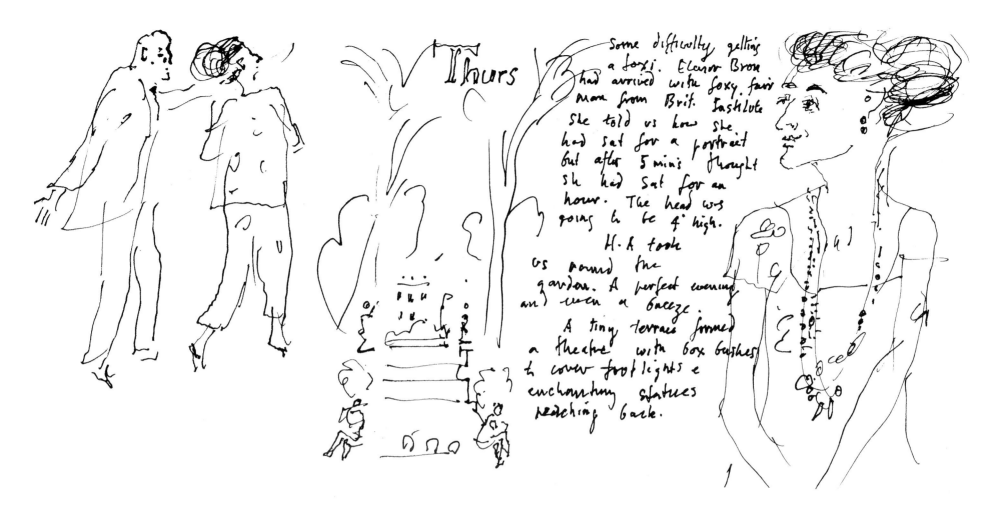

## Thurs

Some difficulty getting a taxi. Eleanor Bron had arrived with foxy, fair man from Brit. Institute. She told us how she had sat for a portrait but after 5 mins thought she had sat for an hour. The head was going to be 4' high.

H.A took us round the garden. A perfect evening and even a breeze.

A tiny terrace formed a theatre with box bushes to cover footlights & enchanting statues retching back.

---

## Friday

Jack's last day and we met about 8 & walked along the Zattere & had coffee in the place we'd been to yesterday. Much cooler, a true autumn day, exciting, with wind & changing sky.

Jack wanted to walk right along to the Dogana but going over the bridge just after the Calcina we were hailed by a lady at a window of the pensione. I couldn't think - or recognise who it could be - to my great joy it was Rosie Guépine Jones. She shrieked at me that she was painting in the Jesuati & we much

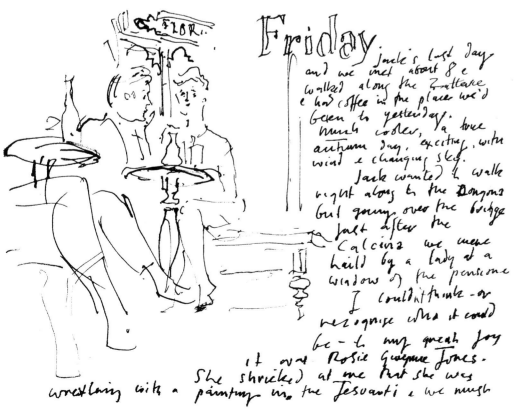

wrestling with a

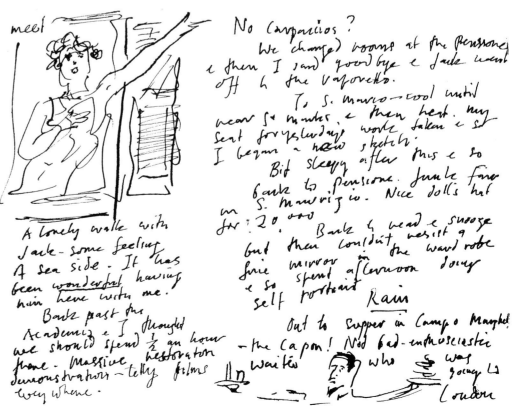

meet

A lonely walk with Jack - some feeling. A sea side. It has been wonderful having him here with me.

Back past the Academia & I thought we should spend ½ an hour there - massive restoration demonstrations - telly films everywhere.

No Carpaccios?

We changed rooms at the pensione & then I said goodbye & Jack went off to the vaporetto.

To S. Mauro - cool until near 5 number & then heat. My seat for yesterday was taken & so I began a new sketch.

Bit sleepy after this & so back to pensione. Jumble fare in S. Maurizio. Nice doll's hat for 20.000

Back to bed & snooze but then couldn't resist a fine mirror in the wardrobe & so spent afternoon doing self portrait.

### Rain

Out to supper in Campo Manghel - the Capon! Nad bed-enthusiastic waiter who was going to London

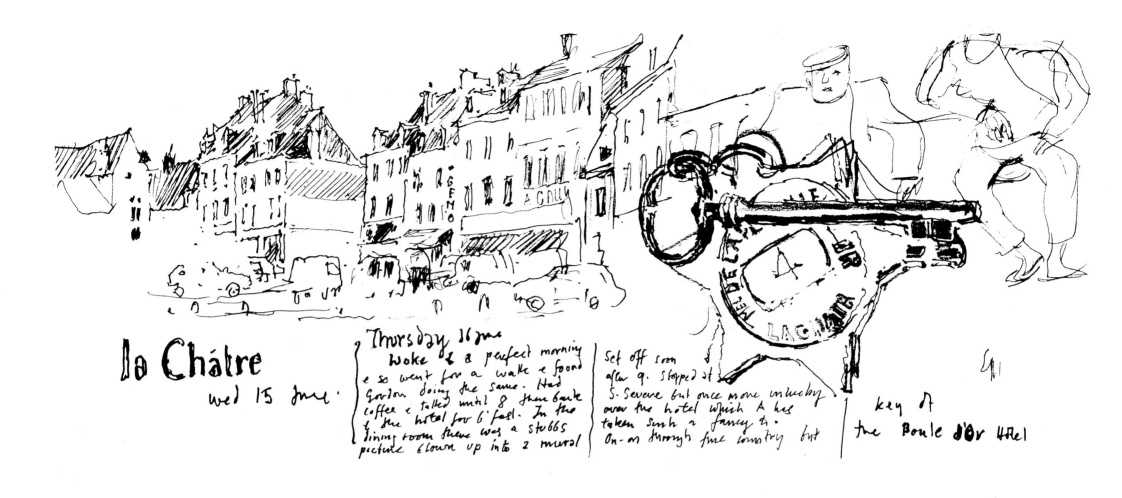

# La Châtre
### wed 15 June.

**Thursday 16 June**
Woke to a perfect morning & so went for a walk & found Gordon doing the same. Had coffee & talked until 8 then back to the hotel for b'fast. In the dining room there was a Stubbs picture blown up into a mural

Set off soon after 9. Stopped at S. Severe but once more unlucky over the hotel which A has taken such a fancy to. On-on through fine country but

key of
the Boule d'Or Hotel

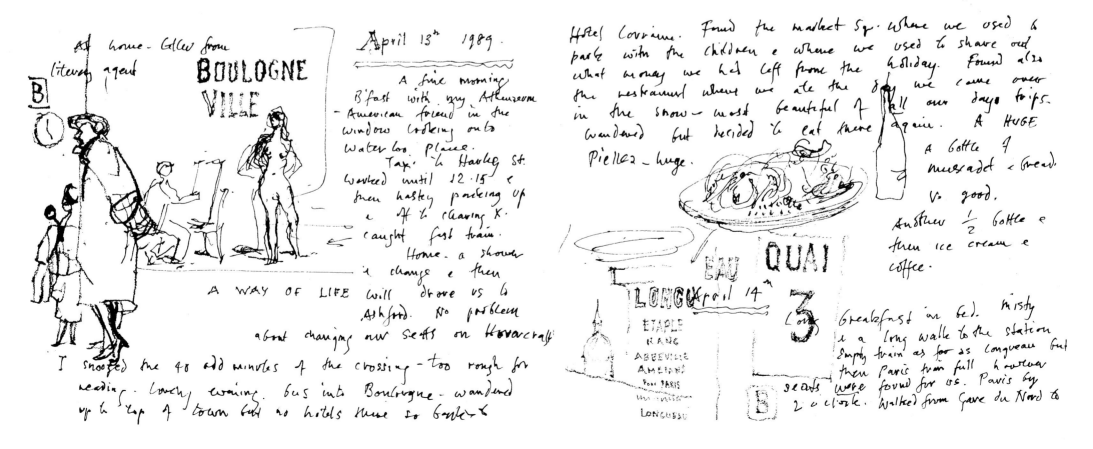

At home - letter from literary agent

**BOULOGNE VILLE**

A WAY OF LIFE

### April 13th 1989.

A fine morning. B'fast with my Athenæum - American friend in the window looking onto Waterloo Place.
Taxi to Hanley St. worked until 12.15 & then hasty packing up & off to Charing X. caught fast train.
Home - a shower & change & then Will drove us to Ashford. No problem about changing our seats on Hovercraft

I snoozed the 40 odd minutes of the crossing - too rough for reading. Lovely evening. bus into Boulogne - wandered up to top of town but no hotels there so backed

Hotel Lorraine. Found the market sq. where we used to park with the children & where we used to share out what money we had left from the holiday. Found also the restaurant where we ate the day we came over in the snow - most beautiful of all our days trips. Wandered but decided to eat there again. A HUGE Pierrez - huge.

**EAU QUAI**

**LONGU** April 14th
ETAPLE
RANG
ABBEVILLE
AMIENS
Pour PARIS

LONGUEAU

A bottle of muscadet & bread. V. good.
Another ½ bottle & then ice cream & coffee.

(on) breakfast in bed. Misty & a long walk to the station Empty train as far as Longueau but then Paris train full however seats were found for us. Paris by 2 o'clock. Walked from Gare du Nord to

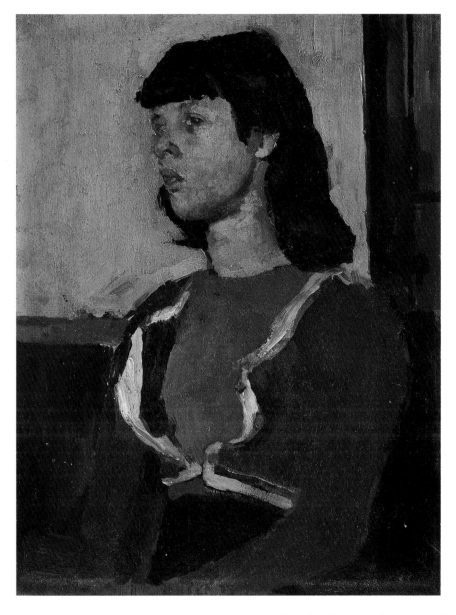

## Stella Marchant

Oil on board, 10 x 7¾ins. 1937

This is one of the few paintings which has survived from my RCA days, painted in Hereford in 1937. Stella was the daughter of the grandest grocer in Hereford. Her mother, May Marchant, the daughter of ancient Hereford farming stock, was a gifted woman: she played the cello, was a good actress and had a passion for painting, pottery, fashion and horse-racing.

I met May Marchant at the local Arts and Crafts Exhibition which, when I was sixteen years old, was the highlight of my year. Dear, great-hearted soul that she was, she invited me to tea, to her pleasant Regency house where the front door stood open most of the year and good food was served. Lying around were the latest art books, the novels of D. H. Lawrence and the poems of T. S. Eliot.

Every Thursday I would go to tea. Pottery had be-

come her leading passion, and she had become no mean practitioner herself. She had got to know Michael Cardew and Bernard Leach, and long and intense were the talks about shapes and glazes and decoration. For me pottery, along with architecture, is the great abstract art, and through May Marchant I found a whole new world to cogitate upon and delight in.

There would be expeditions to Michael Cardew's pottery in Winchcombe. Michael Cardew, very handsome and intellectual, his wife ample and glowing in filmy Hungarian blouses, the children sitting on *their* pots on the front steps – I felt myself in Bohemia!

This portrait will ever remind me of my good fortune in meeting May Marchant; her talk, her scorn of the commonplace, yet relish for vulgarity when need be, still tingle in my memory. I don't think I ever painted a better picture during my student days. May was indeed an important and rich influence on me.

## Maria – Dutch Child, Holland 1944

Pen, ink and watercolour, 11¾ x 7⅝ins. 1944

This child was drawn in the winter of 1944–45. The unit I was in was billeted in the byre of a small Dutch farm. There were six or seven children, and I drew them all in exchange for half a dozen eggs. Maria moved me because she was at that stage where her baby teeth had begun to go and their replacements hadn't arrived. I found children – French, Dutch, Belgian and German – willing subjects despite my not possessing a word of their languages. I loved the solemnity of their faces. In adults solemnity often lies next to glum boredom, but not so with children. If they are bored they just clear off – or howl!

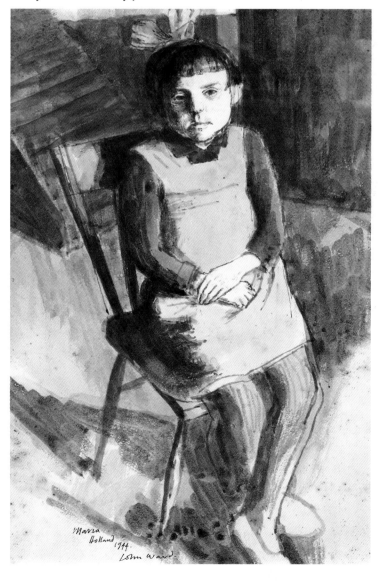

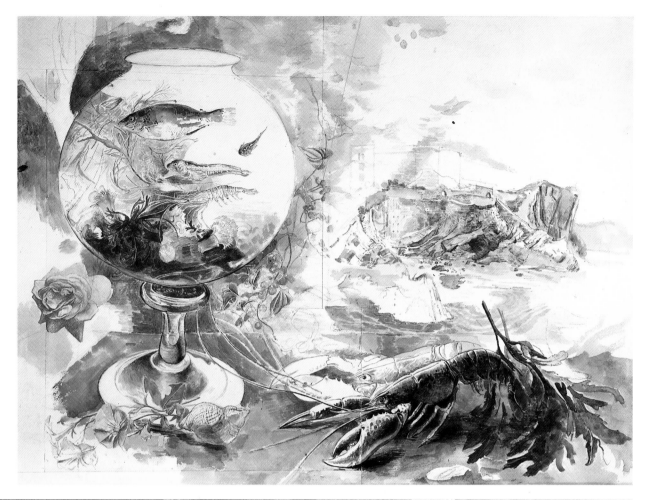

**Summer**
Pen, ink and watercolour, 22 x 30ins. 1957

**Rockpool**
Oil on canvas, 30 x 53ins. 1978

I had a brother who was an ardent fisherman and so saw plenty of fish around, and caught his excitement in watching them in the river. Strength and delicacy beyond belief, but the colour and loveliness fast fading once out of the water. There are moments when eye and hand, and paper and brush, work better than usual together and I took great joy in this sheet of drawings.

One of my favourite books is Edmund Gosse's *Father and Son,* and the moment when together they explored the rockpools of Tenby in Wales and spent their evenings drawing and painting the day's finds has remained as a vivid picture in my mind.

When I came to spend holidays in Tenby it was inevitable that I should attempt pictures of rockpools. The still life *Summer* was one attempt. The fish were drawn by the rockpools, the bits of weed and shells brought back and floated in a glass globe made, I believe, to magnify candlelight for sewing or close work.

Alas, I never managed the pictures of rockpools with figures which so excited me. I made endless sketches and notes but perhaps I lacked the courage needed to paint satisfactorily 'out of my head', since it was a subject you could not set up like a still life.

But painters, perhaps foolishly, entertain a Peter Pan outlook, and hope that they will get round to it again one day, regardless of fading energy and eyesight.

A painter's mind is full of wondrous pictures, and many a sleepless night has been filled with the expectations and visions of masterpieces, but how often just rubbish ensues the next day. Half one's time is spent in a panic wondering whether one is painting as well as one used to. The other half is madly optimistic, still envisaging old subjects retackled and success at last.

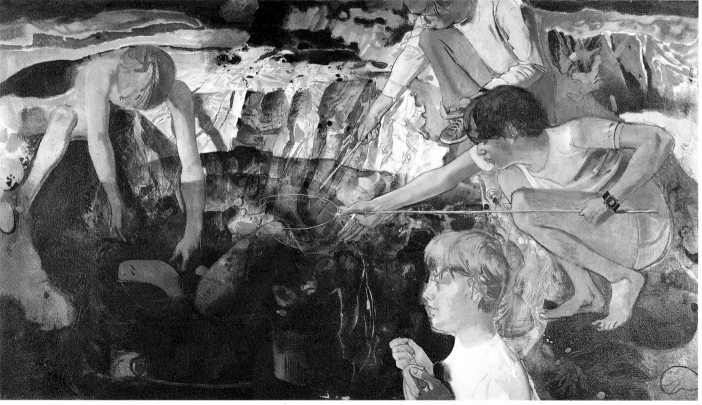

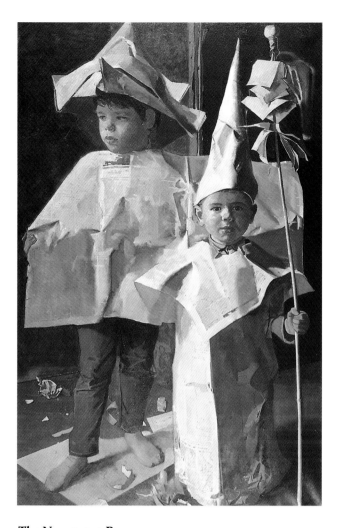

**The Newspaper Boys**

Oil on canvas, 54 x 36ins. 1960

In Italy workmen make little caps out of newspaper, which gave me the idea of dressing up my two sons, William and George, in some. Painted soon after my election to the RA, it was an elaborate effort. I think my children always sensed how important time and opportunity were – and, since children are quick at grasping facts, how financially important time was – and they posed with great patience. They also demanded, and got, extortionate sitting money!

All through the picture the paper made good geometric shapes. I concocted some kind of lay figure for George, the shorter of the two boys, and I had a child lay figure for William's costume. There was a touch of *Commedia dell'Arte* about the arrangement, and scribbles were made to include the other three children in a larger picture. Somewhere there is a watercolour of the set-up as a still life. It was shown at the RA and sold. One is so pleased and relieved to have sold that keeping track of the buyer gets forgotten. In later years pictures float back via the sale rooms. It's so hard to realise that the first sale is only the beginning of a picture's life.

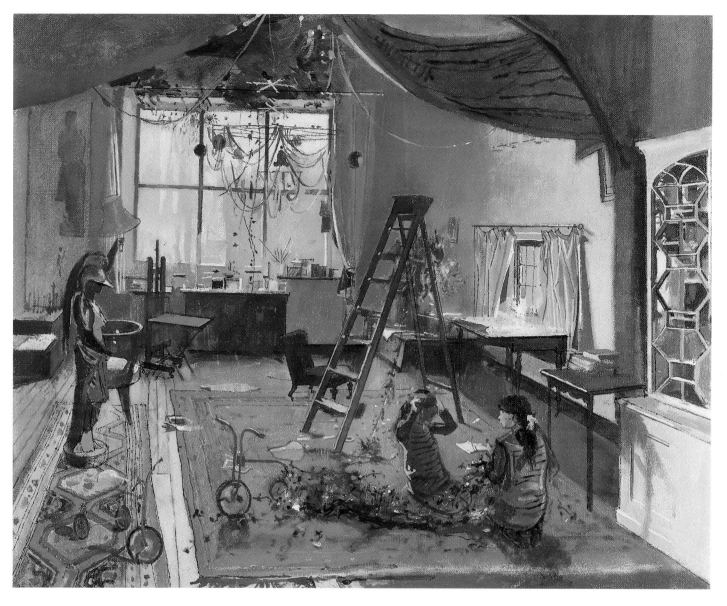

**Christmas with the Twins**

Oil on canvas, 18 x 22ins. 1966

This is an early painting where the twins appear with their tricycles, machines I like painting; the moment is during the Christmas preparations. The step-ladder is there because we use it for the decorations, and because I like them in rooms; they have a good shape. How empty the studio looks compared to later days! Joyce and Reggie Grenfell bought this picture.

**Charlotte Under the Apple Tree**

Pen, ink and watercolour, 12½ x 18½ins. 1970

It was the apples under the tree which first attracted me here, but then the wild shooting apple tree branches held me, and at some point my daughter Charlotte turned up to rest on the swing and munch an apple. The sun shone and I loved my days pecking out the shapes of tree and sky.

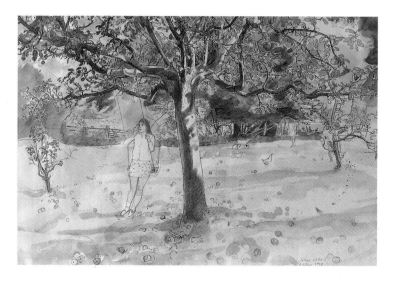

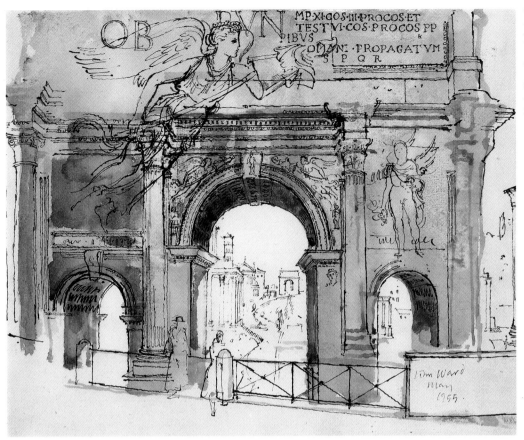

### The Arch of Septimus Severus, Rome

Pen, ink and wash, 9¼ x 11½ins. 1955

This is from one of my earliest trips to Rome. It is an everlasting subject for me. The work was too small to give full value to the beautiful reliefs and so I just enlarged them across the drawing. And lettering is always fun to copy. The picture was bought by that rare painter and collector, Eliot Hodgkin – to my great delight.

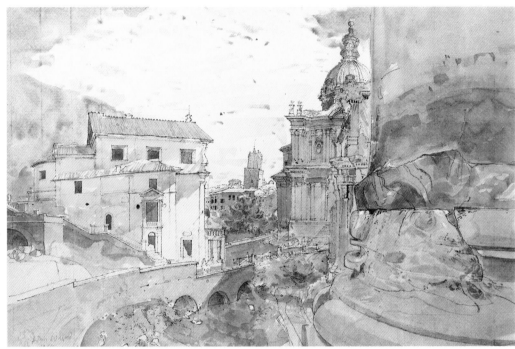

### Rome – The Forum

Pen, ink and watercolour, 12¼ x 18½ins. 1968

A watercolour made in the Forum. The foreground an irresistible chunk of marble pillar, in places worn or chipped back to the original rock, contrasting with the Renaissance church and the great tower so splendidly aslant. Great mounds of energetic building steadied by the firm window shapes and the perfect intervals of their placing. I ever hope that copying fine architecture may refine one's judgement over the abstract problems of picture-making. Anyway, it makes one take one's hat off in deep respect to such superb building.

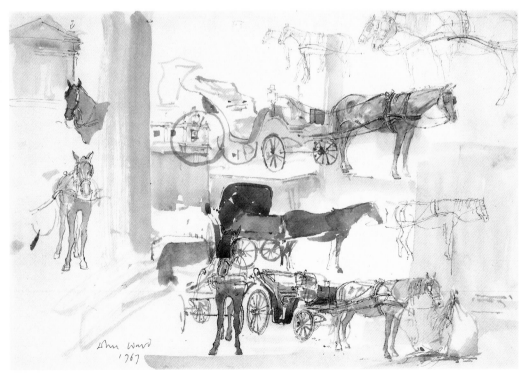

### Horses and Carriages in Rome

Pencil and watercolour, 12¼ x 18½ins. 1967

Oh, the delight in drawing horses and carriages. These sketches were made outside St Peter's, possibly as light relief after drawing exacting architectural proportions.

Perhaps because of Stubbs I have always enjoyed paintings and drawings of horses. The largest I ever did was on the wall in the nursery at home, which over the years came to include a volcanic island, pirates and wild animals. Now the children have grown up it is covered by rather more sedate wallpaper!

**A Sheet of Studies of a Cat**

Pencil and watercolour, 5¼ x 9¼ins. 1971

I am sure that the seemingly random stripings and blotch markings on animals have a scheme and rhythm. This favourite cat curled and stretched shell-like and soft until bored, and her claws moved lazily.

In the sixties I drew sketches for an opera about cats. I bullied and begged various people to write a libretto but nothing ever came of the idea. A pity, there were to be human legs 14ft long, as seen from a cat's eye-level, and humans wearing cat masks would wander and sing between them. There was to be a duet sung between two telephone boxes.

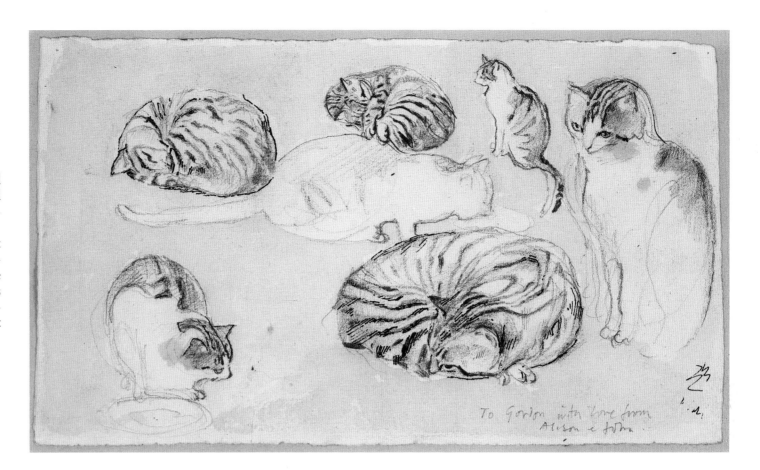

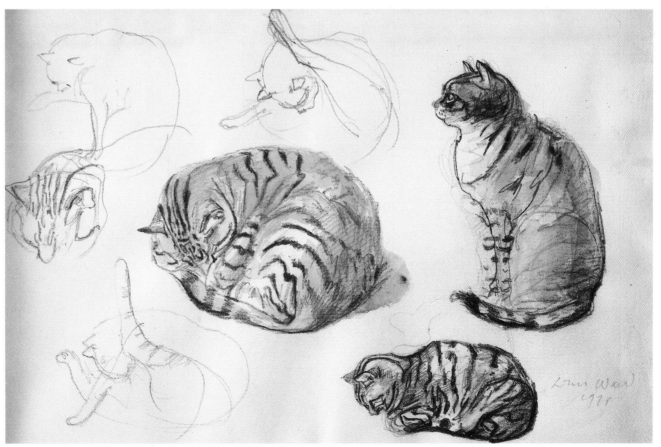

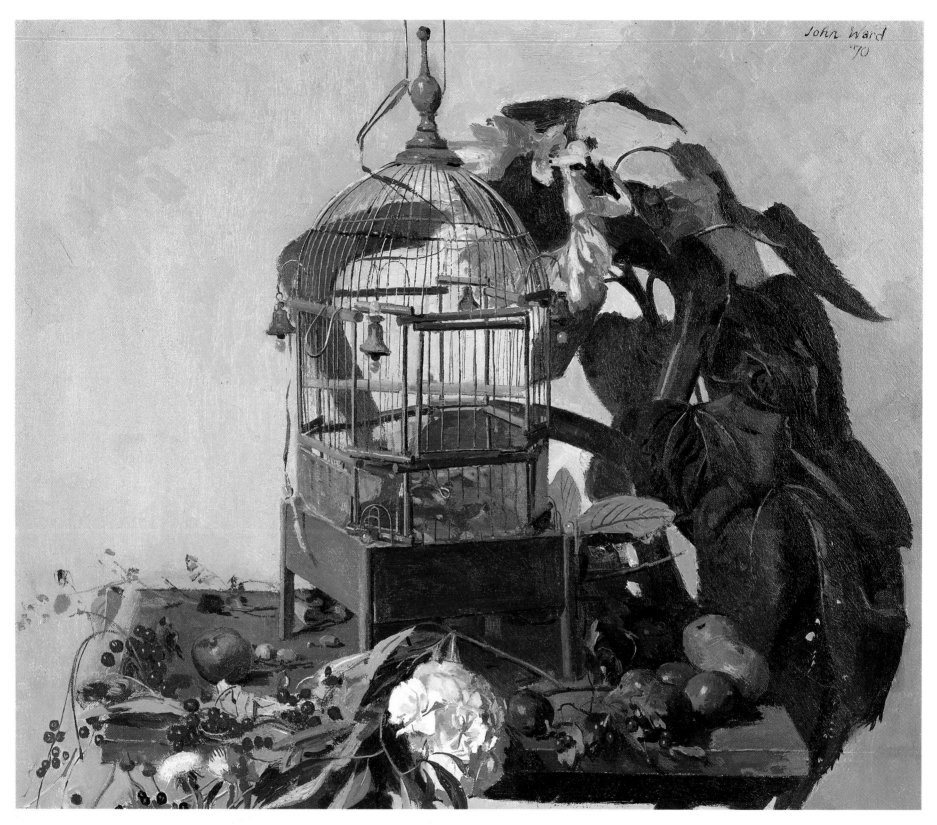

**Sunflower with Birdcage**

Oil on canvas, 20 x 24ins. 1970

The birdcage in this still life I found in Paris, and it appears again and again in my paintings. I didn't set up the subject in its entirety when I began, just the sunflower and the birdcage. But then whatever was to hand, the berries, walnuts in their green cases, and sprigs of willow, got caught up in the excitement – the raggle-taggle contrasting with the prim delicacy of the birdcage and weight of the noble sunflower.

## Still Life with Mug and Paintbox

Oil on canvas, 8 x 12ins. 1970

I paint the still life created by the assembly of gear and bits and pieces used or discarded during a work because it so often makes a wonderful subject. Watercolour boxes I have a great affection for, and dandelions are lovely flowers. The mug looks like an old army job. I had a steady hand when that was painted.

## Still life always makes me wonder – is the studio womb or tomb?

Pen, ink and watercolour, 12½ x 18½ins. 1969

I have often suggested to art students that the art school is a desert in the middle of an oasis, that we always need pushing out of the quiet, sympathetic refuge – which a school can be – into the street, where everything moves and paintboxes, stools and easels are a possible public nuisance. Of course it is a matter of proportion; the studio or school is necessary for the working out of problems, but possibly the best problems lie outside in the street.

Is the point of a still life that it should be immobile – dead? Or is it possible for there to be a sense of life suspended? Objects left around that someone will return to, a group representing a moment captured?

One of the joys of travel is sketching the still life which always crops up on café tables; coat hangers and hotel rooms. An arrangement which is still vivid in my mind occurred in a French country restaurant where a dozen workmen had lunched, and lunched well. Then they all, bar one, had left the table. Chairs were pushed back or aside, table napkins left crumpled or on the backs of chairs, bottles giving height to the plates, cups, cutlery and bread baskets. A battlefield of sorts, but with echoes of earnest appetites and busy talk now stilled and over; and of the Last Supper.

Every painter's ambition when young is to possess a studio, large and well lit, and perhaps quiet, with favourite books around and a collection of oddities gleaned from junk shops and sea shores – endless still life. But how can we perceive when staleness descends and the work conceived is sterile? There is no other way than taking our work out, and exposing it in the raw light and cool terms of the exhibition and the dealer's world.

It is important to be serious about what we do, but that is not altogether enough. Complacency can arrive quietly and comfortably; silliness must be listened to. The odd 'funny' remark must be noted and considered. I have a friend who adopts a mincing tone when he spots the arch or the coy in my work. Perhaps we need to invite the milkman, the dustman and any odd neighbour to walk through our studios at regular intervals.

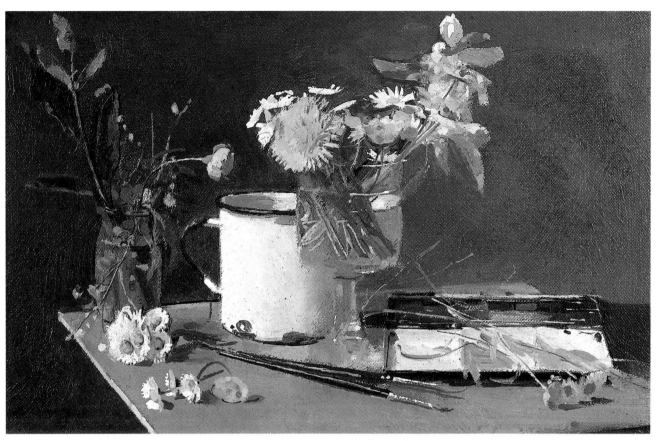

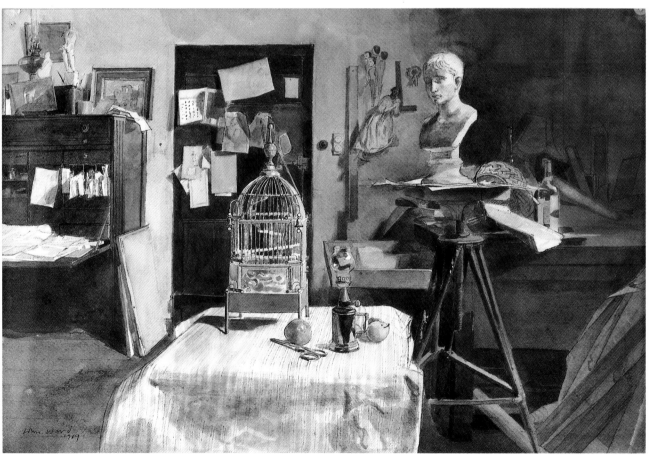

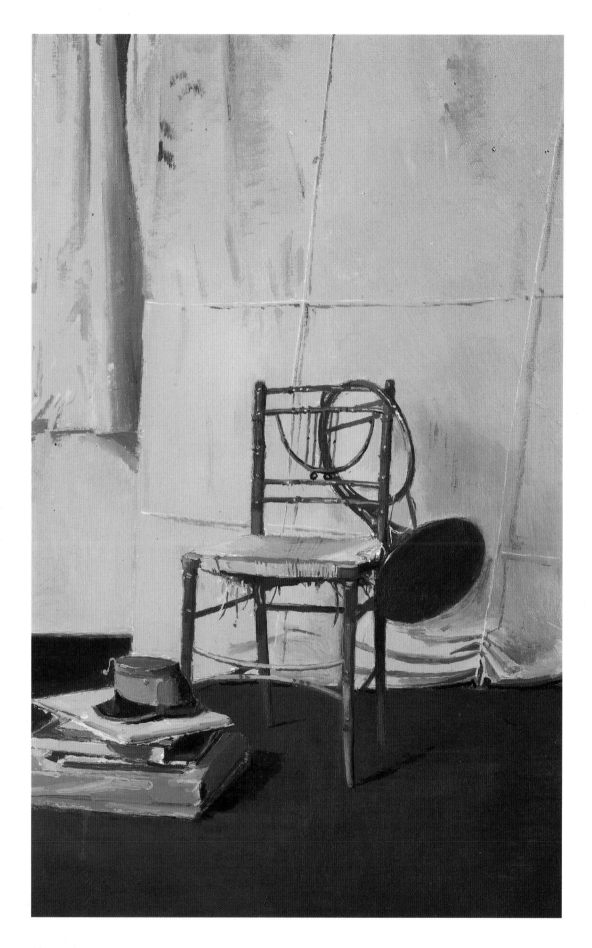

### Still Life with Chair

Oil on board, 12 x 8ins. 1976

The story here lies in the large package behind the chair, which is a life-size full-length portrait of our then vicar, Dr the Rev Graham Brade-Birks. It was painted for the fun of attempting so vast a portrait, and after its showing at the RA was foisted onto Wye Agricultural College, where the good Doctor had spent a lifetime as a scientist and teacher. The painting got damaged during a happy evening and was sent back to me handsomely shrouded in fine old linen sheeting. I never unpacked it, liking it better as an object of still life than as an unhousable portrait – though I should add that a member of the college later took it upon himself to cart it away, and have it restored and re-hung at that friendly institution.

(Opposite)

### Joyce Grenfell

Oil on canvas, 20 x 16ins. 1979

Recalling how paintings came about and how they were done is great fun, but when it comes to people a little more caution is required, especially when the subject is that great lady Joyce Grenfell. Then the simple facts must suffice.

I first met Joyce Grenfell through the 1951 Festival of Britain Exhibition, when I did a series of drawings for Stephen Potter, author of *Gamesmanship*. The job was to illustrate a theme, 'English as She Is Spoken', a series of recordings made by Joyce and Hermione Baddeley of all social types from a Scots surgeon to a Cockney charlady. Stephen Potter was nicely enthusiastic about my work, and, having vague notions of doing a series of portrait drawings of eminent people, I asked him to sit for me. Afterwards he gave me an introduction to Joyce, and I went along to the theatre where she was playing and made a sketch.

Thus began a lifelong friendship. Soon after that first meeting she commissioned a drawing of herself in her flat which in those days was above a sweet shop in the King's Road, Chelsea. It was a tiny place and the drawing was made in her kitchen-dining room. Behind her was a dresser with some fine china, and also some that, being gifts from schoolchildren, was not so fine but was dear to Joyce's heart for reasons of sentiment. How enriching is such a juxtaposition – everlasting good taste can pall.

Then came a series of commissions to draw her friends: Victor Steibel who made her dresses; Richard Addinsell, who wrote the music for her lyrics; her great friend Virginia Graham; her lovely mother-in-law Mrs Grenfell; Colonel Grenfell; the doorman at her favourite theatre; always her 'helps'; and, one great day, her friend the poet Walter de la Mare. I drew her husband Reggie while she was in America, and still remember the endlessly fascinating talk.

During the late fifties I had painted a neighbour, Billie Louden, who sensibly demanded a small half-length portrait rather than the usual life-size head and shoulders. Such portraits make for better pictures since there is room for a setting to be recorded. Joyce liked the idea and commissioned a similar job from me.

She sat in her sitting-room in a flat she had moved to in Fulham, still small, but now with separate kitchen and dining room. Behind her in my picture is the superb Sargent of her aunt, a daunting work to confront! The flowers on the little table on the left were tended with immense care by Joyce. They were always small and surprisingly varied considering that she had no garden and local florists mostly sold big stuff.

As with everything she did, ample time and thought were given to the portrait. There was never the usual business with busy, famous people where the promised two-hour sitting suddenly becomes a squeezed thirty minutes. The picture was shown at the RA, and friends and *Country Life* were nice about it.

Later we did two books together, *George Don't Do That* and *Stately as a Galleon.* Both were highly successful and, with her usual generosity, Joyce insisted that we shared the royalties.

During our twenty-odd years of friendship I sent her many illustrated letters which she kept, and after her death Reggie had them handsomely mounted and bound and gave them back to me – a souvenir of a dear and precious friendship, and one that was of the greatest help in my career.

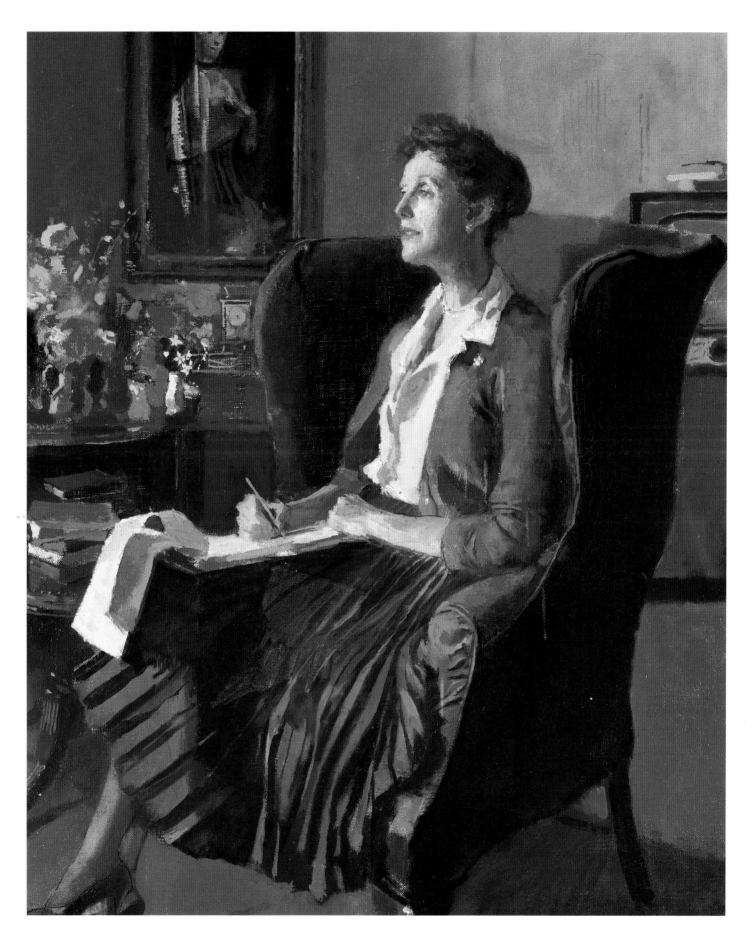

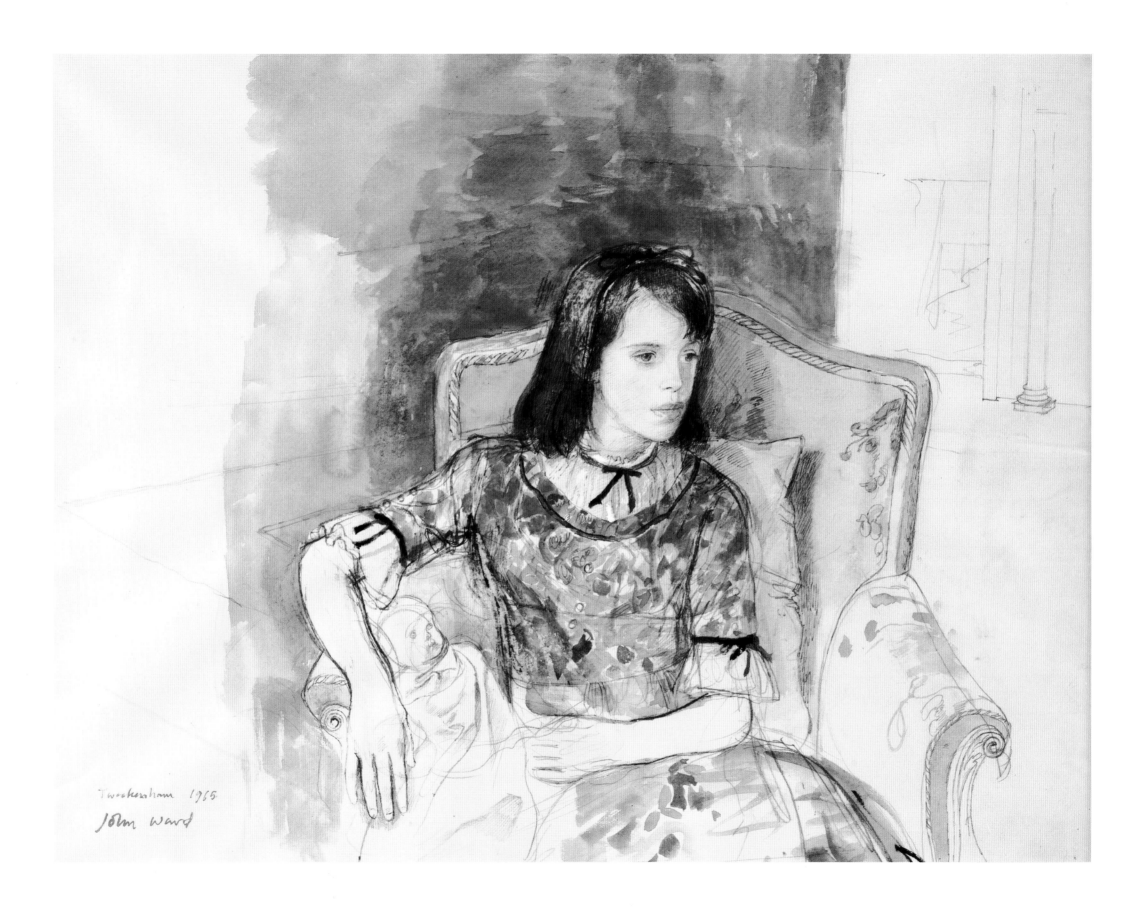

Twickenham 1955

John Ward

(Opposite)
**Athena Maas**

Pen, ink and watercolour, 12½ x 18½ins. 1965

Drawing children from the back streets of Fulham provided a useful exercise which bore fruit when it came to commissions to draw children. This is the daughter of Jeremy Maas, my dealer now for more than twenty years. Obviously some children are absolute horrors, but she sat particularly well and produced the doll. She had a dress that was attractive – so often best dresses are incredibly boring!

I imagine she caught from her father the fascination of seeing a drawing made. A lot of children look upon the process with absolute horror. One had the screaming ab-dabs because, when told she was going to be painted, she thought she was going to be literally painted, like a house. In those days I was pretty good at managing children – desperation made one so. I could tell them stories, and there was the game of The Parson's Cat which kept them going.

It was a matter of diminishing returns. First of all they sat for a while because they were flattered or had been told to do it. Then they would sit for a while because you entertained them. Then there was a bit of bribery; and after that it was sheer hard work.

**Geraldine**

Oil on canvas, 36 x 28ins. 1974

I have often wondered whether I need more colours than black and white. I have always been fascinated by the colours that are white, and when Geraldine, who came to work for me as an assistant for a while, turned up in this suit it was irresistible to get her to sit. I made careful studies of the sleeves and the arms. The pose is a perfectly straightforward easy one, and a paintbox is a nice thing to paint.

Norman Hepple has always said that I do not know when to stop stuffing things into pictures, and that they would be better if they were simpler. I might here have taken his advice. Norman, over the years, has so often given me sound advice. Few painters have so great a knowledge of picture-making.

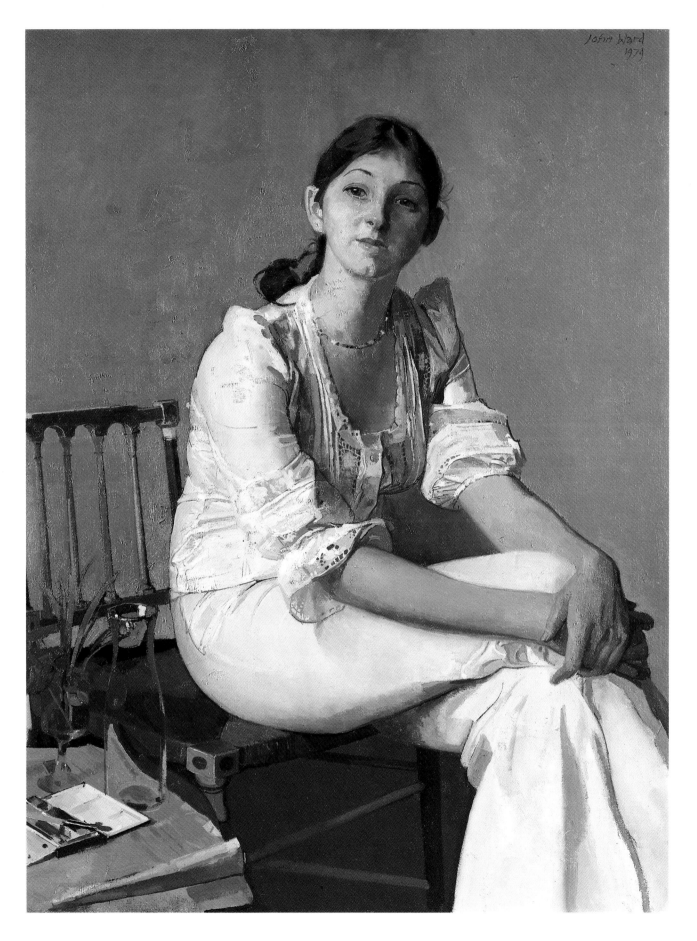

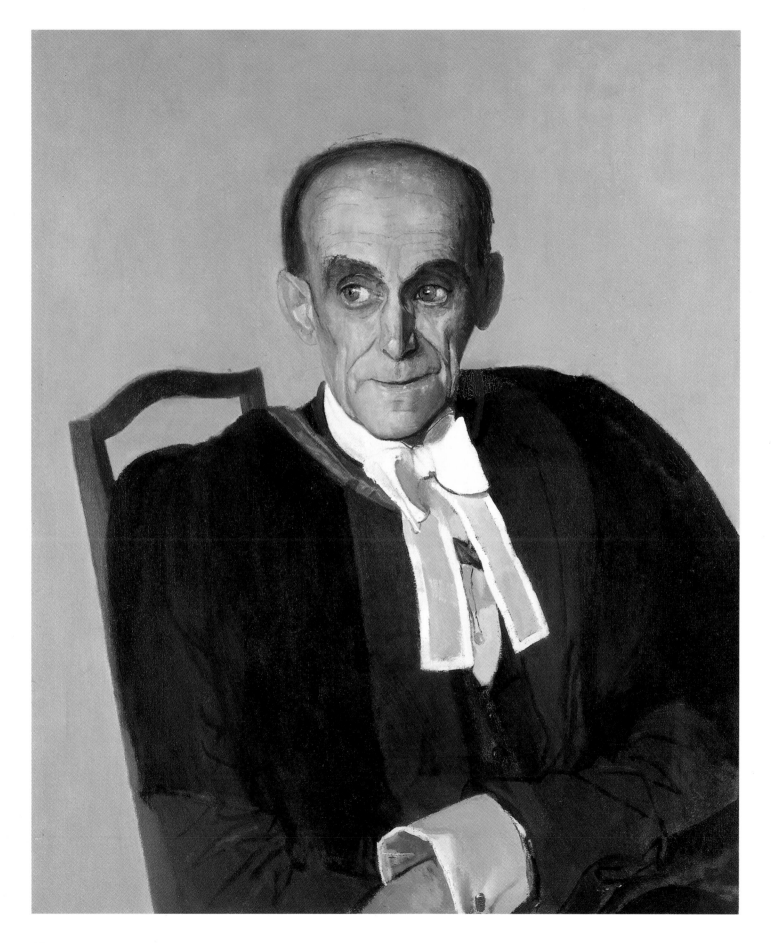

44

(Opposite)
**Sir Arthur Norrington, President of Trinity College, Oxford**
Oil on canvas, 30 x 25ins. 1967
My first job at this College was to draw a formidable old character, a College servant called Mr Cadman. Sir Colin Anderson, one-time chairman of the Tate Gallery, got me the job. This drawing went well, and so the College, having looked me over, commissioned me to paint the president.

A wonderful head, painted at Trinity in what had been the cook's bedroom. I remember having some difficulty with those fine eyes, and taking the painting out onto the staircase where I could get away from the work and my sitter to adjust the drawing. The starched cuff I hoped would indicate the touch of dandyism which so enhanced the appearance of this distinguished man.

**Gerald Norden with Still Life**
Oil on canvas, 24 x 20ins. 1981
This was done to get my eye in for a large portrait of Lord Denning. Gerald Norden very kindly posed and, with so fine a subject, going on and embroidering was irresistible. Gerald is a fine painter with a passion for still life, which he paints with amazing skill.

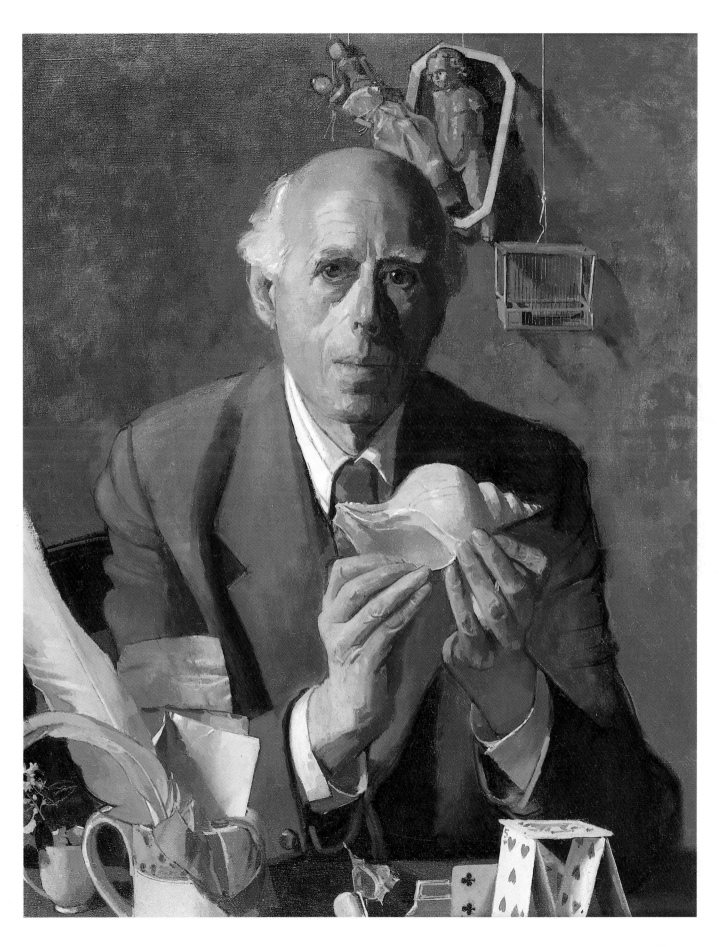

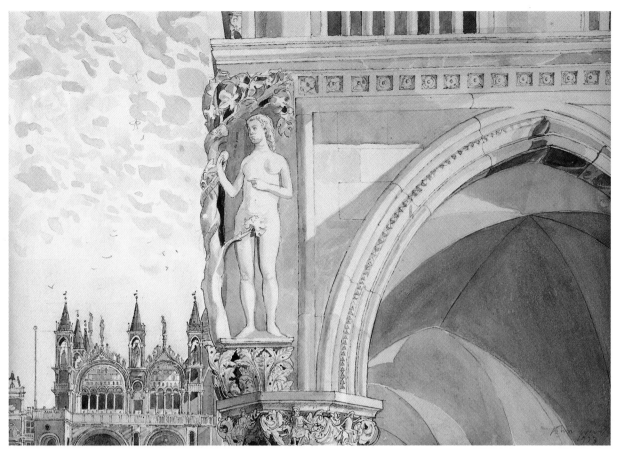

**Eve in the Piazzetta, Venice**
Pencil and watercolour, 12½ x 18ins. 1973
Done at the same time as the Noah, and I had to stand to draw. The really difficult part was the great arch – to keep the proportion of the mouldings and the power taxed my concentration, but then the joy of nibbling away at the end of St Mark's and all the ornament of the capital . . .
Eve, with the lovely awkwardness of the great Van Eyck altarpiece.

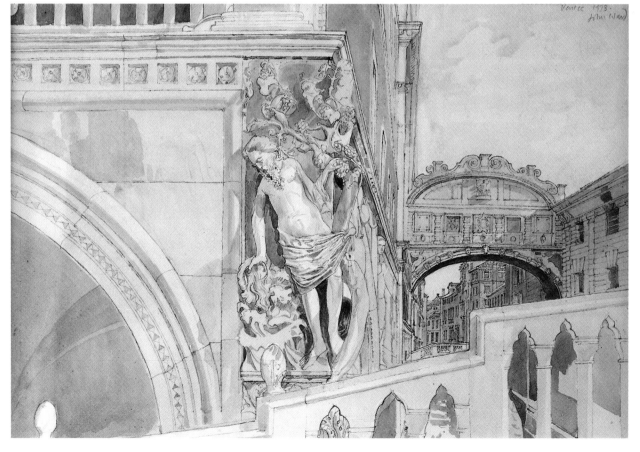

**The Drunken Noah; Venice**
Pencil and watercolour, 12¼ x 18ins. 1973
One of Venice's most touching sculptures. I had passed it so often, and then on one visit I settled down to record the juxtaposition of sculpture and mouldings and bridge and arch. It was done in the early mornings over many days, since most of the time the bridge I worked from seethes with people.

46

### View of the Piazza from the Balcony of the Doge's Palace
Pencil and watercolour, 12¼ x 18ins. 1973

On one of my visits to Venice I managed to get permission to draw from the balcony of the Doge's Palace – a viewpoint I had long coveted. Much labour, but I find that all the shapes that this marvellous building provides make me sharpen my pencil in the hope of capturing the vitality of the architecture.

The fullness of every arch and piercing had to be realised, and the whirligig of perspective on the right. Beyond, everything, even the Sunday flag which is such a gift of colour and movement. A lot of repetitive work, which must be given its due, but the excitement of the chunks of difficult drawing gave me the patience to cope with this.

How glorious is the bulk of the Campanile. Every now and then a cloud of pigeons would race across my view and I sketched them in on a preliminary drawing, then sadly felt that they might be too much of a good thing – but something wonderful for another time.

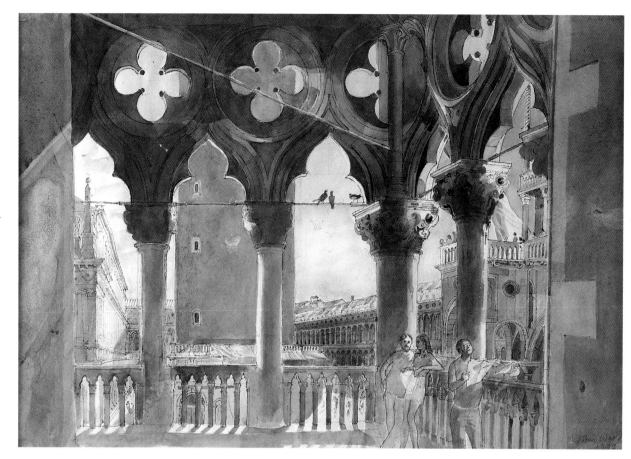

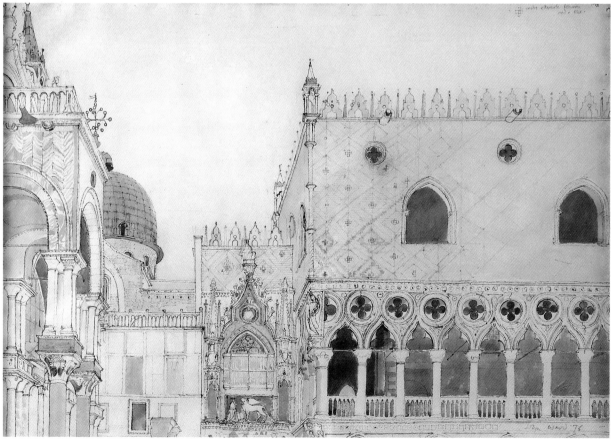

### St Mark's and the Doge's Palace
Pencil and watercolour, 13½ x 19½ins. 1975

This marriage of two of the world's greatest pieces of architecture has always attracted me. The basic simplicity of the Doge's Palace and the rioting splendour of St Mark's, with the Carta Porta snuggling between, provide a feast of drawing.

Great care was taken to make an accurate drawing. There was much rubbing out and trouble counting the bricks on the Doge's Palace to get the diaper pattern right, using dividers to plot the arches, and the drawing of the circular mouldings taxed my patience – all the mouldings so robust and the effect so delicate.

This subject is one I could go back to again and again. As in drawing from the nude, there is no end to the problems and the wonders. I had to sit on a public bench for this drawing, which also needed much patience and tact. But the tourists who sink onto the benches are seldom left in peace for long. Prodded by their tour leaders, they groan and pass on. Luckily no fellow draughtsmen were interested in my perch.

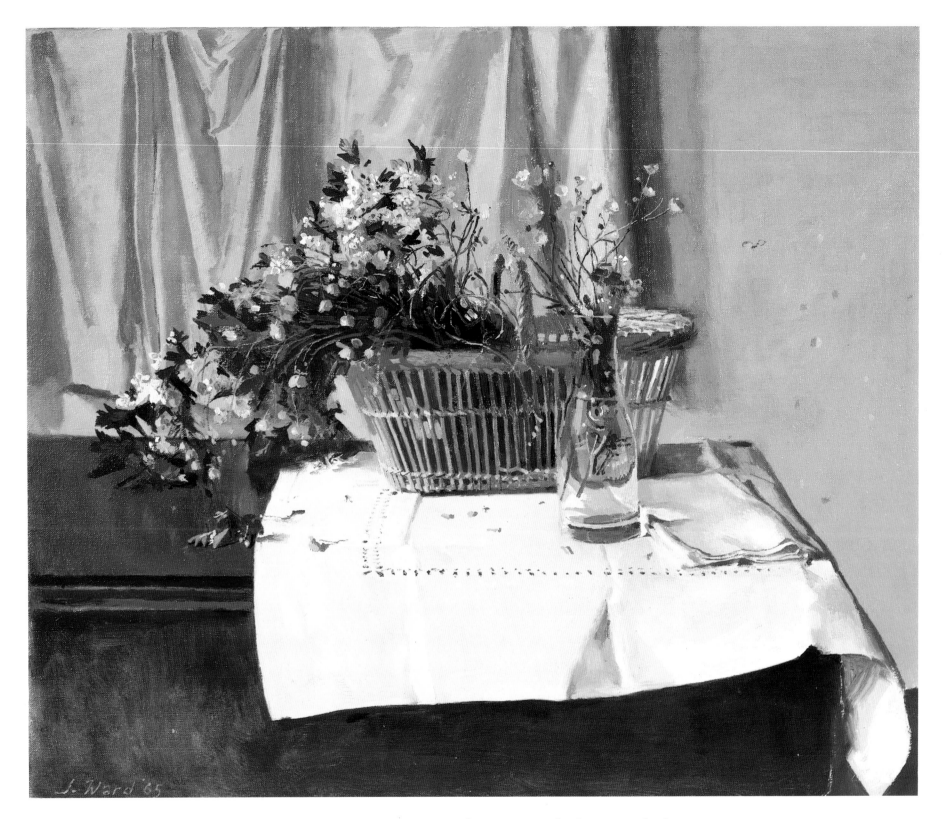

**Still Life with Buttercups and May**

Oil on canvas, 20 x 24ins. 1965

Our garden abounds with nettles and buttercups. The abundance of buttercups is irresistible. So often the proportion of colour to green stem and leaf is better in wild flowers than in the cultivated species. I paused for a moment over the may, remembering my mother's superstition about this lovely blossom – 'Never indoors, my dear, bad luck.' I am highly superstitious about painting, keeping to favourite drawing boards, pencils and old tin boxes. Scraps which have seen me through many jobs.

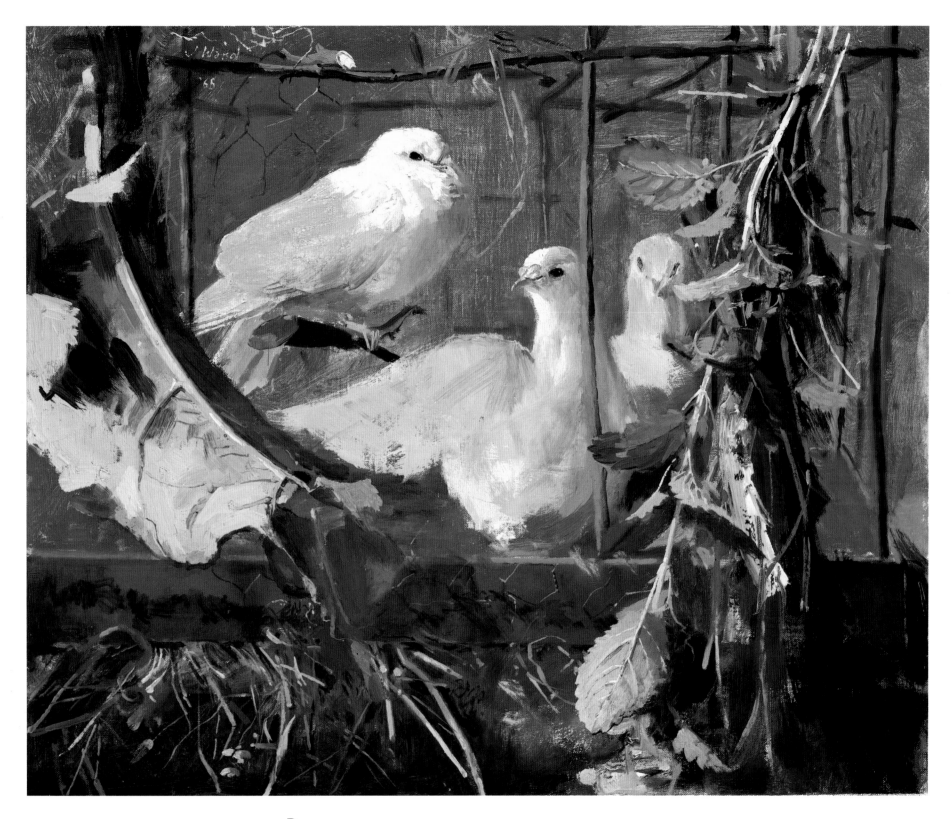

**Doves**
Oil on canvas, 19½in x 24ins. 1965
*Doves* was painted just after the *Buttercups* still life. A friend gave me the doves and a neighbour knocked up the cage, painting it that vile garden green which turned out to be so good to paint. The vegetation was done at great speed. I have always loved the pink of pigeons' feet, but they are difficult birds to draw. Caging them made for speedy work and within a day they were free again. Colin George, a most faithful patron, bought the picture on sight. Lovely!

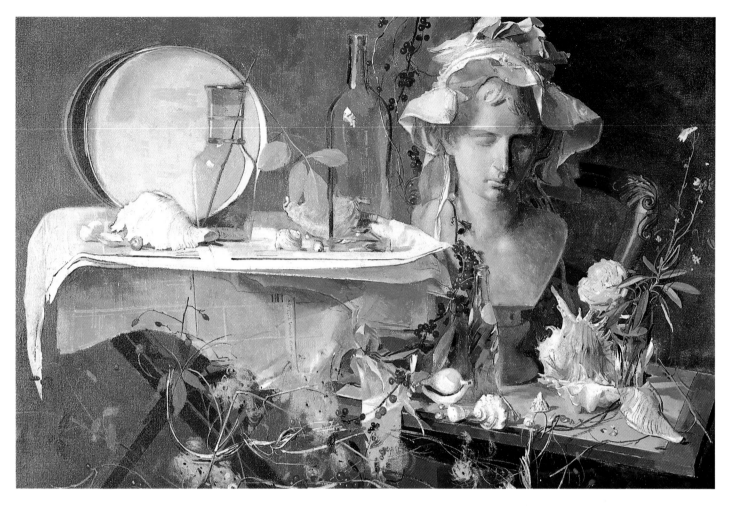

### Still Life with Plaster Bust

Oil on canvas, 20 x 30ins. c.1967

This began with a huge round shallow cheesebox retrieved from the dustbin of Paxton's in Jermyn Street. The mob-cap was found in France and beautifully laundered by my wife; and newspaper is ever a favourite subject. It crumples so grandly, and there is always such extravagance in its abundance.

Like so many of my pictures, this work is sheer indulgence, a gathering-together of things I love drawing and painting. The main colour scheme is of different whites, pale straw and cool greens, with the vivid necklace of red bryony berries and one pink carnation. A feast of drawing and contrasting shapes.

(Opposite)
### The Twins and Jack in the Studio

Oil on canvas, 29¾ x 40ins. 1964

I always felt that I never sufficiently exploited the twins, Celia and Charlotte, and the fact that they are identical, and from an early age sat well; but here I couldn't resist their check dresses – and Jack was around, so he appears as well. The other objects in the picture are favourite things that I have collected from Rome and junk shops. This, I decided, should be my diploma picture, and it was presented to the Royal Academy in 1966.

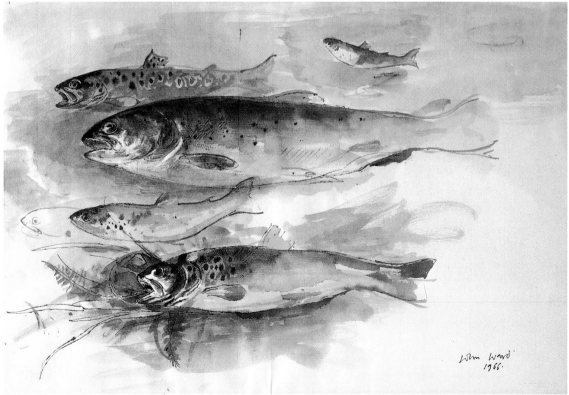

### Fish

Pen, ink and watercolour, 12 x 18ins. 1966

What skills painting fish calls for! Such management to have the fish fresh, to catch the glorious gleam and colour which quickly fade. How entrancing the subtle construction around the head and gills, such a combination of strength and delicacy.

And all fishy backgrounds are good. The rocks and weeds and shells of sea fish, and the grass and river plants of the freshwater variety. Nets and fishing rods, reels and hands and jam jars, the refraction of limbs plunged into water. A subject I dearly wish that I had exploited more. Many plans were made for rockpool pictures, but I never quite executed them. Perhaps next year!

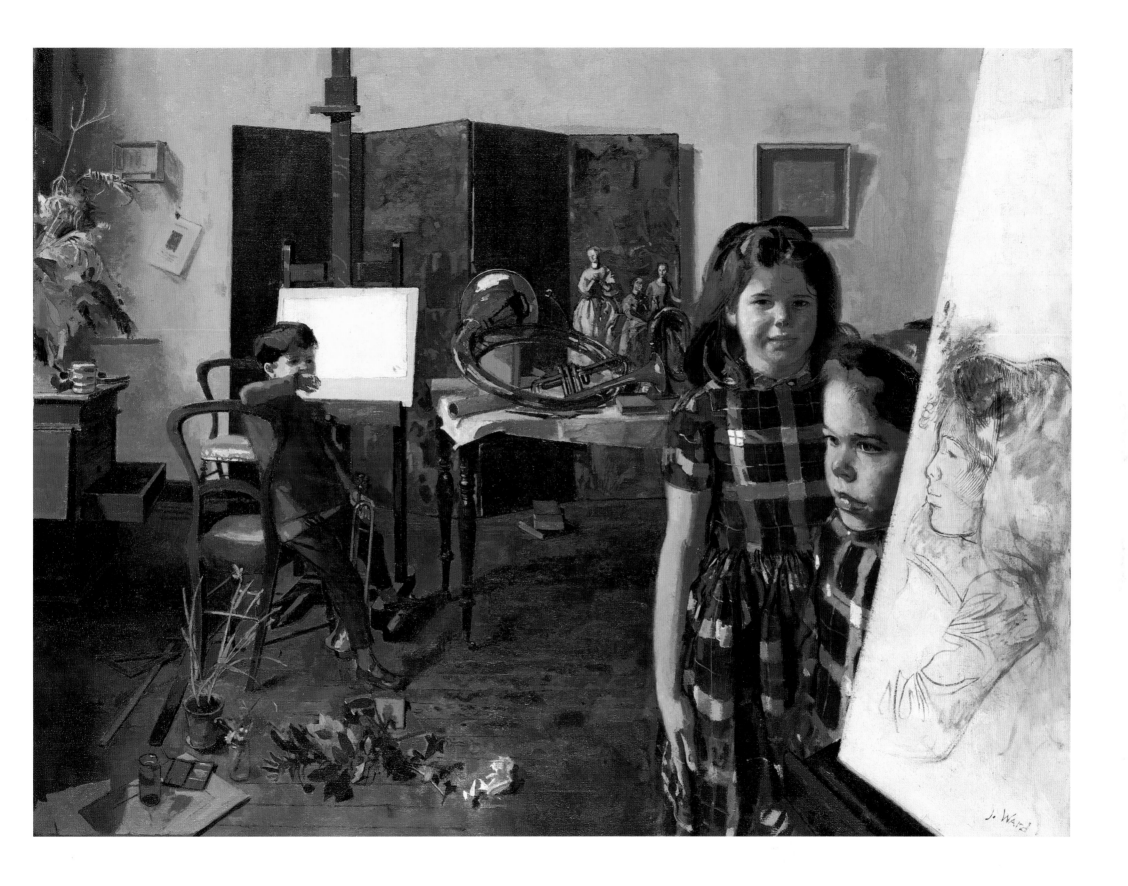

51

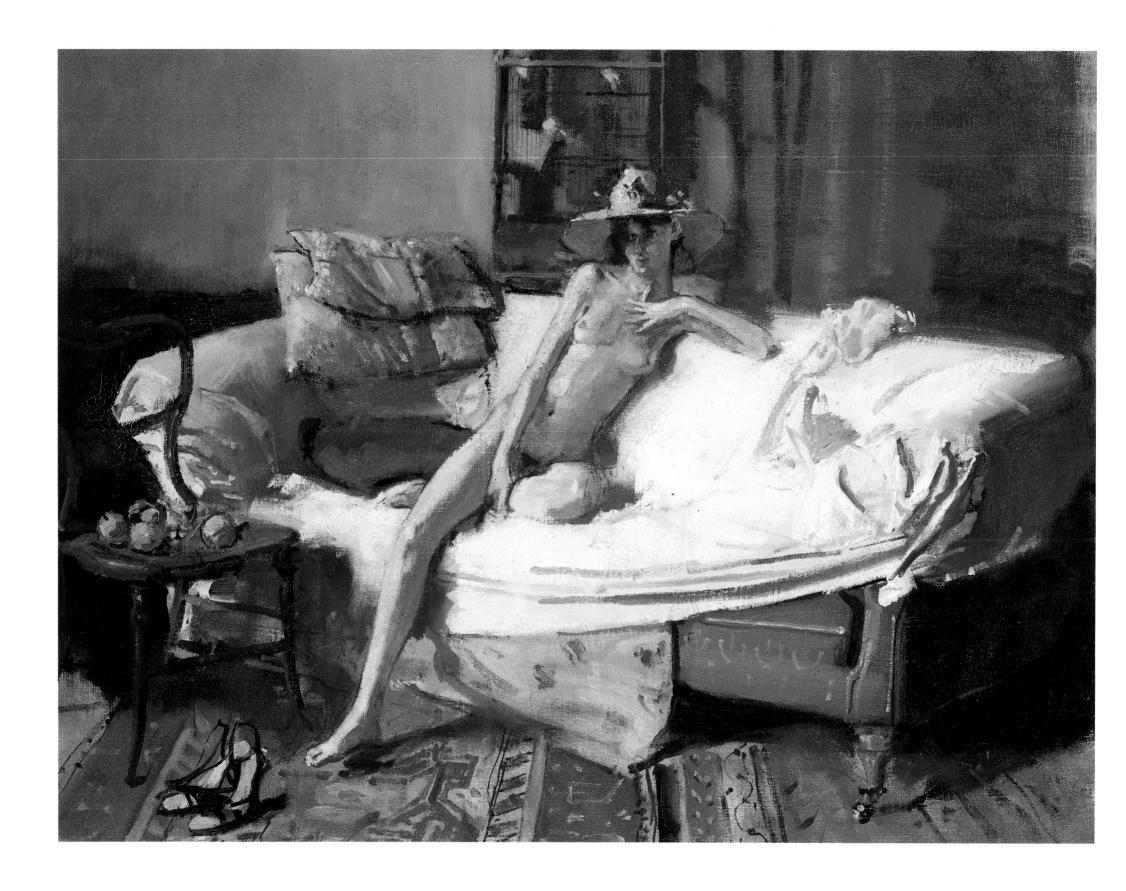

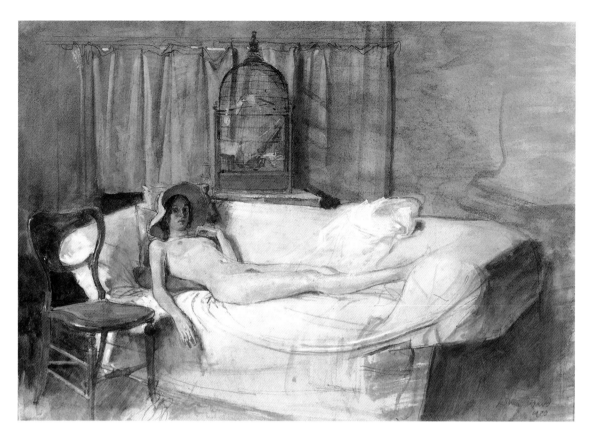

(Opposite)

**Georgina – Nude on a Sofa**

Oil on canvas, 18 x 24ins. 1980

This ravishing young model was brought to the studio by a friend and fellow painter, and for about a week we painted furiously. This painting was done at great speed; one of those rare moments when whatever there was around fitted and added to the loveliness of the subject.

This being her first job, her appetite for posing had not been blunted by the weary, dreary hours of art school work. She could not move without inspiring us to work faster and more intensely.

And it was summertime, and warm. Women are best painted either in hot weather, when sitting or lying around comes naturally, or wrapped in furs with bright frost outside.

If only, before the days of labour in life rooms, students could see naked people splashing and strolling and sun-bathing, as they do along the riversides in southern France, their attitude towards the nude, this marvellous everlasting subject, might be more energetic and cheerful.

Foolishly, I had this tattered old sofa recovered, and I lost the magical colour of the faded ancient green. I have never seen a faded colour that wasn't beautiful.

**Watercolour – Nude on a Sofa**

Pencil and watercolour, 20 x 24ins. 1980

This pose of Georgina was set by Michael Reynolds, who was painting with me. I wasn't madly keen on it, yet when I got down to drawing I liked it so much that I made this watercolour and a drawing of the subject.

**Nude in a Rocking-chair**

Pencil and watercolour, 12½ x 18½ins. 1976

A careful study for a painting which went to Japan. Obviously I yet again found the objects on my studio window-sill too much of a temptation, particularly the relationship between the honesty and the geometric form. In the painting I changed the square table in the left foreground for a circular one. I placed a piece of glass over the picture, painting the round shape on it before altering the composition.

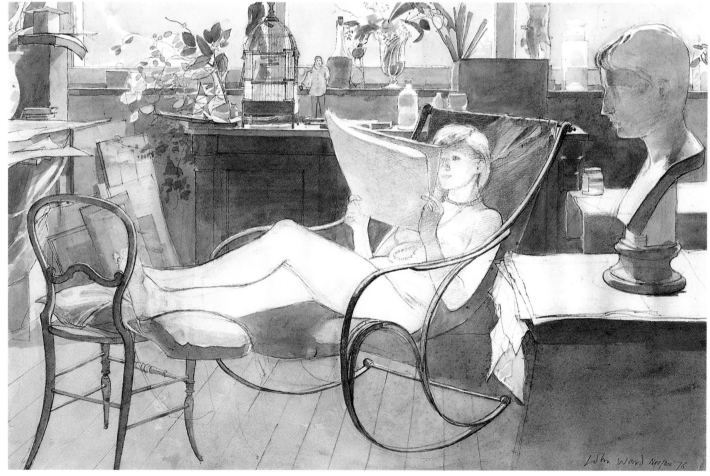

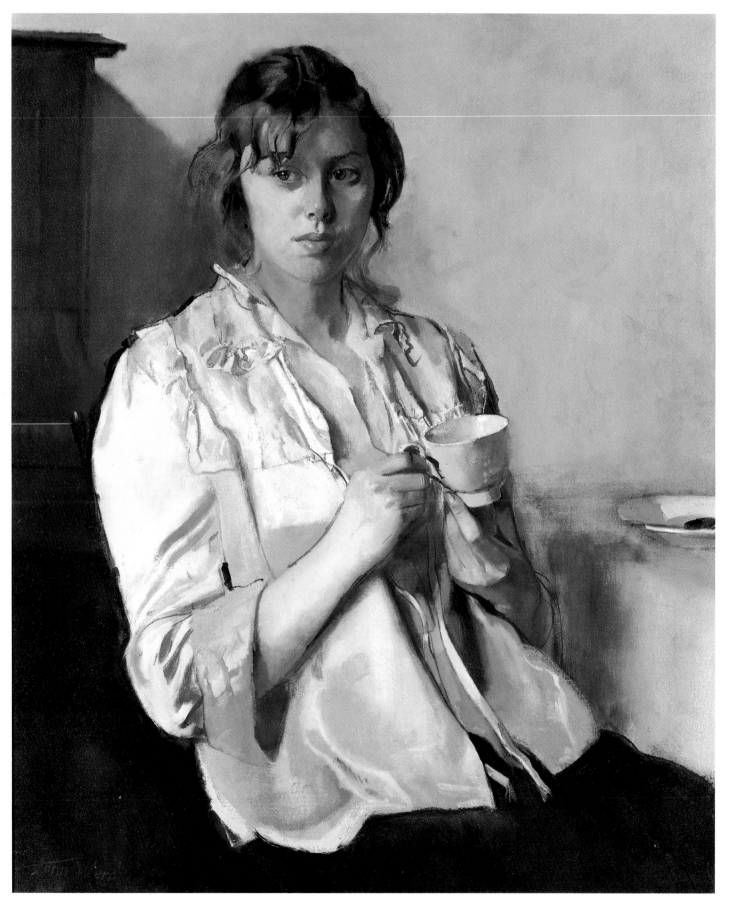

### Stephanie with a Cup

Oil on canvas, 31 x 26ins. 1979

I met this girl when she was a student at Canterbury College of Art. She came into the print room where I was trying to make an etching and I was immediately struck by her looks, and with a little persuasion she came and sat for me. I don't think she was ever particularly interested in what I did, but she found sitting easy, and the more I painted her the more wonderful a subject she became.

In this case I was so struck by her get-up, the jacket she had found in a junk shop, that I made a careful charcoal study. In the study the arms were different. For the life of me I cannot remember why the other hand was brought up, but I think the hands together gave some better and more entertaining grouping than in the initial drawing. I think this picture is one of the best I ever painted.

**Stephanie in Profile**
Oil on canvas, 29 x 24ins. 1979
Once more this beautiful model, and for the first time I included myself in a composition. The girdle came from Rome, an extravagant length of beautiful ribbon in those glorious Italian national colours.

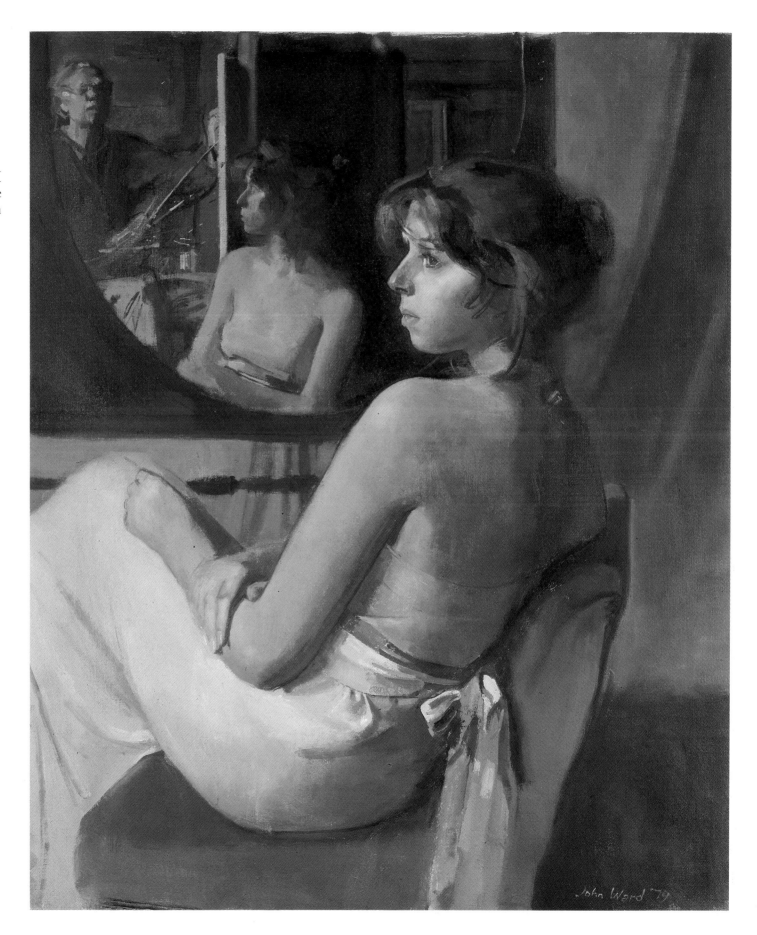

## A Meeting of the Society of Dilettanti at the St James's Club in 1973

Oil on canvas; two canvases, each 50 x 40ins, in one frame. 1976

Diplomacy is all when it comes to arranging who goes where in a picture. In the Dilettanti one had a group of some of the most eminent men in the museum and art world, and I decided straightaway to ask no one's help on who should go in front and who at the back.

I thought that if I were wrong they could accuse me of ignorance, but if I had taken advice and was still wrong I would have another set of complications altogether. I had to stick to my own inclinations. You cannot impose your will in such a way that people bridle; you have to assume that it is the most natural thing in the world that A goes here and B goes there.

And with one exception, where the poor man's head got so squeezed it was hardly there at all, it went well.

A moment did come when, with the two canvases that make up the conversation piece in my studio, and the design well arranged, I thought that I must have more movement in the foreground. Then I realised that the most diplomatic thing would be to choose the youngest man and put him bang in the foreground.

And that is why Lord Gowrie most happily makes that gorgeous great hump of whiteness at the front.

Kenneth Clark: a study in 1976 for the Dilettanti group. Drawn at Saltwood in black and white chalk, and reproduced in the magazine *Apollo* to illustrate his obituary. (12¼ x 15½ins)

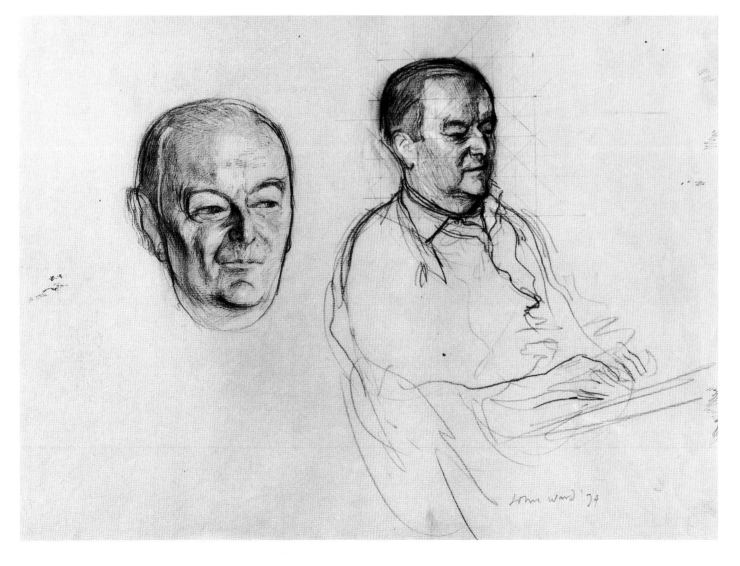

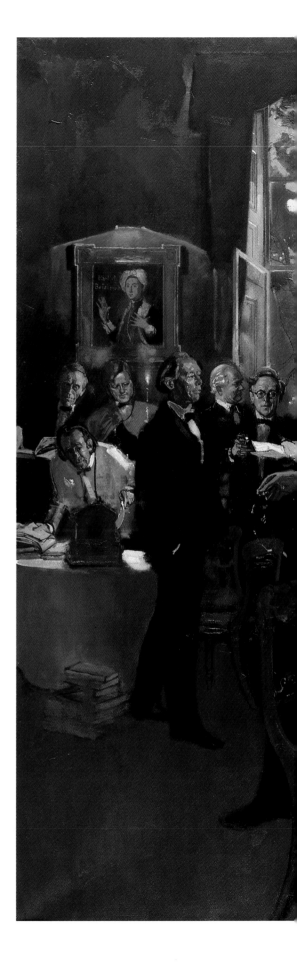

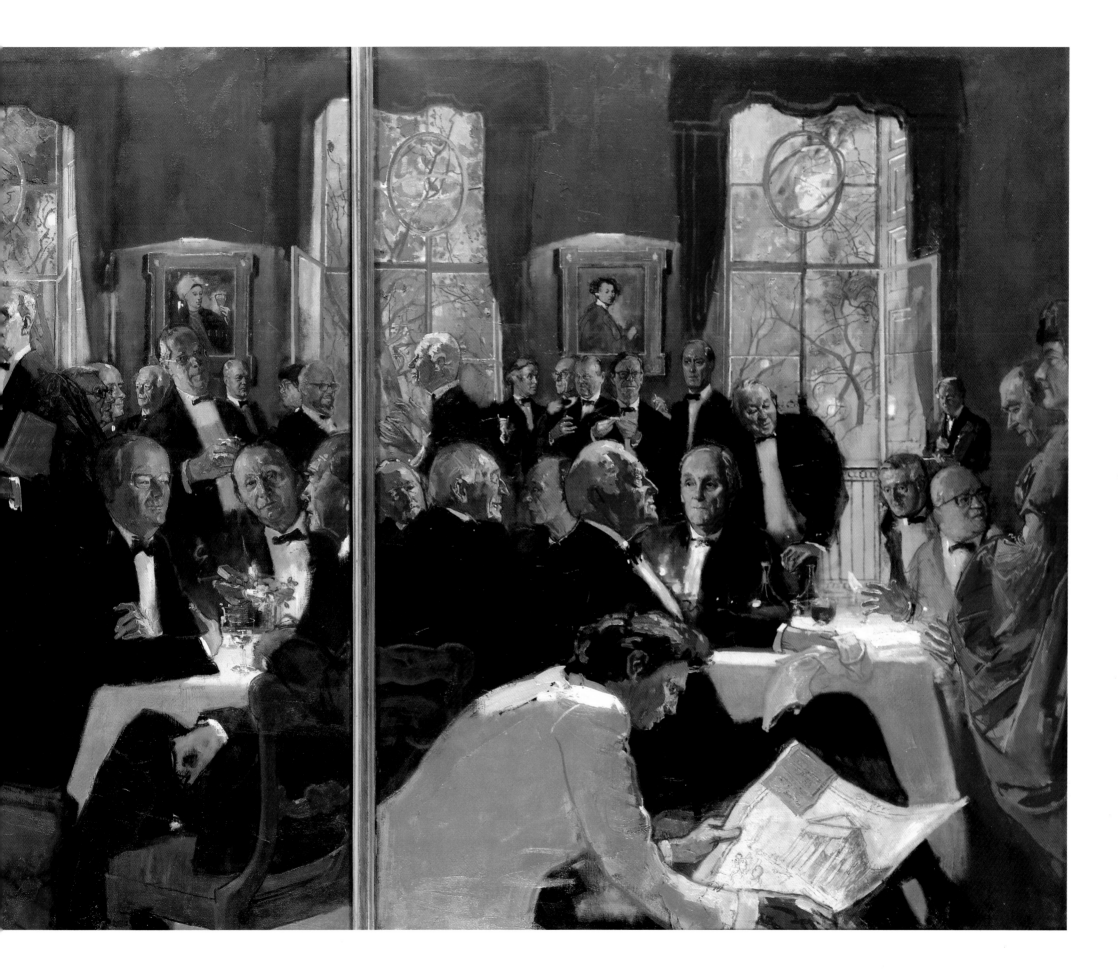

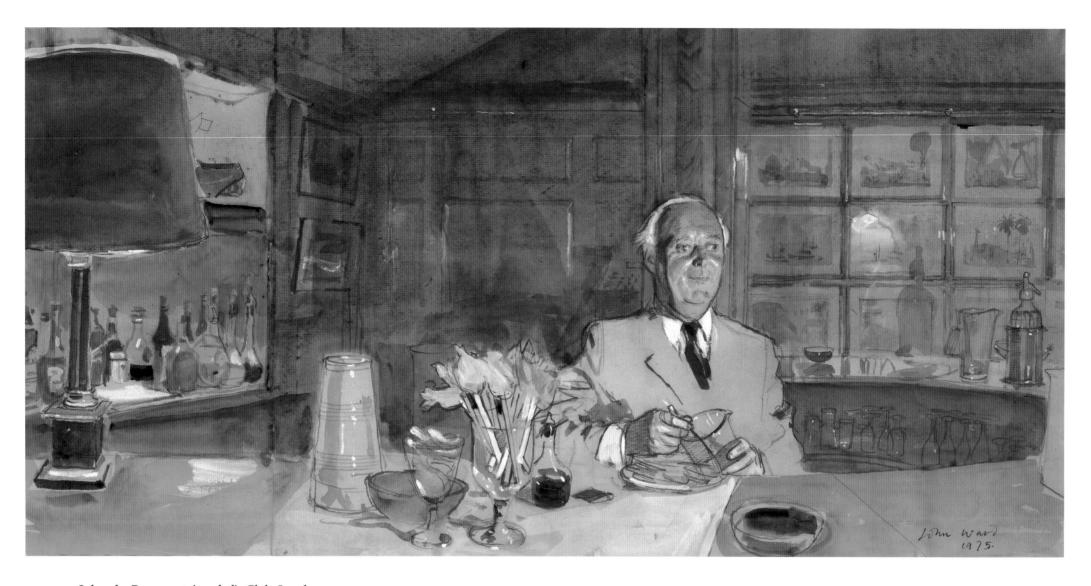

**John, the Barman at Annabel's Club, London**
Pen, ink and watercolour, 12 x 24ins. 1975
This is one of my first drawings at Annabel's, using
pen, pencil and watercolour on a toned brown paper.
All the Annabel's pictures were made in artificial light,
which made for good tonal contrasts. John, a much-
loved man, was a good sitter and the to-ing and fro-ing
of the other members of the staff made for a lively
atmosphere. There is always good still life in a bar, and
the bank of pictures behind John reflects usefully the
light which was on my work.

(Opposite)
**Landscape from Alfred Deller's House, Provence**
Oil on board, 10½ x 14ins. 1976
A tiny picture painted while staying in Alfred Deller's
house. Painted early morning on hardboard. An
attempt to link in rhythm the raggle-taggle fore-
ground, trees, roofs and terracing. I have always found
landscape difficult, requiring intense observation to
get the drawing right, and here to register the bony
structure of this rocky landscape. For me *the* great
landscape, to which I go for inspiration, is Millet's
*Spring* – a very great work, so strong yet containing
such tenderness. I have always been devoted to his
landscape drawings. No one captures the structure of
landfall and tree better.

The other works which I find inspiring are the small
landscapes of Ford Madox Brown, and I believe his
journals telling of his persistence over a painting
should be read every morning as the daily lesson.

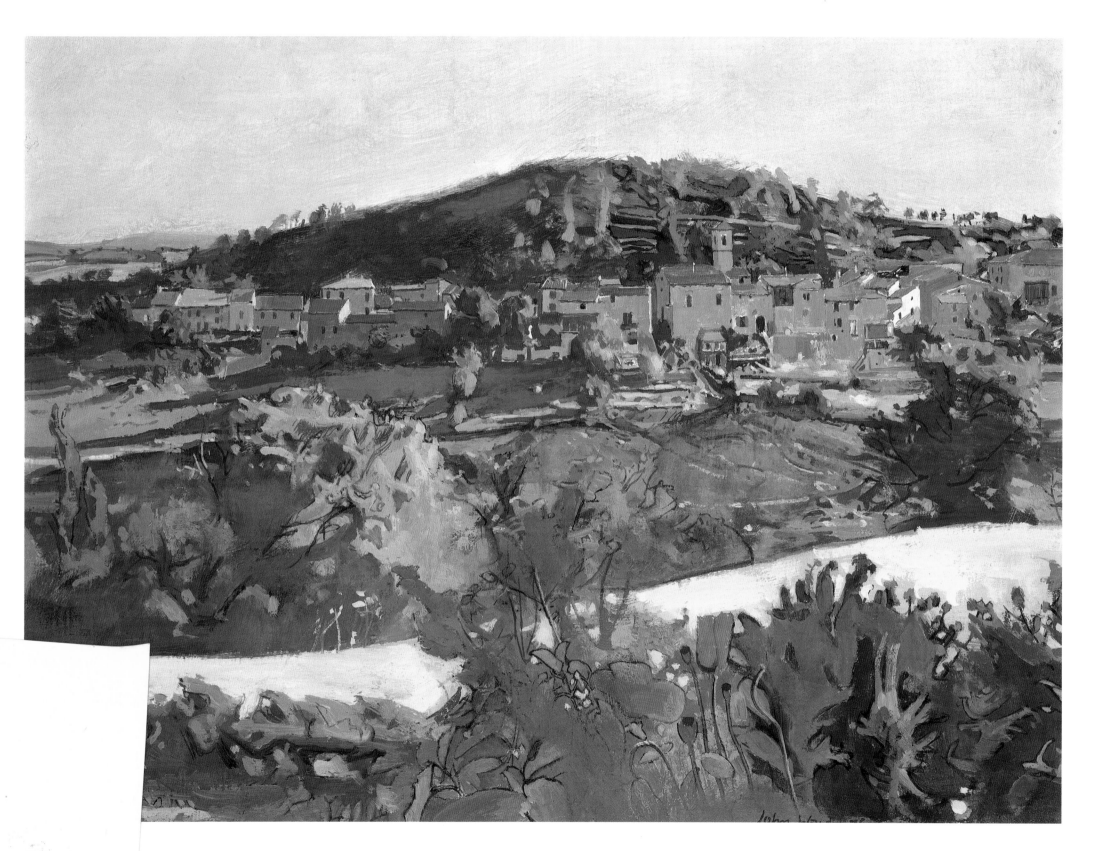

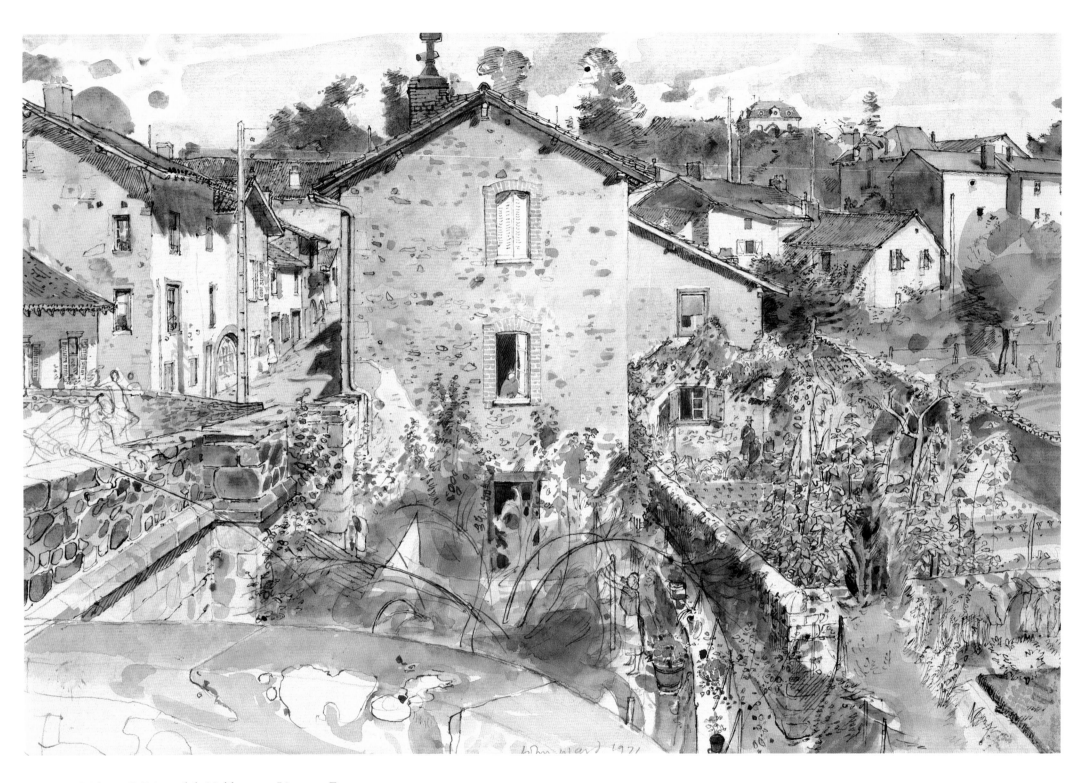

**Bridge at St Léonard de Noblat, near Limoges, France**
Pen, ink and watercolour, c.12 x 18ins. 1971
A camping holiday work. Weeks of fine weather and a
perfect French subject. Years later I went back to
draw it again, but when I was able to compare the two
works I found that I'd moved back a bay in the bridge.

## Views of Siena

Both pencil and watercolour, c.13 x 22ins. 1982

For three weeks I sat with the pigeons – anxiously with those perched above, on the best of terms with those who pecked around my feet. The stall and cart were regular sitters, the canopy of the stall changing slightly, but ever good in shape. The dip and curve of the Campo in simple contrast to the splendour of the Palazzo. The rooftops a constant mixture of every cubist shape, which the light played upon, highlighting and enlarging and then diminishing the shapes. The figures pounced upon and sketched at speed, and the lovely litter of stall produce joining the disorder of humanity. One of those drawings that grew, and was wonderful to do.

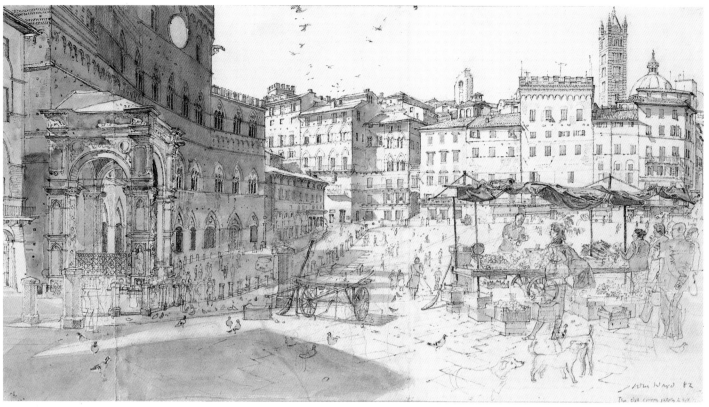

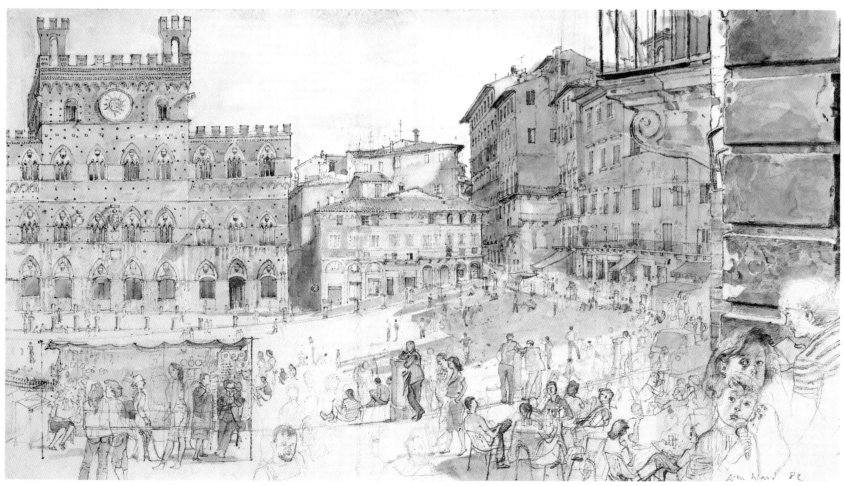

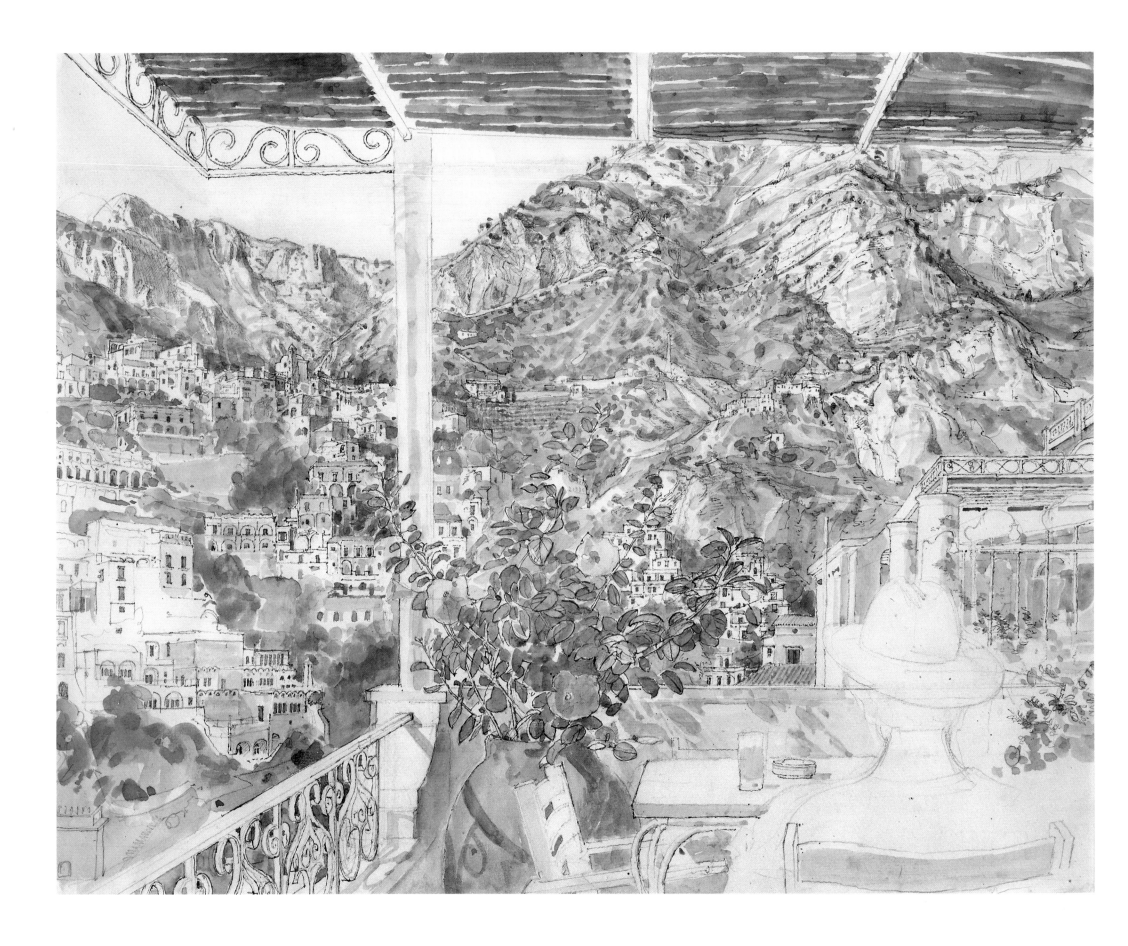

62

**Chef – Positano**

Chalk and watercolour, 22½ x 29½ins. 1987

A Neapolitan of great presence. I was so impressed by him that I drew in the head as rapidly as possible, so that I could hold his interest – once you can demonstrate that you are not wasting time people will be more patient about posing. The display of fish was a joy to work on. The store and its brickwork were tedious to draw, requiring great concentration. It is the boring parts of a work which need fresh concentration to set off the more exciting parts. A portrait-painting friend used to say anyone can paint a head, but it takes skill and gifts to paint a jacket.

(Opposite)

**Positano**

Pen, ink and watercolour, 14½ x 18½ins. 1987

Crumpled rocks, a bamboo shelter, and a slice of Positano picked and pecked at on warm afternoons.

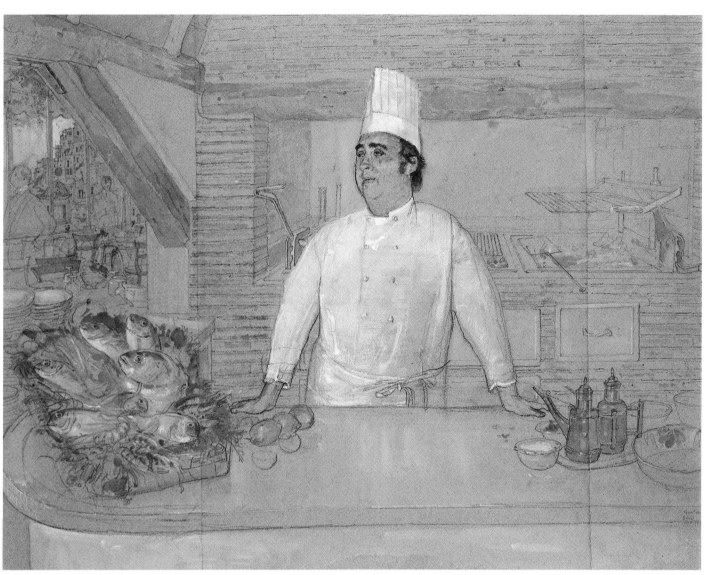

**Maria Grazie – A Letter to Mark Birley**

Pen, ink and watercolour, 9 x 12½ins. 1987

For some reason or another I have always been attracted by lemons. Lemon trees I find very beautiful; the leaf, both in shape and colour, ravishing. But also the fruit, sliced in gin and tonic, distorted, refracted by the glass. Here I had a special lemon liqueur at the end of a good meal in a village some miles from Positano. Our host scrawled the recipe and that inspired me to turn it into a letter to Mark Birley, a good friend and patron and the owner of Annabel's, who had sent us there. One day I will paint a lemon still life.

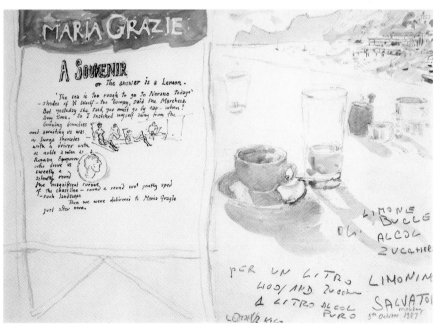

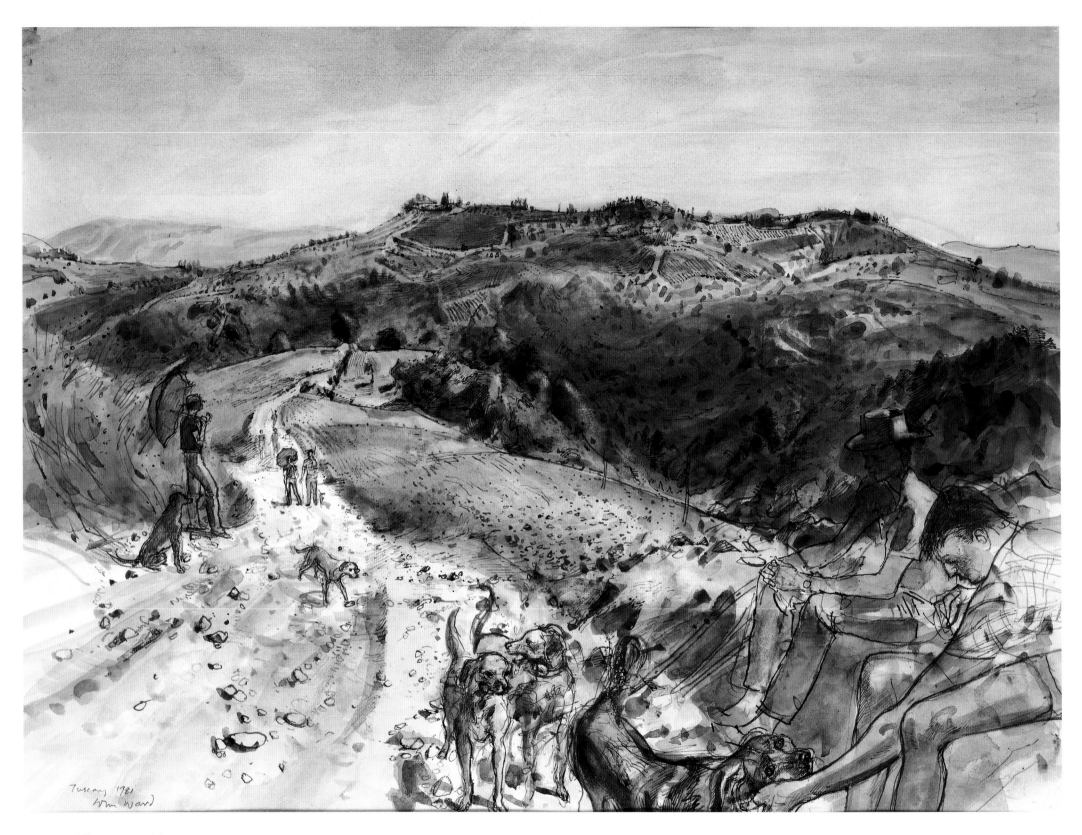

**The Hunters, Tuscany**
Pen, ink and watercolour, 18½ x 25ins. 1981
Painted in two tones, cool and warm, with a lot of pen drawing. In the foreground my son Toby and his friend Dan Pritchard, and the dogs from the farm where we were staying. The stones on the road recorded with all the care that might be lavished on a face covered with warts. How hopeless it would be to attempt to draw the jammy smoothness of tarmac.

64

**Alison in the Auvergne**
Pencil, chalk, pen, ink and watercolour, 18½ x 25ins. 1985
October, and we had wandered down through France to this region because of a chance visit on an earlier trip. An attempt to capture the vast wonder of this landscape. Begun broadly in watercolour without any preliminary drawing because I was so impressed by the magnificence of the subject, and then drawn upon. Alison, always there on these trips, and the still life of our picnics.

How I trembled lest the weather should fail. So much time demanded by the subject, and already well into October. But it was one of those times when one fine day succeeded another – I couldn't believe my luck. It would be nice to think that days spent painting landscapes were days of leisure when the vast silence of the area soothed, but no matter what the subject, panic is ever at hand. Weather, health, time, all clamour for sharp economy and planning.

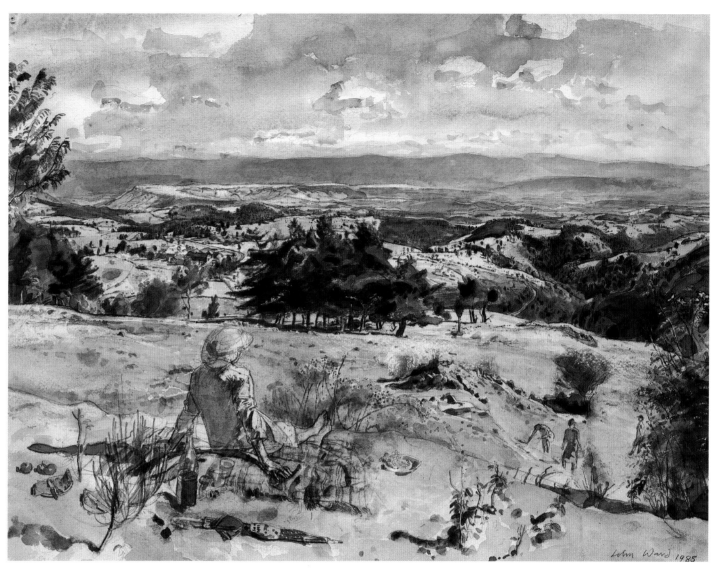

**Paintbox and Ink-pot**
Pen and ink, 6½ x 9½ins. c.1983
Now and then I return to drawing directly in pen and ink; this was a moment when that confidence returned and I happily scrawled away. Wonderful still life is always appearing at my elbow, and often I wonder whether I should forget about the lovely girl who sits and who has caused the array of clutter . . .

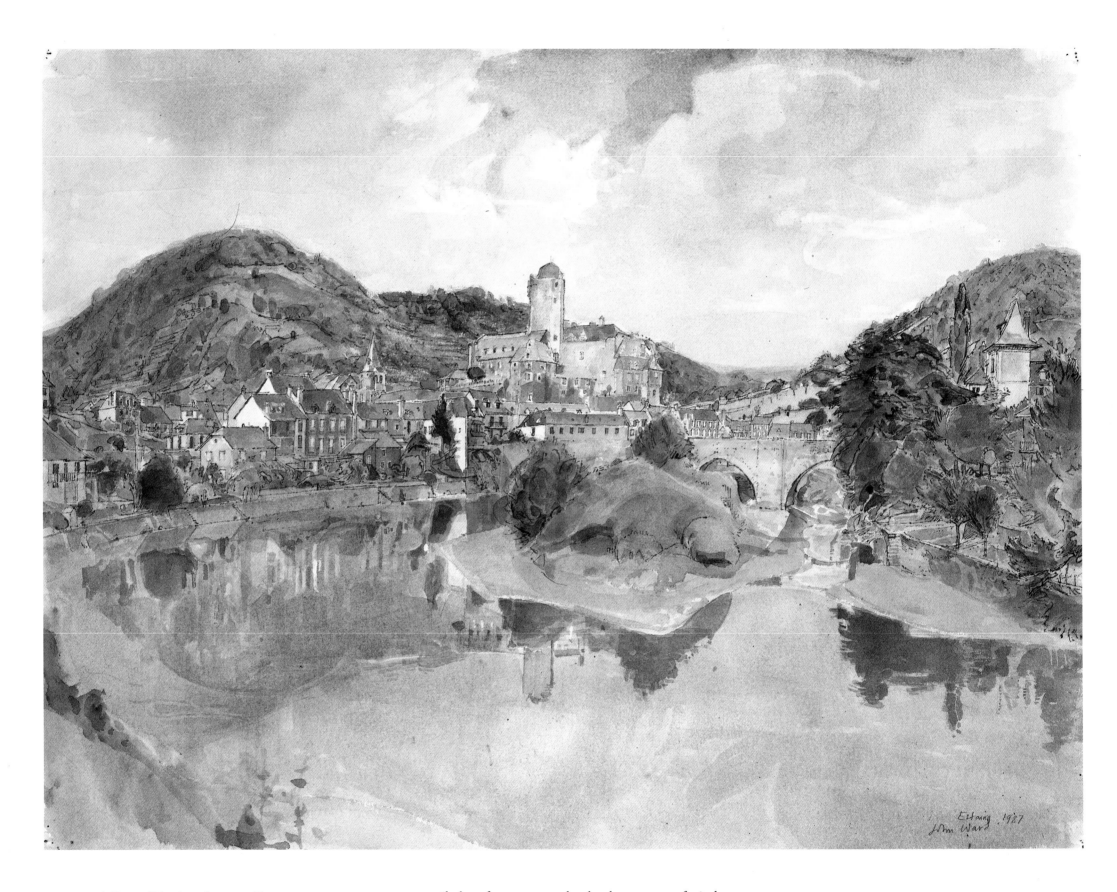

**A View of Estaing, Aveyron, France**
Pencil and watercolour, c.18 x 22ins. 1987
An obvious view, but the hills and the abrupt angular

tiled roofs strung together by the patterns of windows,
the noble castle and the breadth of the river, provided
sufficient stimulus for days of careful work.

**Studies at Moissac, France**
Pencil and watercolour, 18½ x 28ins. 1987
I found these two sculptured figures irresistible; it was a real pleasure to follow the subtle forms and the delicacy of the carving. I have always enjoyed drawing sculpture and was fortunate to grow up in a county which is particularly rich in church monuments. When I later read the novel *The Name of the Rose* I was interested to find that the author was also moved by the greatness of these two pieces. What led from the gothic ornament to the picnic basket I cannot remember, but flowers and fruit and the grotesque are often all mixed up together in Gothic art.

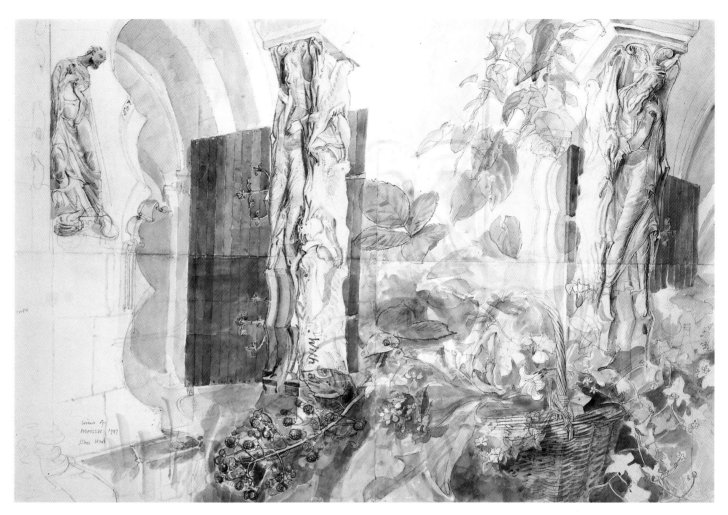

**Actors Making Up, India**
Pen, ink and watercolour, 18½ x 25ins. 1981
In 1982 I spent six weeks in India. Indian friends gained me entrance to the dressing-room where I made these studies, drawn directly in pen and ink in a great panic. The costumes were magnificent. India must surely produce the most beautiful fabrics in the world. The West Indians, too, have a rare and subtle colour sense, but when I saw the great carnival in Trinidad nearly all the costumes were made of plastic, which obliterated this sense – plastic brightness is the same worldwide, vivid and eye-catching at first, but too much of it cloys and becomes garish. This work is one of many of my pictures owned by the actress Joanna Lumley – a constant patron and supporter.

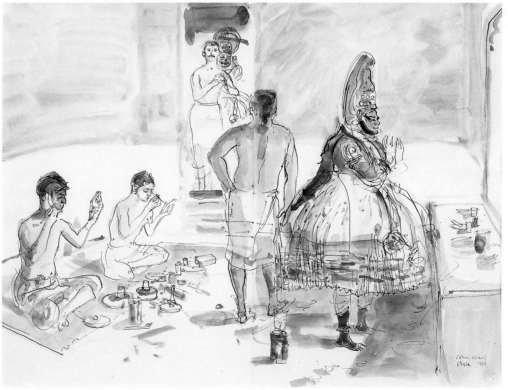

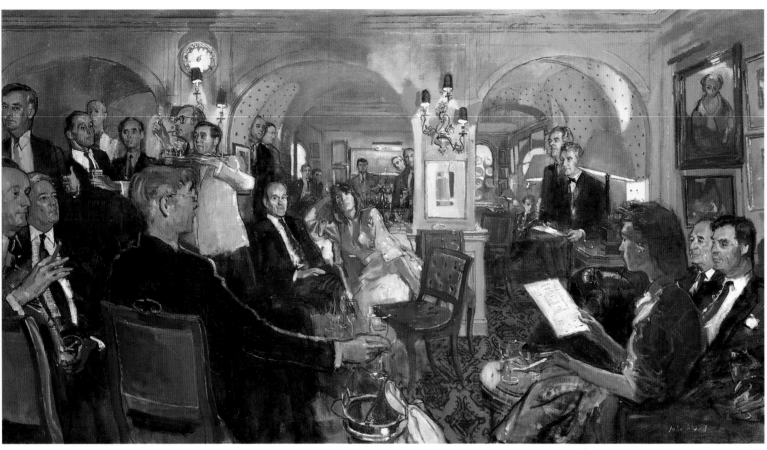

## Conversation Piece at Annabel's

Oil on canvas; three canvases in one frame, 24½ x 15½ins,
24½ x 44½ins, 24½ x 15½ins. 1985

Making watercolour portraits of the staff at this club
made me long to do a painting of its lush and crowded
rooms. Mark Birley suggested a group of the club's
founder members – quite a few portraits to dispose
amongst the alcoves and corners. I made countless
studies of the rooms, sketching in the odd person who
happened to be around to get the scale of the figures
correct.

Then I drew every member who was to be in the
picture, slowly deciding who should provide the main
props for the composition. At some point I decided
that I couldn't manage the whole lot in one picture and
that there should be a panel on either side, which
would enable me to give a little more of the rooms and
to vary the size of the heads.

All the work had to be done by artificial light – in
fact, like the cleaners of the premises, I used standard
lamps with naked light bulbs. Wonderful lighting, and
I kept thinking, why don't I use artificial light more? In
nearly every case I had two sittings, one for the draw-
ing and one for the painting.

## Study for Conversation Piece at Annabel's

Pen, ink and watercolour, ns. 1985

**The Fireplace at Annabel's**
Pencil and watercolour, c.9½ x 12½ins. c.1985
Chairs, like worn shoes, have great character, and are extremely difficult to draw correctly. In my groupings for a beginning to the picture of Annabel's I fastened on this arrangement as an obvious centre, and the rich intricacy held me completely.

One of the uses of such a study is that you can display to doubting staff and customers that perhaps the fuss caused by your presence, paints and gear may be worthwhile.

While doing this drawing and relishing copying the Landseer paintings which hung on either side of the mirror, I was reminded of a wonderful little study by David Wilkie for his picture *Rent Day* which I used to see during my RCA days in the V&A collection.

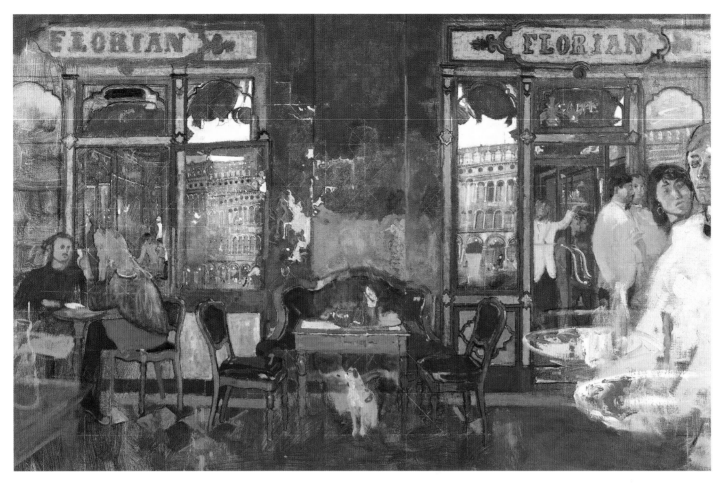

(Above)

**Florian's, Venice – Reflections**
Chalk and watercolour, c.15 x 22ins. 1987
I had a week in Venice and decided that the best use of
the time would be to do one drawing, just bang-on of
the front of the café where the windows mirrored the
Piazza. The peeling stonework, the glittering lights in-
side, the decoration on the windows, all seemed to
hold and echo the riches of the reflections. I toyed with
the idea of the passing figures being transparent,
ghostlike, the fantasy held by the simple rectangles of
the doorways and the solidity of the tables and chairs.
A picture which I didn't think about but where I just
followed a scent, which seemed to hold such lovely
prospects!

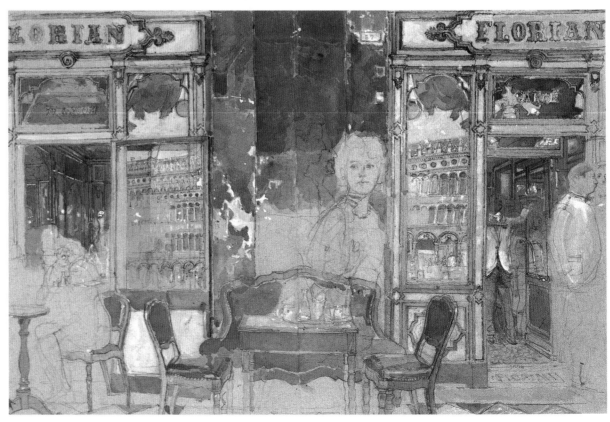

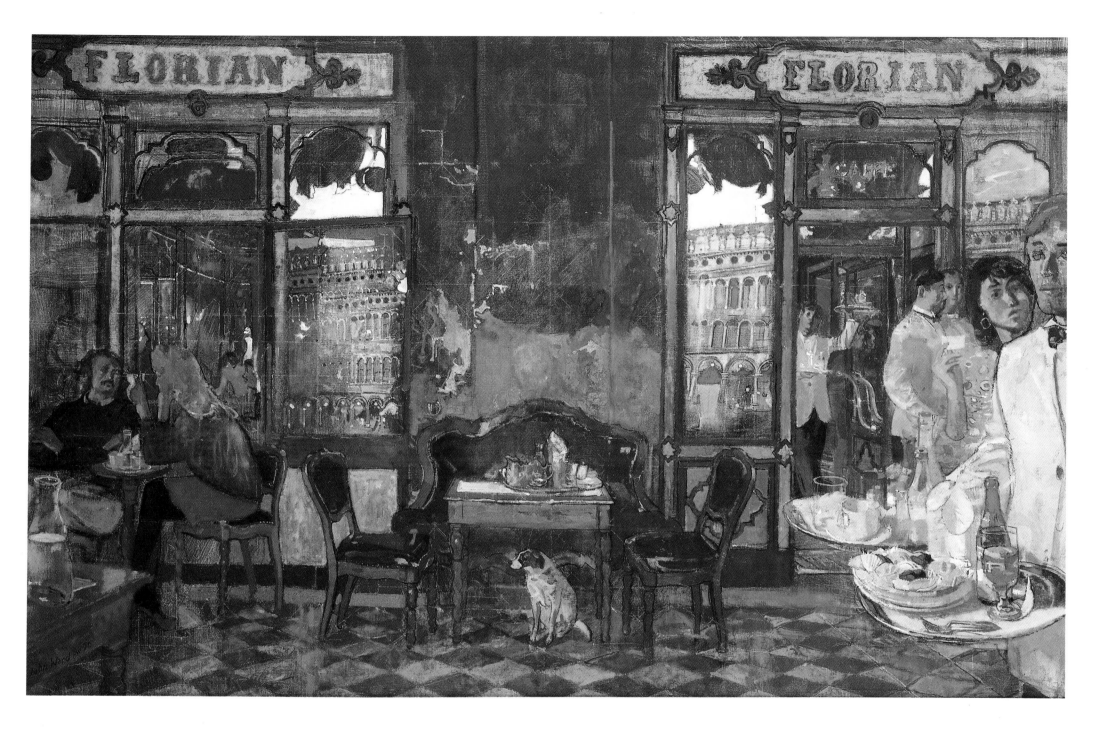

**Reflections**

Oil on canvas, 35½ x 53½ins. 1988–90

I later produced a version of the scene in oils. On the left it is shown unfinished, elaborately squared up and enlarged on either side. Works like this, after the initial stage, are best worked on for short spells only. Otherwise there arises a 'sensible' approach, and the fragile, unknowing, seeking after the picture gets lost.

As the picture developed I remembered the pink and yellow and chocolate cakes which warmed the still life on the tray. I tidied up the dog using our own dog Jiff. That fine landscape painter John Titchell watched helpfully over this work, cautioning me against too much remembering . . .

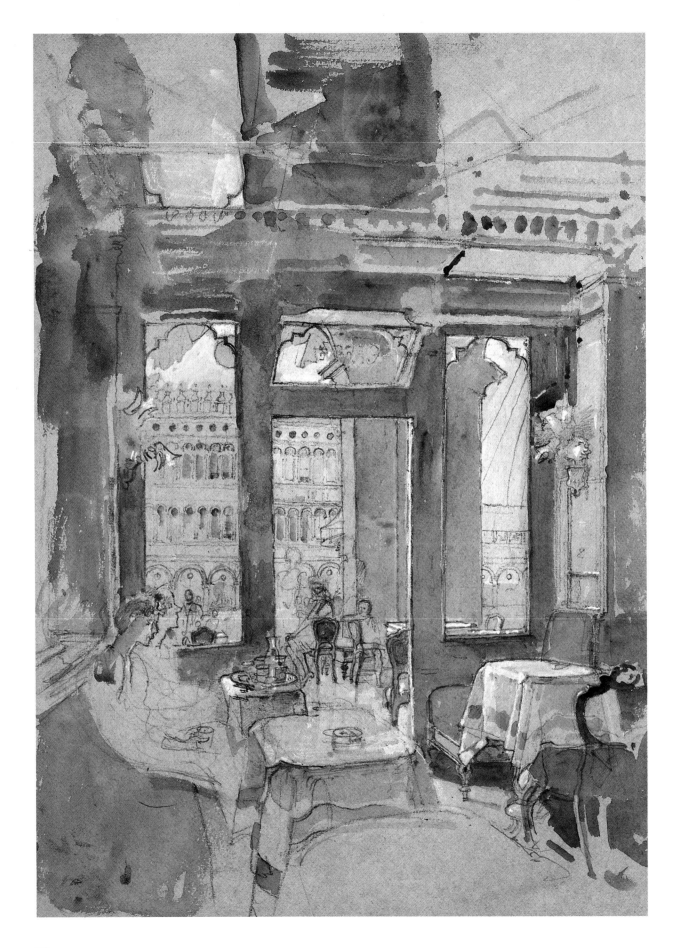

**Florian's, Looking Out Towards the Piazza**
Pencil and watercolour, c.12 x 9ins. 1984

I must have consumed a lake of coffee, but oh such good coffee, in this lovely café. But one tray of coffee and a good tip would ensure an hour or so's drawing. The smallest of drawing boards, a paintbox little larger than a matchbox, a spoonful of water and a little tin of pencils and chalks, all occupying as small a space as possible; my paintbrush a quill one with a 3in handle.

Figures come and go, hot and tired tourists who gaze around bewildered, aged Venetians with papers to read. And the light moves between pillars and canopies. On wet days, snug inside; on fine days outside, with the constant pattern of waiters and table-cloths and the characteristic chairs, and reflections and refractions bouncing everywhere and brilliant as the late afternoon sunshine hits the other side of the Piazza, all making a feast of drawing.

The wall paintings and surrounding decorations are a lesson in colour and deftness of design. The looping, energetic ornament, so swiftly and masterfully painted, requiring the utmost care if it is to be recorded correctly. But why not photograph it? Why spend a fortune on coffee and work in the confined space of seat and café table? Because it gives me great pleasure, and because before this cramped space pass heads and bodies of such rich variety, hands that wave with Italian vigour and eloquence, the purse-searching hands of the tourists, and the anxious eyes questing for the one decent loo in the Piazza.

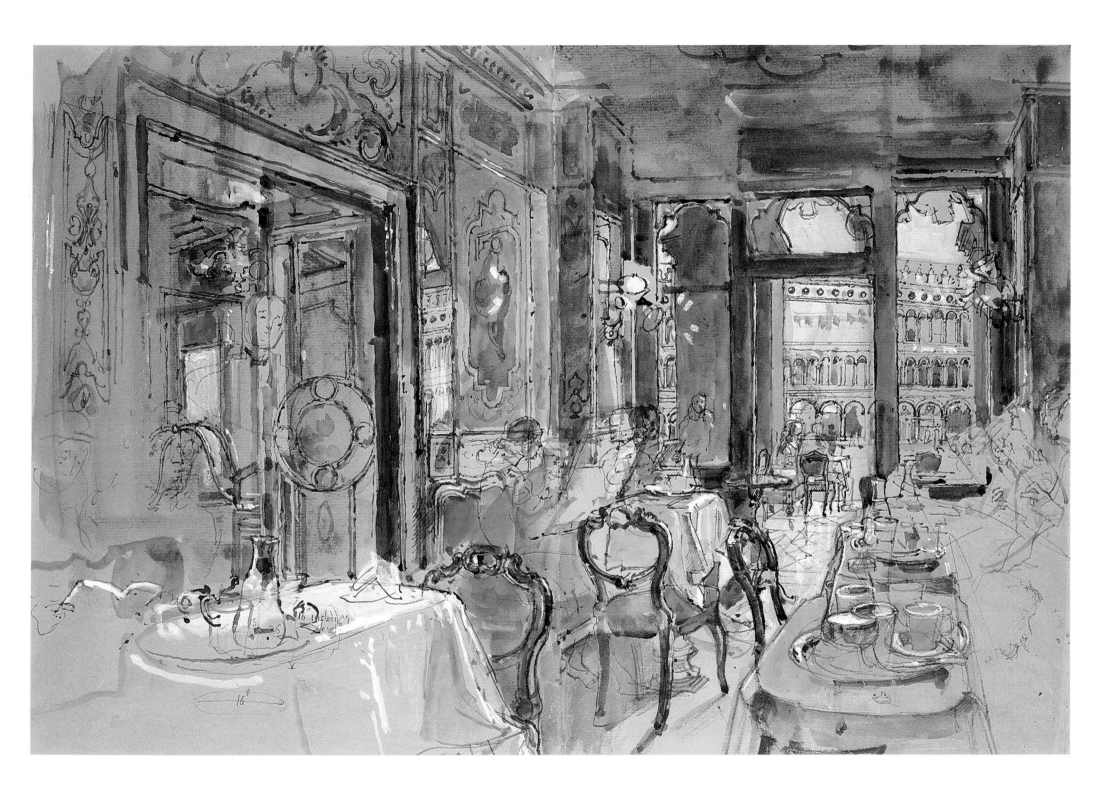

**Florian's, Interior**
Pencil and watercolour, 9 x 12ins. 1984

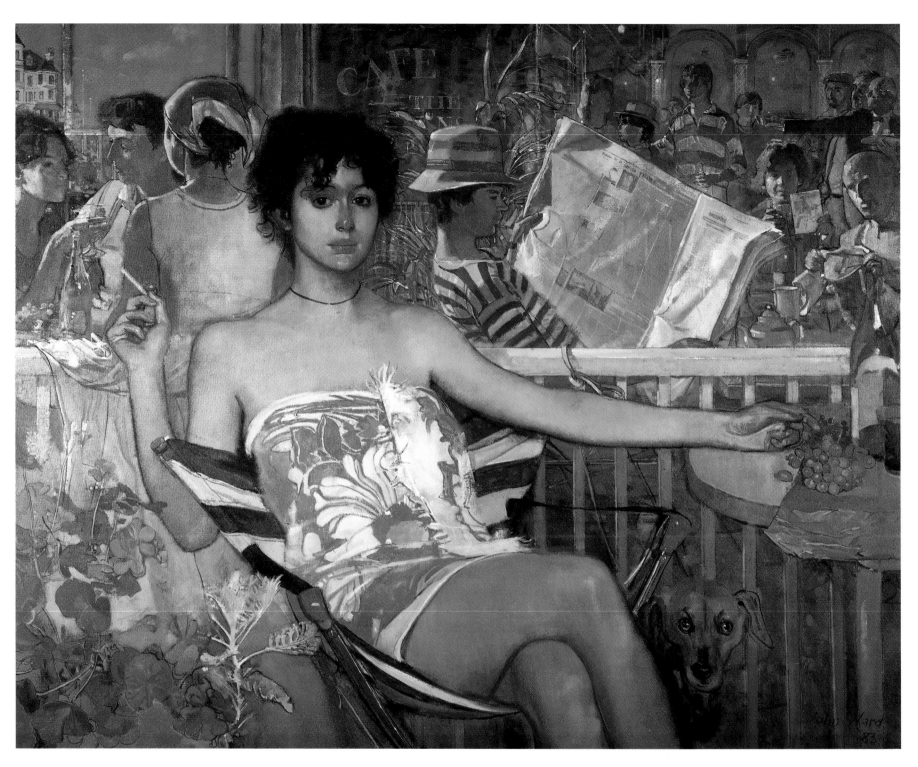

### Claudia in a Towel

Oil on canvas, 40 x 50ins. 1983

I was inspired to do this picture by the combination of a glorious model and a new camping chair. I made an elaborate nude study and then my son Toby enlarged the drawing onto a 40in x 50in canvas. It is very exciting to paint on a foundation that has been so carefully planned and worked out in a previous study.

The background grew out of sheer high spirits. I changed it a lot. Things were put in and taken out, but then two figures seemed satisfactory: the one of Toby reading a newspaper and the back, which is to the left of Claudia's head, which is another view of her. A neighbour provided the other two figures. On the right is my wife holding a catalogue of the exhibition in which this picture appeared.

On her right is my friend Gerald Norden, who is repeated directly above as a waiter. Behind him is Gordon Davies, next to him is my son William, and to the left of Gordon in the striped football shirt is Toby once again, talking to the girlfriend of the moment.

The lettering, which I can never resist, just seemed to fit so well. At one time I had two dogs down near Claudia's knees, but in the end one fitted better than two. The view behind the heads on the left is of Folkestone.

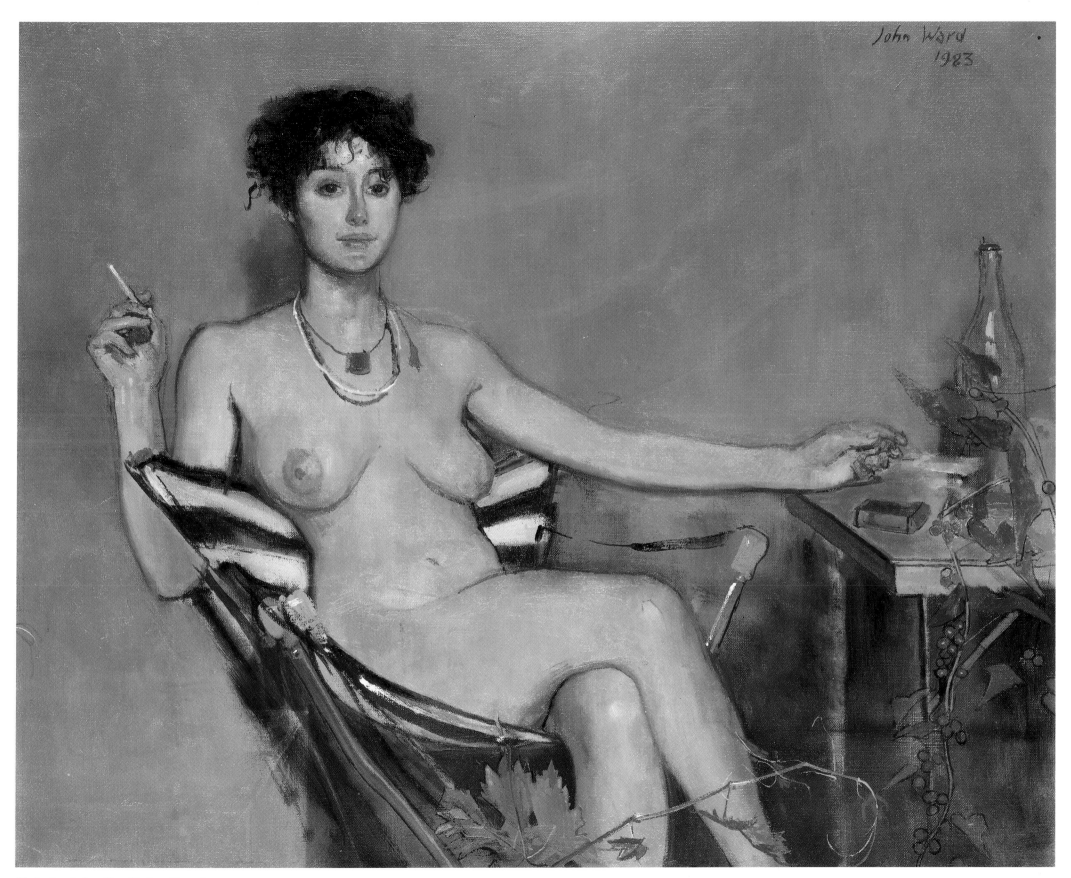

**Nude Study for Claudia in a Towel**
Oil on canvas, 23 x 29ins. 1983

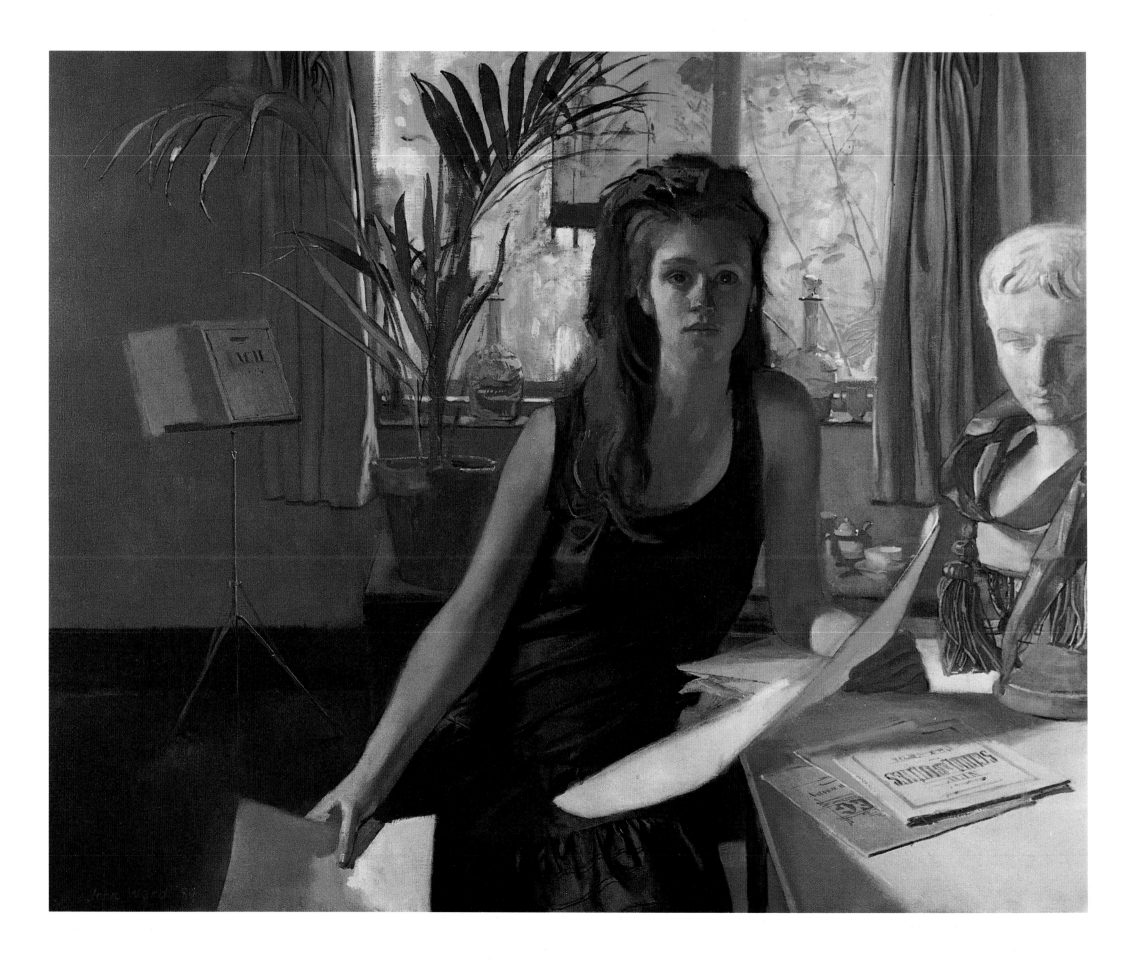

OPHELIA
There with fantasic garlands did she com
Of crow flowers

**Olivia as Ophelia**

Pen and ink, 11 x 17ins. 1984

Ophelia is an excuse for drawing a wildness and mixture of hair and flowers. This was drawn one evening, directly with a pen. Pens have a life of their own. Sometimes the nib will work beautifully, sometimes it splutters and is difficult and obstinate. I have never been able to draw with a biro or a mechanical pen; the marks seem boring compared with what most people term a dip pen. The drawing was made with a Gillot 303 and a mixture of brown and black ink, probably watered down with boiled water.

(Opposite)
**Olivia with Music**

Oil on canvas, 40 x 50ins. 1984

Olivia is the daughter of Nicolas Barker, the great bibliophile. She was between school and university and I grabbed her because she was so beautiful. She turned out to be a good model (alas, the two qualities don't always go together).

She brought a black dress that I was not particularly enamoured of, but it is nearly always better to let models choose their own clothes; they tend to produce the unexpected. In this case it went marvellously with the great mass of her hair.

In the background are two blue decanters which I found in a market in Rome. On the right is Jehan Daly's plaster cast, and then come the sheets of music. Books of music are always a good colour. And once I had that idea, the music stand, which is a lovely way of putting in a shape almost suspended in air, was an obvious addition.

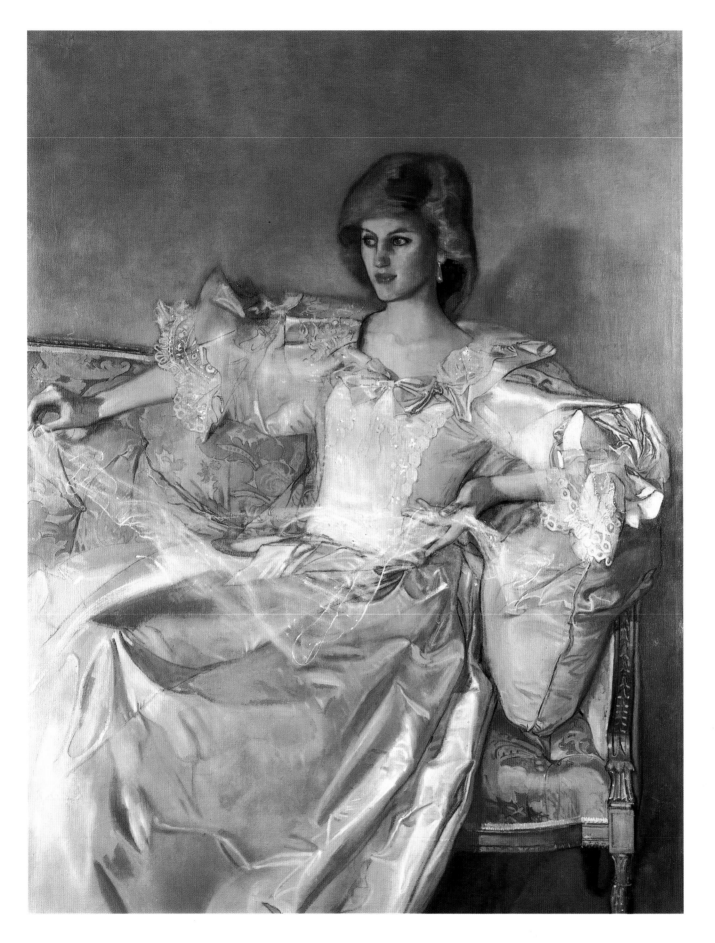

## HRH The Princess of Wales

Oil on canvas, 58 x 48ins. 1984

When I was asked to paint this portrait I was immensely pleased and flattered. A glorious subject. The wedding dress was chosen by mutual consent. A preliminary pencil study was made and squared up on the canvas, which was loosely pinned onto the stretcher with plenty of overlap for extension should it be needed.

The portrait was painted at Kensington Palace, where the windows and ceilings are low, and so it was best to paint sitting – risky for so large a canvas, but best for light. With the elaborate dress and the simplicity of the shape of the couch I eliminated all background – a rich tapestry hung behind the Princess. It was wonderful to attempt so splendid a subject.

(Opposite)

## HRH The Princess Royal

Oil on canvas, 74 x 38ins. 1987–8

There is a strong notion that princesses, flying ducks and thatched cottages are no longer the stuff of paintings, but when the National Portrait Gallery asked me to paint the Princess Royal I jumped at the offer. True, I had seen the Princess at an RA dinner looking radiant and sparkling in a white satin and lace dress, and I did mention what a splendid subject she would be ...

I knew that lips would curl at my pleasure in a glossy subject – ought I not to paint her khaki-clad with a Save The Children atmosphere? Yes, but that approach would be for someone else. For me the stimulus was the glitter and sumptuousness of the subject as a princess, and I had all the Buckingham Palace splendour in mind. And of course there was the challenge of making a 'chocolate box' composition work, and of making it win over the prejudice against such a style. Easy to avoid, but so much more of a task to confront head-on.

There was some discussion about size, but in the end it was left to my own discretion. Size is a fascinating problem; I am so glad that the postcards sold at the National Portrait Gallery now give the dimensions of the picture – it is a great help in deciding size.

I am attracted to narrow shapes rather than square ones, and going round the National Gallery I decided that the size of Whistler's *Portrait of Miss Alexander* was what I wanted. Two canvases were ordered and delivered to Buckingham Palace, where the painting was to be done in the Yellow Drawing-room. There would be a background of Chinese wallpaper which I found enchanting, and my mouth watered at the

thought of having the energetic splendour of the chinoiserie fireplace, candelabra and mirror as adjuncts to my portrait.

Sittings were fixed, and permission was given for me to take along my assistant Gillian Andrae so that I could see how the light fell upon a face, and how the background was, and settle things before sittings began. I find this settling-in essential. Always there will be much that one won't have foreseen – the whole business of talk and pose and rests is enough, without the worry of where paints and brushes are placed, keeping turps bottles safe, and of ensuring that charcoal and paint rags are to hand.

On my way to the Yellow Drawing-room, where I was painting, I would pass portraits by Sargent and other Victorian and Edwardian painters, as well as the immense and hair-raisingly skilful painting by Frith of the wedding of the Prince of Wales – the one that took three years, and nigh on killed him, which Jeremy Maas wrote about so brilliantly in his book *The Prince of Wales's Wedding*. It was stimulating to study these paintings and to see how problems of lighting and pose were dealt with.

The Princess arrived wearing, as requested, the white dress, and I knew just where to stand her and, from the experiments with my assistant, just where the head should go on the canvas. What a plunge the first attack is! Mostly my practice is to make a drawing or drawings if time is plentiful, and then square it up onto the canvas, but here I felt the work should be attacked with all the vigour I could summon up.

Sittings were of two hours' duration, and the Princess didn't wilt for a moment. Standing is hard work, and such is the standard of portrait painting today that sitters who have suffered so often at the hands of portrait painters, as the Royal Family have, cannot be very optimistic about results. I believe portraits are better painted if the painter stands with the canvas next to the sitter and a good 10ft of run-up. One has to paint broadly, and the main design is seen more clearly. True, this makes for a crudity at the beginning – sitting, one can achieve a linear intensity more rapidly, but it is on the first action that something is captured.

Sittings were in October, the light was always tricky, and over the great windows were heavy net curtains, but the Princess quickly saw the problem and they were tied back. The figure was set up fairly rapidly. However, during one sitting when the light was poor, I couldn't resist painting close to the canvas, attempting to make the drawing firm; but next day I took rag and turps and cleaned off the head. This sounds drastic but always there is enough left behind to encourage further work – much better clean off than try to work over what is wrong. That I find demoralising, whereas rubbing the whole thing out is invigorating.

An excellent lay figure was produced for the dress and many days were spent relating the complexity of the background to the movement in the elaborate dress. Whole days were spent on dress and background, with entertainment every morning when the Guard was changed and the band played.

Friends were permitted to come and see the work and give opinions. This I always like – one can so easily get things wrong and then develop a blind spot for the mistake. The excitement never flagged and I had plenty of time to make sure the Chinese hand-painted wallpaper was given due care. One of the spin-offs of tackling elaborate backgrounds is that the spirited quality of the ornament can be enjoyed and realised. The dragon which clings to the pillar on the right-hand side of the picture had immense vitality and bite.

The huge Chinese lamp was difficult to paint. To give the scale, and to imbue it with the weight of palatial splendour, and get right the vicious wriggle of the serpents which crown the piece. Too much background? I felt that the figure could take it. I have often toyed with the idea of doing another version.

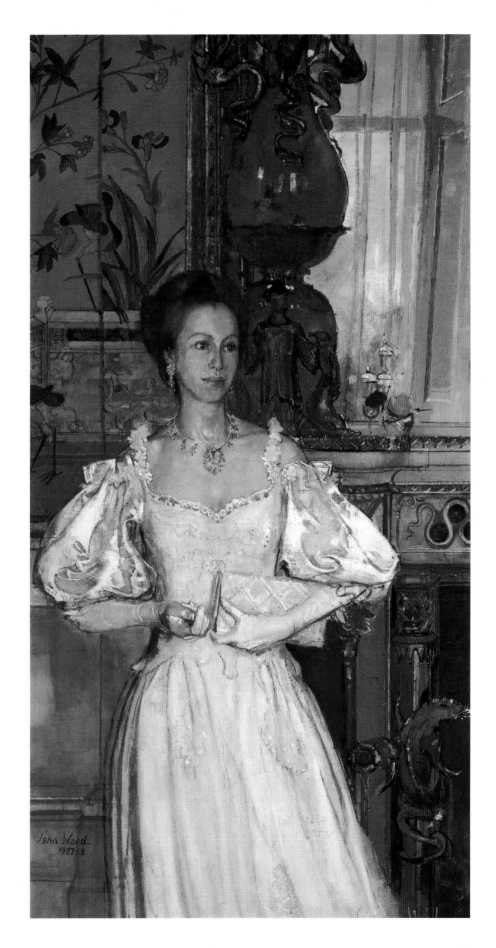

## Susie with Sunflowers

Oil on canvas, 25 x 30ins. 1985

Susie Williams, the model for this work, I met when I was painting a portrait of the Princess of Wales. I was desperate for a blonde so that I could study the skin tone against the sofa on which the Princess was sitting. I happened to go into Jeremy Maas' gallery and, sitting there at the desk, was a new secretary whose hair and complexion were just what I wanted.

I asked Jeremy if I could borrow her for a day or so and he introduced me to her. Susie came along to Kensington Palace where she posed patiently and well, and when I had finished I persuaded her to come and sit at weekends. She became a favourite model.

One day we were having tea in the garden, and the sunlight on Susie, the hop plant behind and the sunflowers made, I thought, a wonderful subject. The painting of the hop plant was an immense effort. I started in the morning and worked on right through the day. The complexity of sorting out something as rich as that kind of growth calls for immense concentration and it had to fit into the brickwork, so there are even portraits of individual bricks!

The objects on the table on the right varied greatly during painting. At one time we had a great bunch of tulips there, but these were too distracting and, having painted them with the same care that I had lavished on the hop plant, I reluctantly had to clean and scrape right down to the canvas again and stick to the simple objects, the teapot and apples.

It would be nice to think that you saw a picture from the beginning and just painted it. Sometimes that does happen, but a picture is essentially a voyage. At the beginning of the voyage you have the idea, but as you get into it it develops and becomes more exciting, and possibilities are thrown up that hadn't at first occurred to you.

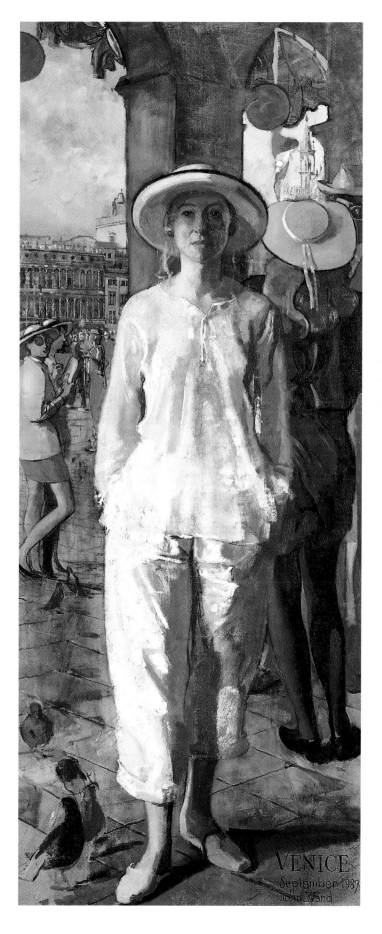

**Susie**

Oil on canvas, 18 x 14ins. 1986

The excuse for this was the fascination of painting skin against an embroidered white pillow and a mirror. Susie's fringe gave a lovely mist and held the light, marrying the reflection to her hair.

**Susie as Giles**

Oil on canvas, 60 x 24ins. 1987

This was inspired by the great Watteau painting of the clown Giles. Susie is in front with Gillian behind, and the design, set outside Florian's in St Mark's Square, is held together by the two straw hats, repeated in the hanging lamps, and the pillar behind Susie.

Florian's comes into so many pictures because once you have made a lot of studies, and they are promising, it would be foolish not to go on exploiting them. The more you explore a good idea, the better it usually gets. Now when I go to Venice I rarely move far from Florian's; there is plenty to keep me busy.

The Italian flag is a lovely gift to paint. And the pigeons, like hair and clouds, are a good free-for-all.

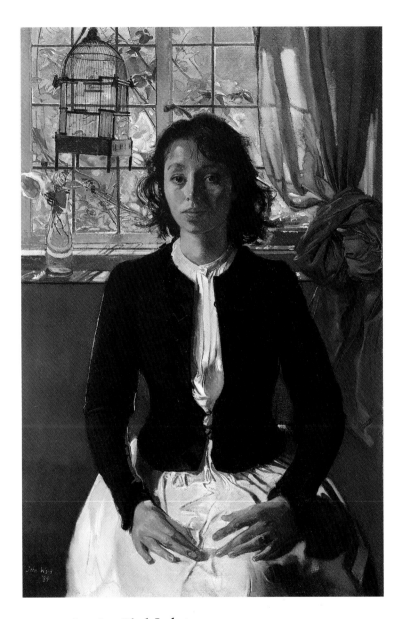

**Jane in a Black Jacket**
Oil on canvas, 36 x 24ins. 1984

**Jane at Florian's**
Oil on canvas, 61¼ x 41¼ins. 1985

The lovely Jane Dunn came via a raffle – she won me, third prize. I had been painting a large portrait for the City Club and had become hopelessly lost in the wasteland of the sitter's blue suit, the nightmare of portrait painters. I pleaded for more sittings and, nice man that my victim was, he agreed, but asked if in return I would give a portrait drawing in aid of Charleston House, that highly decorated, delightful and historic home of Vanessa Bell and Duncan Grant.

In my panic I agreed, but the moment the blue suit was framed and out of the studio I forgot all about the matter. Weeks later I had a phone call from a lady to say she had won me, third prize, in a raffle and what did I propose to do about it? Silently groaning and wondering what I might have to face up to, I suggested she came to Bilting, stayed one night, and I would do the drawing. Come the day, I braced myself, peeped through the studio curtains when the expected car drew up, and when Jane stepped out I could hardly believe my eyes.

'Of course you go for character when you paint a portrait,' people say to me, and yes I do, but I must confess that when character, and there is plenty in Jane Dunn, is wrapped in so fair a form then indeed I am moved to work. I made the drawing for her and then pleaded, like Oliver Twist, for more. The dear, generous soul, she gave up endless weekends to the tedious task of sitting. First the painting of her sitting in front of the window, known to us as the 'Black Job', entailing much careful work not only over the figure but also the background.

*Jane at Florian's* was stimulated by a lovely dress a sister had made for her. She stood gloriously and I was at a loss as to size of picture and whether to make a painting or a drawing. But then, for some reason or another, she raised her lovely right arm and I knew that I needed the largest canvas to hand, and that I must plunge at once. I must immediately register my intense excitement and desperately hope that she would respond, as she did magnificently. The reflection came a little later than the first lay-in. At first I set her *outside* the famous café and made an elaborate study of tables and chairs in perspective, but all this I discarded – hours of work – in favour of the straight-on rectangle of the mirror.

Studies of Florian's I had galore, and coffee pots and trays 'borrowed' from Annabel's. Now and then I paused to think of the expressions of horror with which my fellow RAs would greet the sight of a picture of a lady in an evening dress – just the subject which the RA had been trying to escape from for the past thirty years. But sensible Jane said, 'Just for the hell of it . . .!'

Before going to the RA the painting was shown at the Maas Gallery. Sir Simon Hornby, the chairman of W. H. Smith, peering through the gallery window, spied it before it was even hung, and bought it for his company.

I still look on blue suits with horror, but now it is a qualified horror.

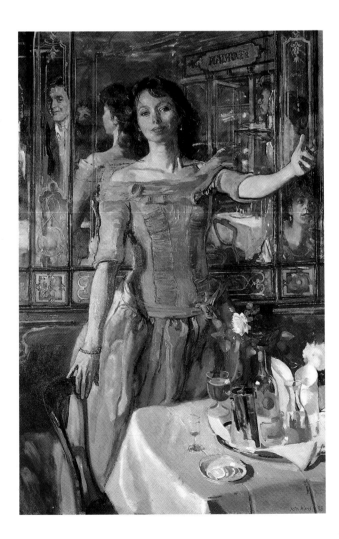

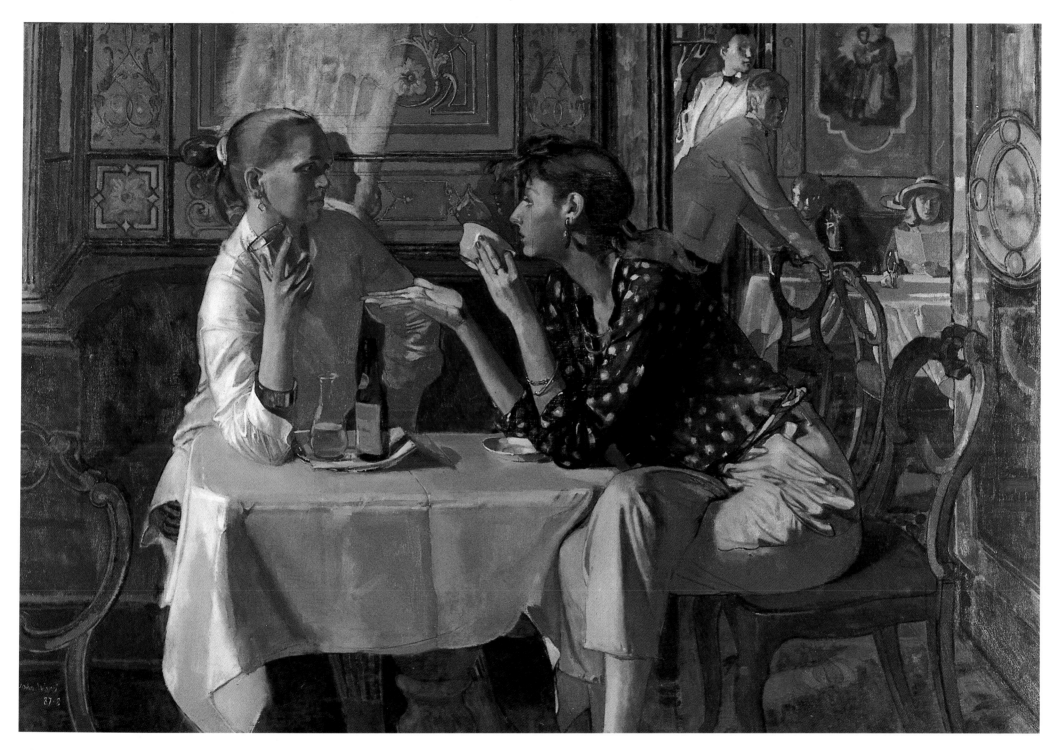

### Conversation at Florian's

Oil on canvas, 36 x 54ins. 1987–8

I was asked to do some illustrations for Evelyn Waugh's *Brideshead Revisited*, and having two female models around I decided to use them for the moment when the two young men go to Florian's to drink and watch life go by. There is no significance in the fact that I used female models for males! I often do, any human figure will serve – it is the relationship between figures that is difficult. You can change men into women and women into men without much difficulty.

However, suddenly this arrangement happened and I realised that it was a marvellous subject. I set the idea of doing the illustration on one side and made studies which became the foundation for this painting. I had details for the background and I made endless drawings throughout the painting, particularly of one of the most difficult parts of the arrangement, the chairs. Chairs give a beautiful pattern and are an easy way of introducing perspective into a picture. I greatly re-

lished painting the beautiful decorations on the walls of Florian's – what a lesson in drawing they are!

The clothes are just what the ladies were wearing when I set out to do the study for the *Brideshead* illustration. Luck was with me and it all seemed to fit. Thank heavens they weren't clothed in that fashion of the moment – father's old jacket. Jackets are bad enough on men; on women they are even more boring and drab.

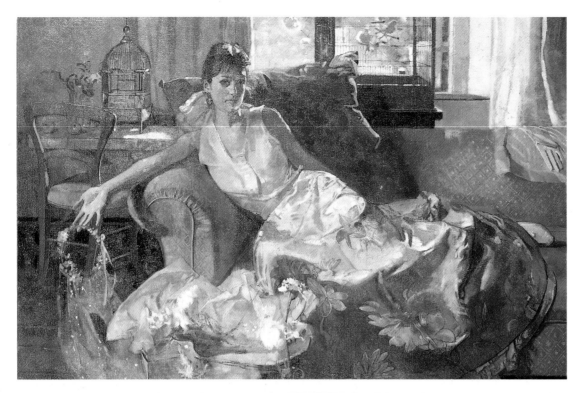

### Gillian in the Edwardian Wedding Skirt
Oil on canvas, 36 x 54ins. 1987

Gillian Andrae came to work for me as an assistant, and very good she was, but she also became a favourite model – models are seen to advantage by being around and doing things, rather than just arriving and posing 'cold'.

The wedding skirt I had found in a local antique shop, heavy satin with a superbly drawn lily pattern, which suited Gillian's long, elegant shape. The right arm and hand, which are the keys to the composition, were very difficult to get right. But then I always find bare arms difficult – and they are parts of the body that no one notices when they are OK, only when they are wrong.

The canaries shed seeds over Gillian, and some days the sun shone, sometimes not. Tremendous care went into the painting of the arm of the sofa, the buttress of the composition.

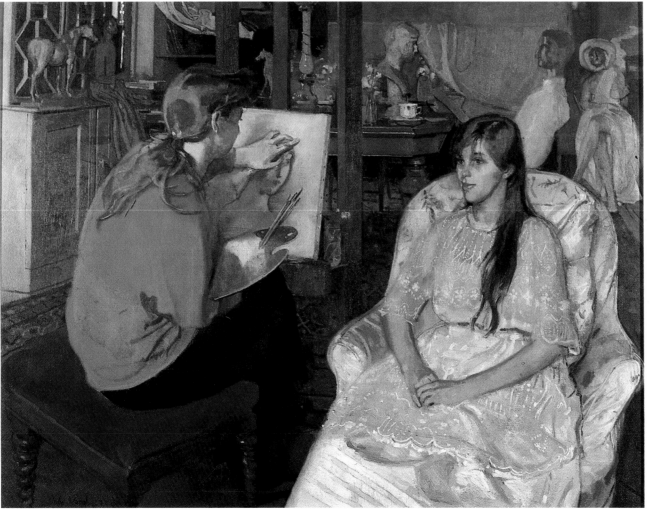

### Gillian painting Lucinda
Oil on canvas, 28 x 36ins. 1987

Again and again in my student and teaching days I would notice that the painter was often more interesting than the model. The whole set-up of someone sitting still and someone painting is a marvellous arrangement. Here Lucinda is wearing the same lace dress as in *The Doll Girl*, and sitting on the same chair. All around are the lay figures and plaster casts that I have always so enjoyed painting.

Now and then I have used the lay figures for their proper purpose, but they are wonderful furniture, and have a curious life of their own.

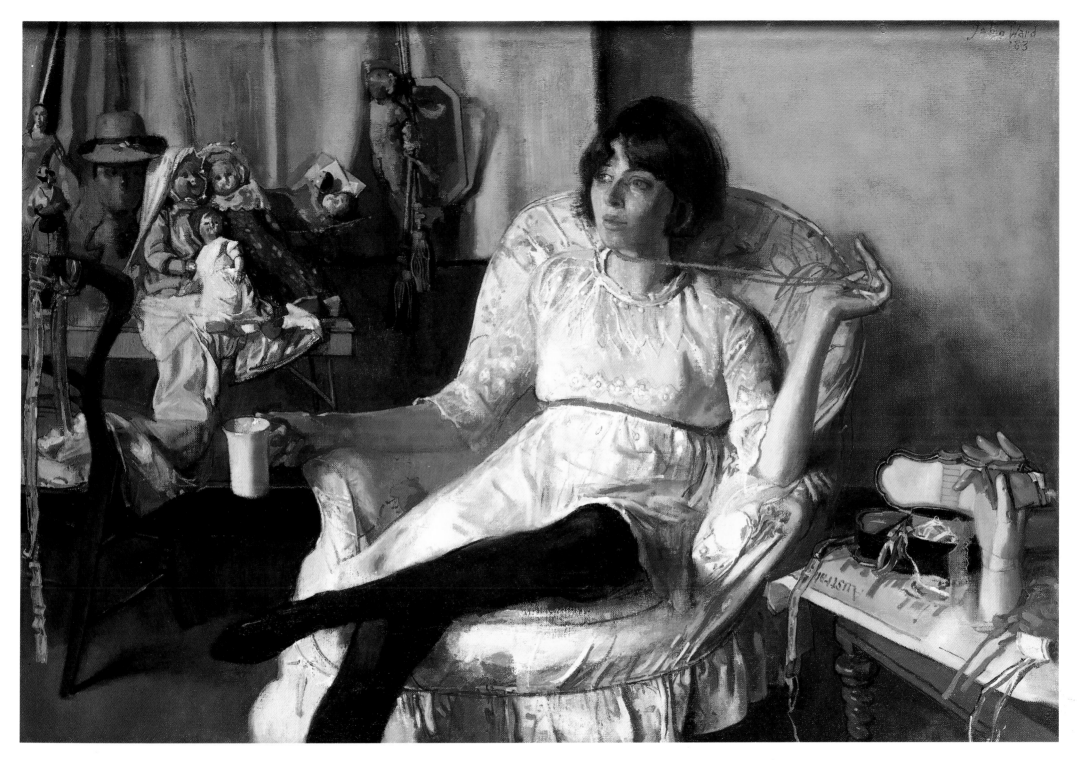

## The Doll Girl

Oil on canvas, 20½ x 30ins. 1983

A lace dress bought in Ghent, and a quiet and gentle art student model sent by a friend. For some reason or other I asked her whether she had been taught singing at school. 'No', she said, 'there was too little discipline for that kind of thing.' In this case the peace and quiet of my studio suited the sitter, and she could think thoughts which the turmoil of her schooldays had denied her.

She was a sculpture student, but had a passion for dolls. This awakened all my ideas about toys and works of art. Could sculptors find a way back via toys?

My wife has a few dolls which I brought into the picture, providing both contrast and conversation. And always the bit of luck, by way of the armchair with its chintz cover. A friend assured me the composition was too cluttered, but for me it all fell into place. Once the pose was settled, or pretty well settled, I made nude studies in order to get the pose as well drawn as possible, and enlarged the canvas at the top to avoid losing the edge beneath the frame.

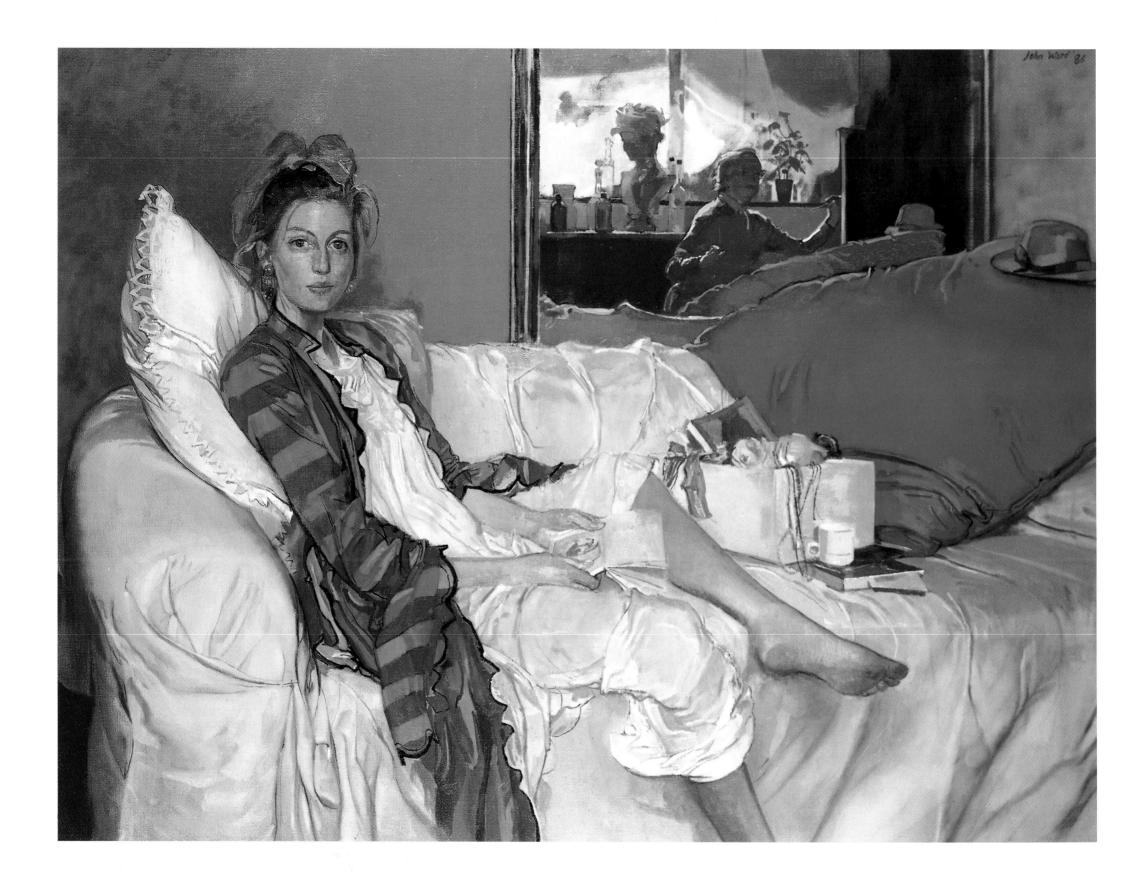

(Opposite)

**Fiona in the Turkish Gown**

Oil on canvas, 36 x 50ins. 1986

This model was stolen from a friend who is an amateur painter. Jehan Daly discovered him trying to paint this beautiful girl and was so impressed by her that he persuaded the artist to bring her along to me. Since she was not working then I managed to employ her for some months. The Turkish gown I had had for a long time, and it suited her to perfection.

The pillow is the same one that I used in the painting of Susie. The little book she is looking at is a collection of Delacroix watercolours. The medal ribbons, which I find so beautiful, I buy whenever I go to Paris. I find them irresistible, and about the only pretty things one can still afford in that city.

At one point I had another dress draped where the cushion is, but in the end the cushion produced a greater mass and simplicity. The hat, with the reflection, gave a distance to the picture, and movement to the self-portrait.

**Fiona**

Oil on canvas, 48 x 28ins. 1986

It has always seemed sensible to vary the model's pose halfway through the day. This version of Fiona was painted in the afternoons, the *Turkish Gown* in the mornings. When I came to finish the head the model stood beside me so that I could see details with the greatest clarity.

With age comes the inevitable problem of deciding which spectacles are best. Mostly I use half-glasses, but I do have bifocals and there are times when I like to be near and see sharply. Not always a good practice, as it can lead to disunity in a picture.

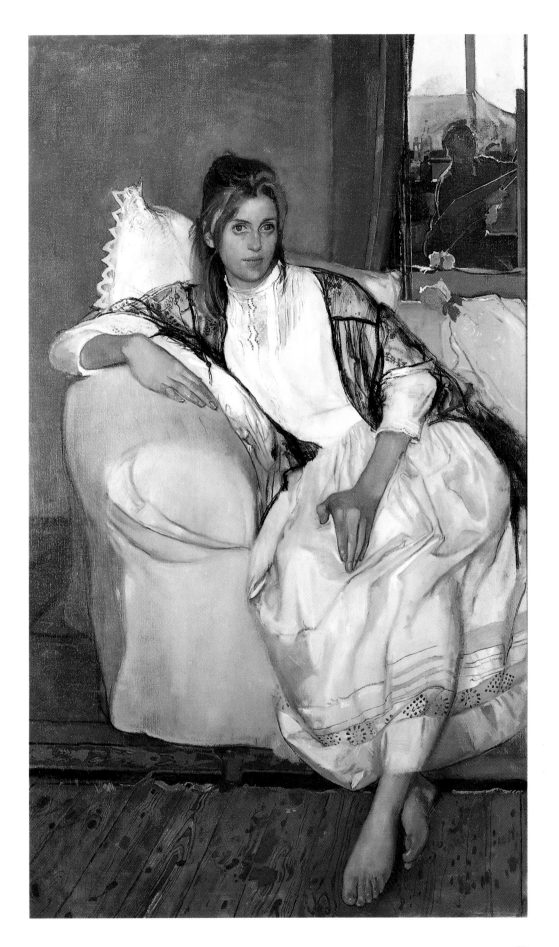

### Self-portrait
Oil on canvas, 23¼ x 19¼ins. 1983
I rather think I happened upon this arrangement by chance, when I was shifting two mirrors around. But from earliest days I have glared at myself when there was no one else around to suffer as a model and, as an arrangement of mobile meat and bone and hair, the self-portrait is a wonderful practice ground.

It would be entertaining to say that I search for character on these exercises, but I don't. I strive to get it right – the fun lying in the correct rendering of the hard and the soft, the suggestion of bone and the tingle of movement which animates a head.

In early days I learned a lot about drawing heads from these exercises – and not to show the result with any high hope of approval. 'You look very glum/stern/ cross-eyed', friends would say, few of them giving marks for the attempt to achieve a picture of so complex an object as a head.

The self-portrait was bought by Norman Parkinson on first sight at an RA dinner.

### Two Hands
Pen, ink and watercolour, 12½ x 18ins. 1973
Hands, drawn and painted, are a marvellous subject, and in a group portrait can be used to give animation and movement. Their complexity, folds and tensions are like exercises on a violin, a lovely feat of dexterity.

The pair of hands was drawn in Salzburg where I had gone to draw a child, and since sittings were brief I had time and a model available – so I drew them. I think I tried to give a touch of heraldic pattern by the light and dark backgrounds.

My practice of drawing hands was useful in the early days when I earned my living by commercial art. With lipsticks, flowers or a book, a drawn hand often served better than a photograph.

(Opposite)
### Norman Parkinson with the Golden Hassleblad
Oil on canvas, c.96 x 48ins. 1988
This was to celebrate Parks' seventy-fifth birthday. He wanted a large portrait, 'a bit on the lines of Lord Ribblesdale'. And he wanted it done in Tobago. Alison and I were to spend a few days in Port of Spain to see the famous carnival. Taking a stretcher 60 x 80ins was no easy thing, but Alison still retained her pram skills and by turning the trolley broadside we negotiated Heathrow.

Photographers are magnificent managers, and on arrival a small car met us, and our gear and luggage were loaded and lashed down onto it. We drove to the rather ancient hotel which Parks had been using for twenty years and were given a room overlooking the road down which the great carnival procession would go.

Parks sat while I made studies, watching, with comments, the efforts of an elderly couple of West Indians to erect a shed where they would sell oranges, beer and Coca Cola. Old used timber and corrugated iron didn't make for either ease of building or shapeliness, and there was much standing around and discussion and desultory nail-banging.

In the end Parks could restrain himself no longer. He had to go and help. When he had finished helping with the fundamentals he asked where their sign was, how could people know what they had to sell without one? Well, they said, their nephew was going to make one, but he hadn't had time.

Ah, said Parks, luckily for you I have a painter staying with me who can do you a sign. So the hotel was ransacked, a signboard produced, and I undid my paints and had a happy evening remembering my old sign-writing master Fred Lofts.

Next day we took it across to the old couple who giggled appreciatively. Parks volunteered to hang and centre the board properly. They produced an ancient newspaper bundle of old bent nails. 'God', said Parks, but neatly and firmly he straightened enough nails and soon the sign was in place. For most of that day he stood by the stall, selling and advising on supplies, and providing the conversation which makes shopping so charming an occupation in the West Indies.

From Port of Spain we flew to Tobago and to the house which had been rented after Parks' own beautiful home had burnt down. I laid out the stretcher on the floor. It was hot, so hot that I borrowed a pair of Parks' shorts. When I came to lay the canvas over the stretcher I saw to my horror – my very hot horror – that the stretcher had been wrongly measured and was too short. With Parks' son Simon I fled to Scarborough, the metropolis of Tobago. There I found a sheet of hardboard and over this I pinned the canvas, anchoring it, since there were breezes of some force, to an iron table and various heavy chairs.

The drawing I had made in Port of Spain was squared up and transferred to the canvas and I began to paint. I wondered how long I could keep a seventy-five-year-old standing, but my subject was indefatigable and I was gasping for a chair long before he was.

The white suit, the handmade boots, the belt – what a superb subject! No interruptions, lunch cooked by Simon, very simple, and when work was over there were quiet expeditions and all the enchanting conversation and reminiscences of this remarkable man. One evening I happened to mention that I had never tasted Château Yquem. 'We have one bottle saved from the fire', he said. And that evening with our mince and fruit we drank this rare and wonderful wine.

The painting was completed in just over a week, rolled up wet, and survived the journey back to Bilting.

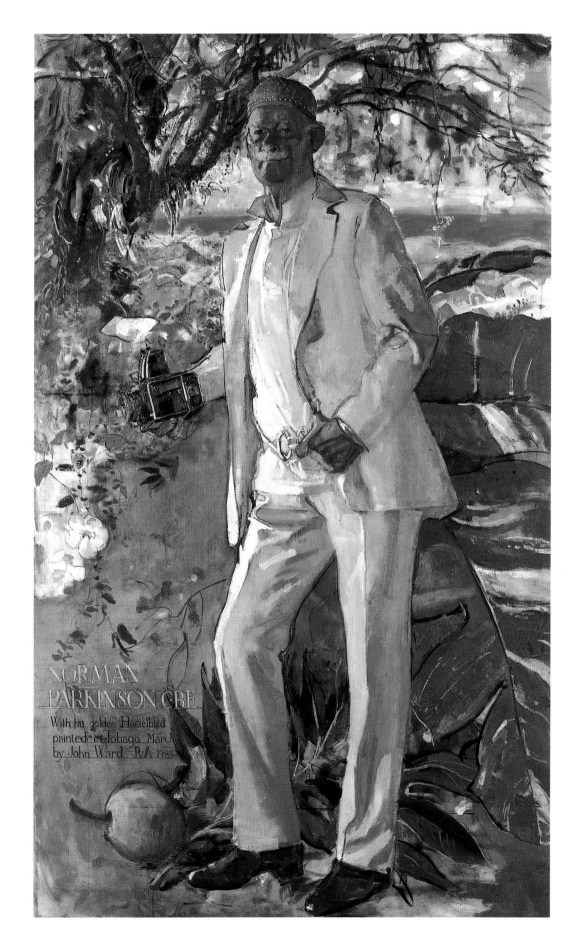

NORMAN PARKINSON CBE
With his golden Hasselblad
painted in Tobago March
by John Ward R.A. 1988

**Still Life with Cups and Jug**
Chalk and watercolour, c.31 x 19ins. 1989
This drawing was to have been a study for an elaborate painting – I enjoy moving from the monochrome drawing into colour. It was squared up and drawn out on a canvas, but it faded as a picture and so I returned to the drawing, adding leaves and bits of flowers. Great pains were taken over the drawing of the tablecloth.

(Opposite)
**The East Kent School**
Oil on canvas, 40 x 50ins. 1985–7
Throughout my career, whenever I have got into a jam over a picture, I have sought the aid of Jehan Daly. In this case it was a painting of a family stuck around a magnificent silver Rolls Royce.

Jehan had come and groaned at what he saw, made suggestions and then, most happily for me, painted part of the picture. This was a gift he had, and it was like a singer being given the right note in music when he has lost his way.

When Jehan was painting he looked wonderful. We had painted and drawn one another ever since we first met in 1937 and I said I must paint him again. He was not busy and was perfectly agreeable, so I did a painting of him that went well as he has a very fine head. It was also the first time I had ever painted him with a beard.

This gave me the idea of doing a group of friends, starting with Jehan. He came along and picked up the mahlstick and just sat there with dignity, making a magnificent subject. I painted away, giving great attention to the hand which is holding the mahlstick and the sleeve, which is going back. You could not miss it, it was such a magnificent piece of form leading up to the head. Jehan, thank God, wore no tie. The other hand, which was on his knee, was very much more difficult. It was a simple shape but, though I tried it again and again, it still looked boneless. However, in the end I got it to this state.

The others in the group, Gerald Norden and Gordon Davies, also both have fine heads of which I made studies. On a large canvas, 40 x 50ins, I sketched out from the studies what I thought would make a reasonable composition but I changed the thing time and again, rubbing it out and rubbing in the heads, squaring them up and painting them in again.

I painted them individually in the studio, with Gerald Norden coming along once when Jehan was there in order that I should get the relationship of size right, and then Gordon came when Gerald was there. The heads of Gerald and Gordon I painted very rapidly. I think that having spent so long doing Jehan my eye was in.

The man on the right is an old, old friend, Jim Slawson, whom I had known since I was sixteen. He happened to be visiting us so I slipped him in, again painting very rapidly. Behind him stands a patron and friend, Colin George, and behind Colin there am I.

The figure in the background is the lay figure which belonged to Sir Gerald Kelly and had borne the clothes of all the famous and the great from the beginning of the century right up to the fifties.

It helped enormously that I had known the sitters so long. I knew their form and relished the task. Painting those three heads was like a pianist playing a favourite piece. They were heads I had drawn so often that it was a great pleasure to paint them yet again.

I worked on the picture from 1985 to 1987. Where, as with this picture, there is no financial necessity to finish a painting because it is not a commissioned work, you can drop it when you come to a problem. You stick it on one side and then one day you will see some bit that you think can be improved, and it starts up again. I rather think, if you look on the extreme left side, that there were far more figures, including a plaster bust, that came and went. This picture went through many stages. It is lovely to have a picture going over a long period because the paint becomes nice and dry and you can rub over it and work into it. The actual handling is such fun.

This group of friends have been painting companions since – Jehan Daly since before – the war. Gordon Davies has seen me through many problems because not only is he a fine and skilled painter, but he is possessed of great imagination and a highly irreverent sense of humour, and also a down-to-earth practicality, a quality I sadly lack. So often he has supplied the ginger to the pudding of my painting.

Gerald Norden is my constant critic and at all stages of a picture I turn to him for approval. He was senior to me at the RCA, a fact which I never forget!

The picture was bought for the Royal Museum, Canterbury, with money subscribed by friends and some help from the National Art Collections Fund.

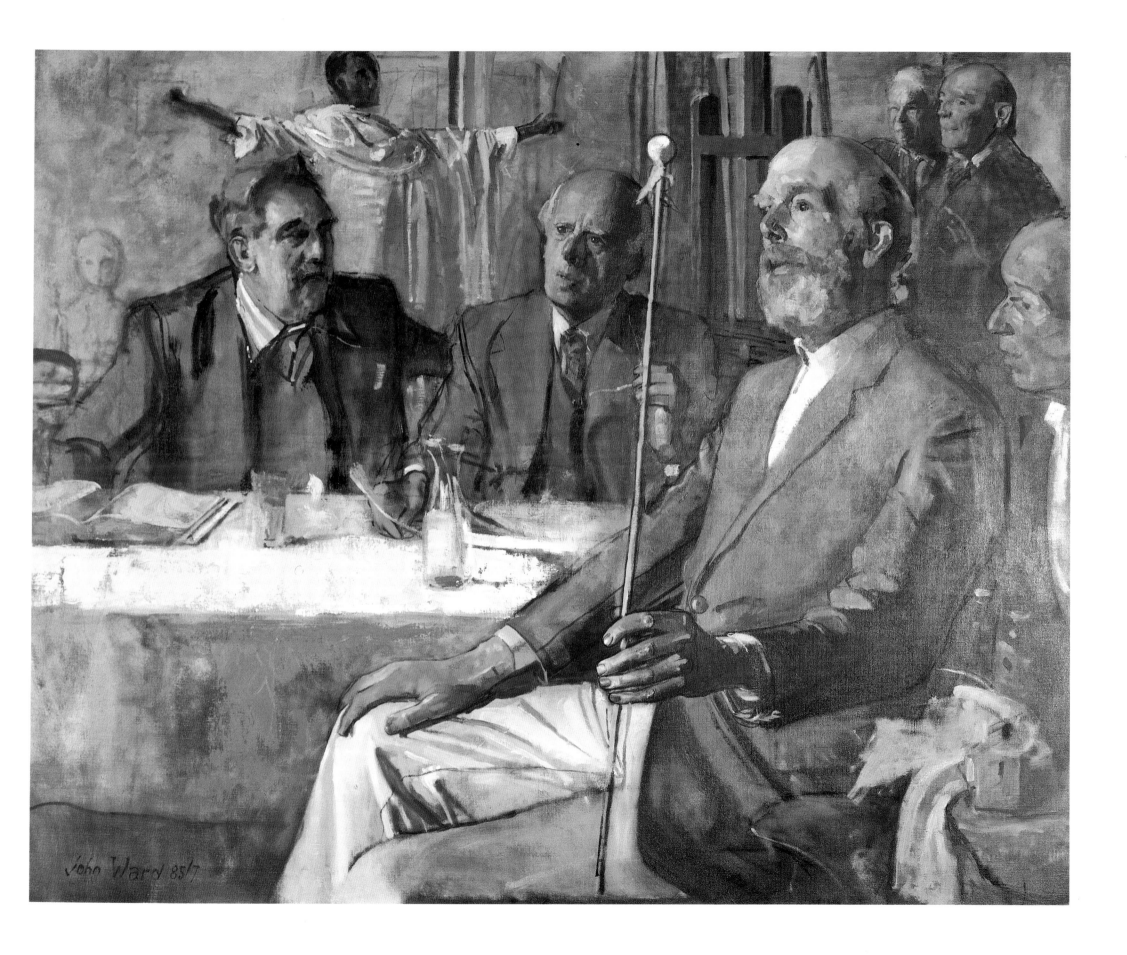

John Ward 85/7

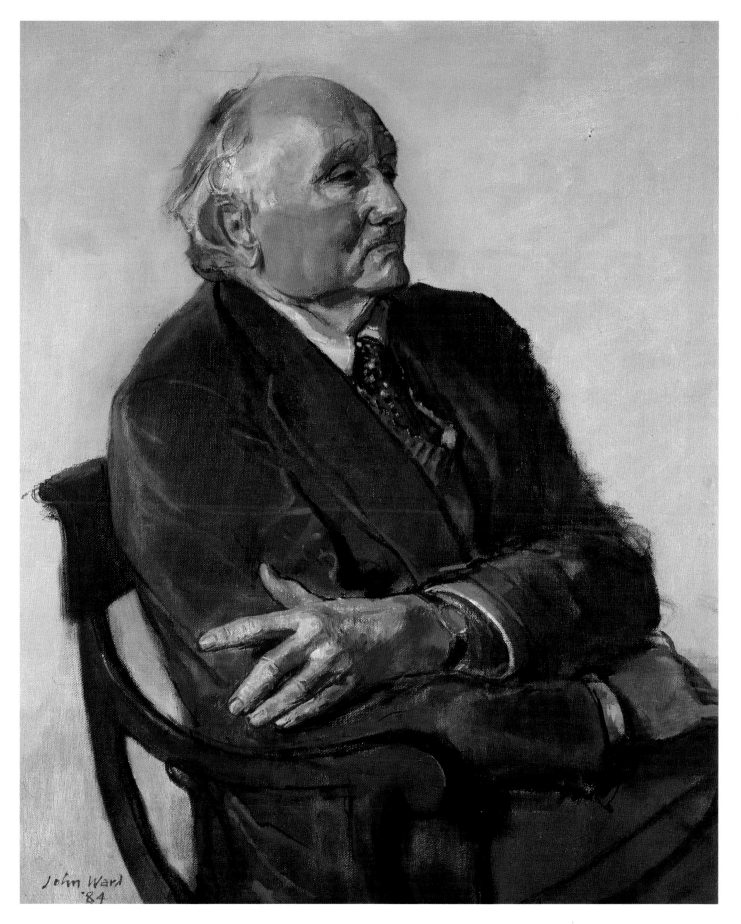

John Ward
'84

### Patric Dickinson

Oil on canvas, 24 x 20ins. 1984

I met Patric Dickinson when we worked on an Arts Council project: he wrote a poem and I illustrated it to produce a poster. When we first met he had a beard and I longed to paint him. I think I even mentioned to him that I would love to draw or paint him. But it was not until some years later that his wife wrote to me to ask if I would make a drawing of Patric, and I jumped at the opportunity.

By then he had lost his beard, but what had been under it was immensely paintable. A very good-looking man with fine, powerful eyes. Not the Pekinese eyes of Lord Clark, which bulged with impatience now and then; Patric's are large hooded eyes, and the area above has a great simplicity overlain with wrinkles that lead to what hair he has, which clings thinly but beautifully to his cranium. Wrinkles are always fascinating and immensely useful. They are a kind of ladder you can climb to the top of the head on, if you count them carefully. The hair is fine and grey, and had to be painted as delicately as a harebell. The colour of the head was ruddy, which gave an extra delicacy to the grey and white hair.

His jacket was corduroy, well beaten to his body. His tie, an object I usually so dislike painting, was a hand-woven chequerboard affair which was sufficiently strongly patterned to break up its boring shape. Then there were his hands. He has very fine hands and when I said I must paint one of them he just grasped his other arm – not in a natural way, but rather as if he had hurt himself, as if he had a pain in his arm. But anyway, it seemed to fit and he was quite happy to stick it there. I painted his hand and the sleeve with tremendous care.

One of the problems of this kind of painting is that you are so attracted by the details of the head and hands that if you are not careful you lose the simplicity, the bulk of the man; and the power of the man can be wasted by this clinging to detail.

Patric sat well, but he would move his head round quite a bit. Often when we spoke, being slightly deaf, he would turn to hear what I said. The portrait was bought for Rye Art Gallery, Patric being a Rye man, with help from the National Art Collections Fund.

We did a book together, Patric's poems, my illustrations. When I approached a publisher the reply was a polite hollow laugh and so I went along to Geerings, our local printer. Grandfather Geering had known

Conrad, and Ken Geering had been a great friend of H. E. Bates, so I knew that I would have a sympathetic ear. With the sensitive guidance of Michael Curtis we produced the book; a limited edition of 750 copies. What an intoxicating business book production is!

**The Cabinet Secretaries**
Oil on canvas, 54 x 36ins. 1984
Sometimes when a picture takes a long time you become quite desperate. When I was painting *The Cabinet Secretaries* I thought I would never finish it. There were problems that I thought I would never solve. If I had not had the National Portrait Gallery behind me I would have scuttled and run.

There was the feeling that you were taking up space with your easel and your paintbox and gear in a room where a lot went on. While they could not have been more polite or considerate you did feel that it was not the kind of place to hang about in. It was where decisions were made and they expected other people to realise that time pressed.

In this picture the first problem was how to arrange them. What I realised first and foremost was that the most senior man, Lord Trend, should not be sitting on a chair as if he were the most exhausted and ancient one. So we have him standing, John Hunt sitting in front of him because he looked robust and full of beans, and Sir Robert Armstrong, as the man who was still in charge, sitting at the table.

It was irresistible to introduce one or two minor figures. It was good to put in the young man in his waistcoat and the young woman who was, I believe, one of the great law experts in the Cabinet Office. They gave an indication of the intense and youthful existence that went on round the Cabinet Secretaries.

I found the drawing of the room extremely difficult. The panelling and the cornices took me a long time. That was sheer application, I just had to count the things, get them right, and work away.

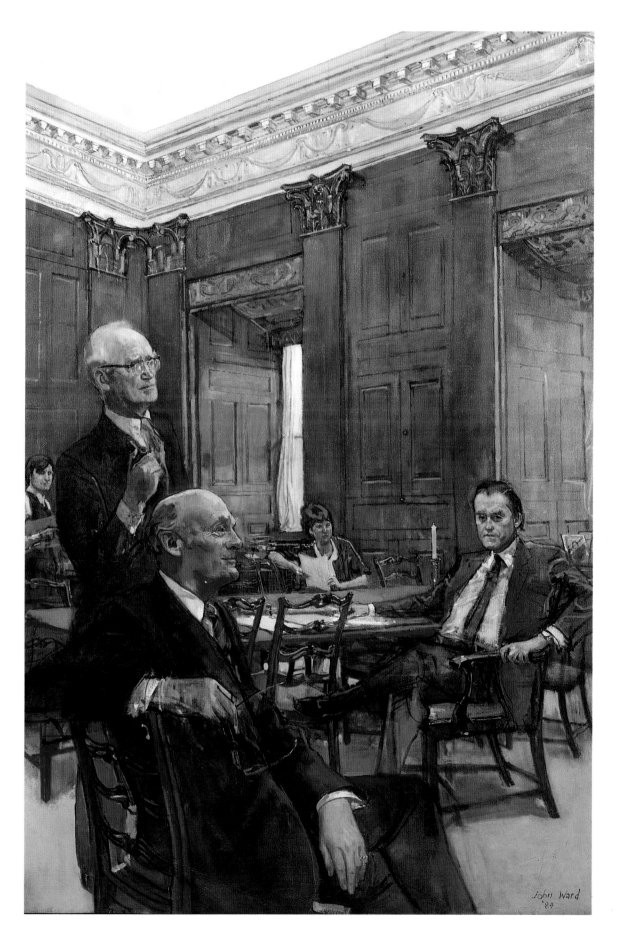

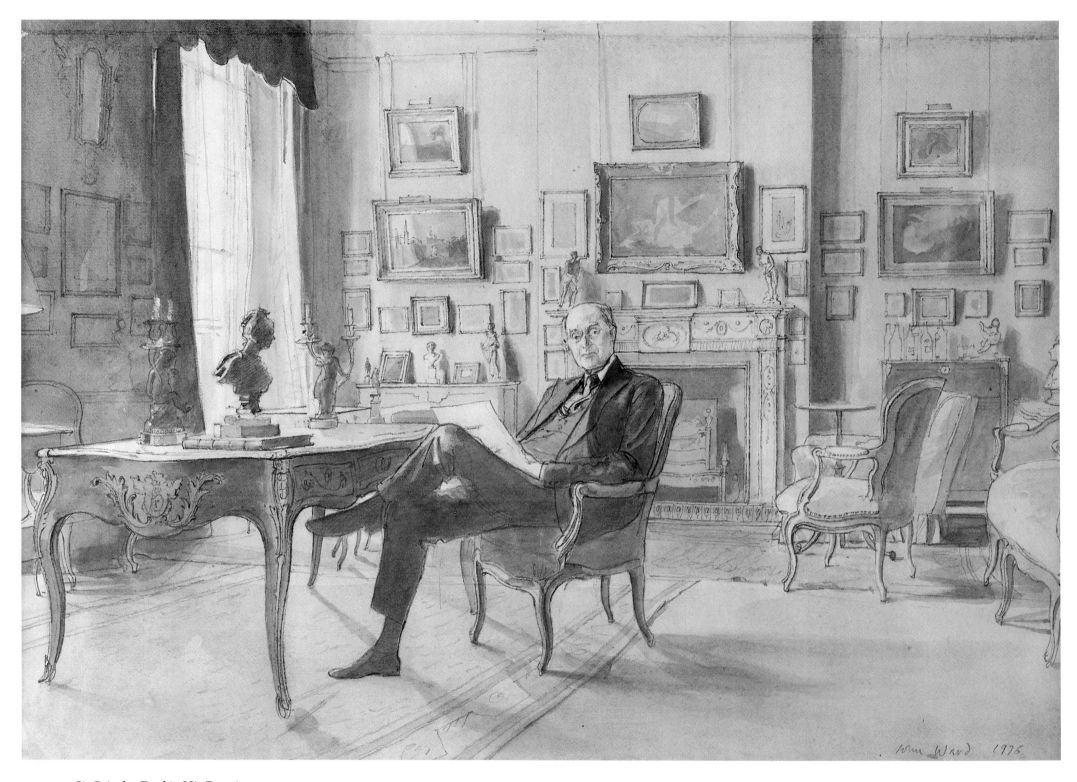

**Sir Brinsley Ford in His Drawing-room**
Pencil and watercolour, 12¾ x 18¼ins. 1976

About the time I made this drawing there had been an exhibition at the Hazlitt, Gooden and Fox Gallery of paintings and drawings of interiors, which impressed me profoundly. Mostly small pictures, often by painters unknown to me, they were works of art of the highest quality.

One or two of them reminded me of the shock of delight I had when I first saw work by the nineteenth-century Danish painters, in particular Købke's little interior of two brothers, one working at a desk. Here was work of a quality with which my friend Jehan Daly's pictures could happily sit.

This exhibition provided the steam for the painstaking recording of this beautiful room. With what care I watched over the chips of my pencil sharpenings, and that vulnerable water pot. When I used a pen I used watercolour rather than ink from a pot, thus being able to vary the strength and colour.

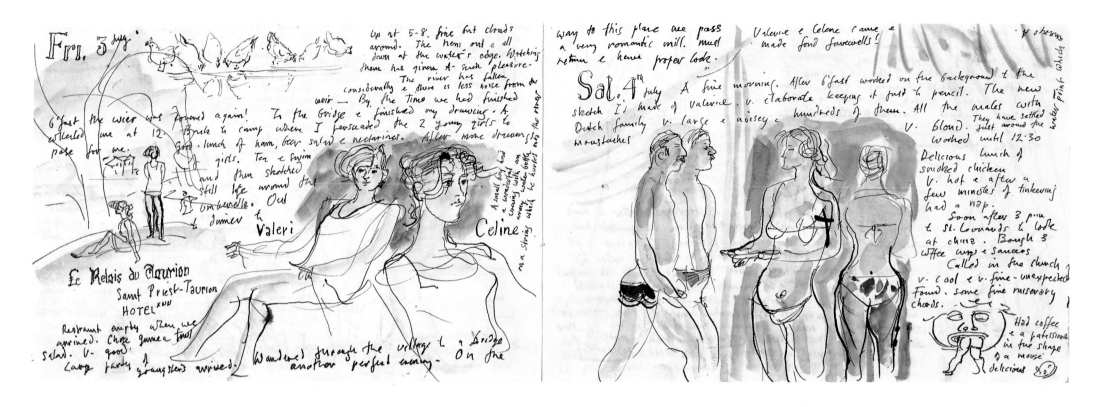

Pages from a couple of my travelling sketchbooks: France above and Turkey below.

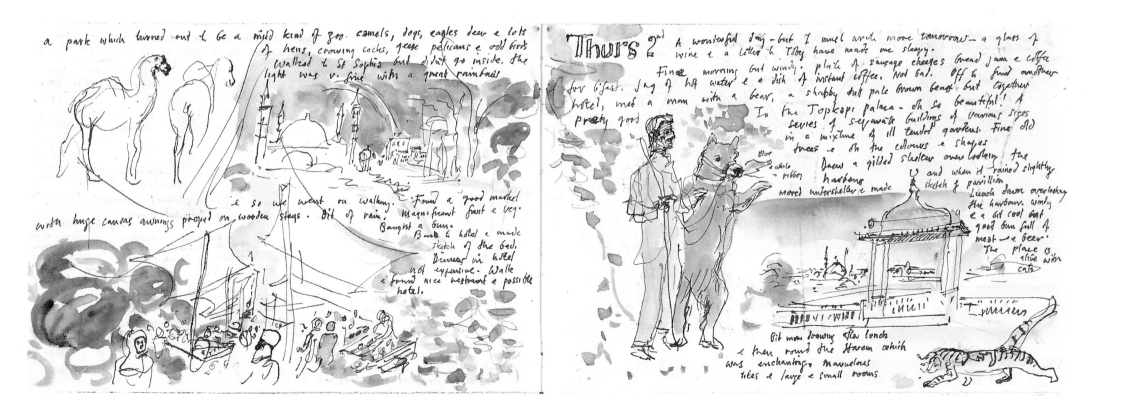

# INDEX

Numbers in **bold** refer to pages on which illustrations occur.

If undelivered please return to—
ROYAL ACADEMY OF ARTS
Piccadilly, London, W1V 0DS

Pass on your
Postcode

*J. T. Burns Esq.,*
*Frame Maker*
*To The Royal Academy*
*Burlington House*
*Piccadilly*
*LONDON*
*W·IV ODS*

5th Jan 1969.

BILTING COURT NEAR ASHFORD KENT TELEPHONE WYE 478

Dear Mr Burns
        I feel most ashamed
for not collecting the little drawing.
        But my wife thought
the chances of William (my son)
finding your shop in his pre-christmas
mood were slender and, as always
there were a host of things I had
left undone, things which I should never
have left undone & I ended with no
time at all before Christmas. But I
look forward tremendously to visiting you this
week, I have some more drawings
for you to frame & I LONG to see
the little drawings I do hope
you had a very good Christmas
and a very HAPPY NEW Year

John Ward